JOHN HEDGECOE'S Complete Guide to

Ple

PHOTOGRAPHY

BROMLEY LIBRARIES

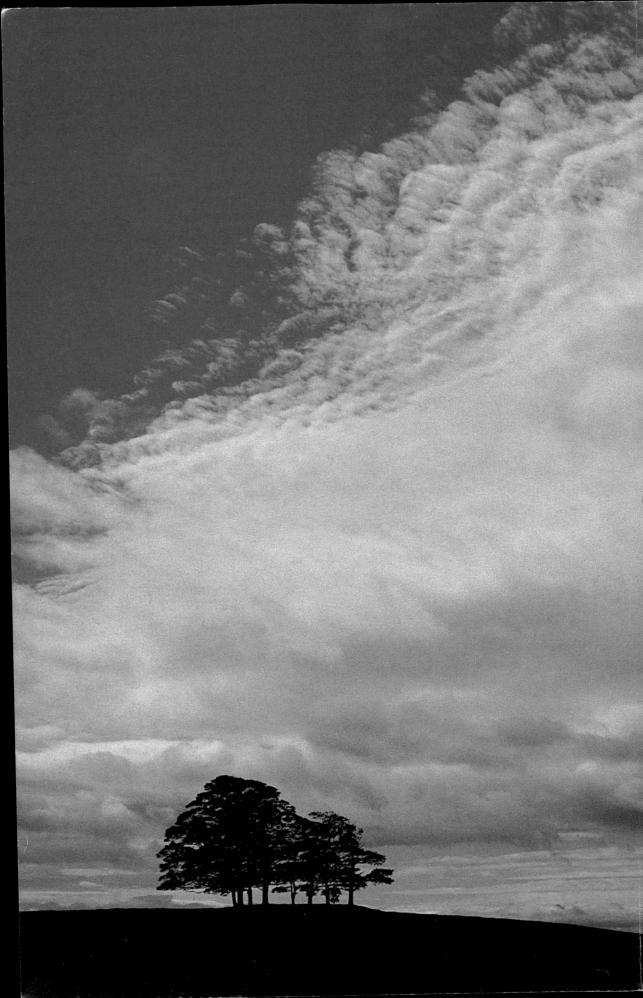

JOHN HEDGECOE'S Complete Guide to

PHOTOGRAPHY

BROMLEY PUBLIC LIBRARIES				
02669831				
Bertrams	08.02.06			
771	£12.99			
BECAPB				

Revised editon published in 2004 by Collins & Brown An imprint of Chrysalis Books Group The Chrysalis Building, Bramley Road, London, W10 6SP United Kingdom

An imprint of **Chrysalis** Books Group plc © Chrysalis Books Group

ISBN: 1 84340 119 3

First published in 1990 by Collins & Brown

Text © Collins & Brown and John Hedgecoe 2004 Photographs © John Hedgecoe 2004 Volume © Chrysalis Books Group plc 2004

The right of John Hedgecoe to be identified as the author of this work has been asserted by him in accordance with the Copyright, Designs and Patent Act, 1998.

All rights reserved. No part of this book may be reproduced, stored in a retrieval system, or transmitted in any form or by any means, electronic, mechanical, photocopying or otherwise, without the prior permission in writing of Chrysalis Books Group

10 9 8 7 6 5 4 3 2

British Library Cataloguing-in-Publication Data: A catalogue record for this title is available from the British Library

Contributing editor: Chris George Project Editor: Chris Stone Designed by Anthony Cohen Repro by Classicscan, Singapore Printed in Malaysia by Times

Contents

Introduction	6
The Basic Techniques	14
Broadening Your Scope	36
The Essential Elements	66
People	106
Places	134
Still-Life	178
The Natural World	192
Action	208
Glossary	216
Index	220
Acknowledgements	224

Introduction

Photography is about making informed choices; there is no one way to take a picture. Almost any picture as it is first seen, whether it is a landscape view, group of people, still-life or historic monument, could be improved by investigating a different camera position, a more suitable aperture or shutter speed combination or a different lens. But, beyond these considerations, it is the quality of the light illuminating the subject – affected by the time of day and even the time of year – that has the potential to make an ordinary shot exceptional. Get the lighting right, and you are on to a winner.

The word 'photography' means drawing with light, and as you might appreciate the ability of a painter to communicate the atmosphere of a scene, no matter what the subject matter, so it is with photography. Many enduring, masterly photographs are not the result of chance. Certainly, it is a matter of being in the right place at the right time, but in order to have captured that special moment the photographer may have visited that spot at different times of day on many occasions over a period of days or even weeks, waiting for the light to enrich the scene.

Technology continues to expand the range of photographs that can successfully be covered by even 'simple' point-and-shoot cameras. Built-in zooms and exposure options continue to get more sophisticated on these pocket cameras. However, it is still the case that if you want precise control over

the photographs you take, a single lens reflex (SLR) camera is still the best all-round choice. Whether it uses film or digital memory, an SLR gives visible control over what is sharp in the picture, keeps you informed about the shutter speed and aperture being used, and allows you to change lenses or accessories to suit the subject.

Of all the changes to equipment and techniques, however, it is the arrival of digital imaging that has had the greatest impact on photography as a whole. For those trying to improve their photography, digital cameras provide immediate results and feedback, helping you to learn more readily from your mistakes and experimentations. As computer files, digital images can be manipulated, edited and improved upon in ways that were not feasible with film – bringing a whole new level of artistry to the subject.

Despite all these changes, it is not learning about the technical aspects of photography that is crucial to taking great pictures. It is more important to learn to see and understand, rather than simply looking. The best way to develop a photographer's eye is by adopting a firm, thematic approach. With this objective in mind, the bulk of this book is devoted to project work, with set assignments and goals to be achieved.

Above all, photography is fun. It is about recording memories and communicating your ideas and thoughts, and is unique in its ability to freeze forever a single instant in time. It is this, perhaps, that accounts for its universal appeal.

A trick of the light Even in the least promising situations, you need to have the camera ready. This picture (right) was taken above the Arctic Circle in Norway. The weather had been overcast for the best part of the day. Just for a minute or two, however, the clouds parted to allow a flood of daylight to wash over a group of cottages clinging to the rocky foreshore.

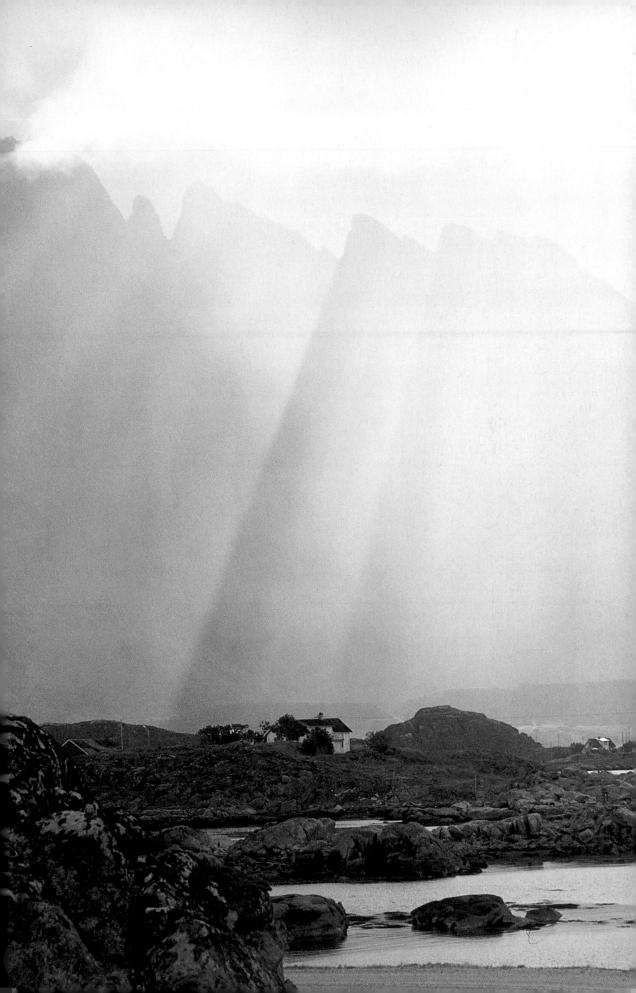

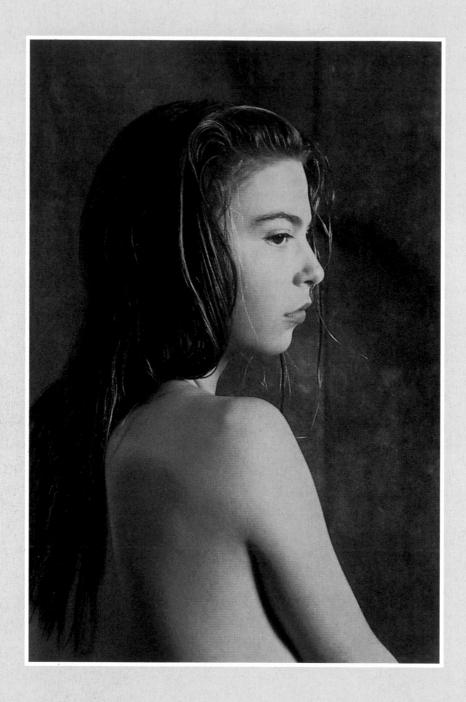

Two moods Although very different in mood, these two pictures are of the same model. For the first shot (above), I wanted the utmost simplicity in the composition, background and lighting. I chose a plain tarpaulin for a backcloth, and used a single floodlight and reflector. The next picture (right) shows the model looking much more sophisticated. Her hair, now teased out and fuller, makes an ideal frame for the face, and two frontally placed floodlights, one to each side of the camera position, ensured near shadowless lighting.

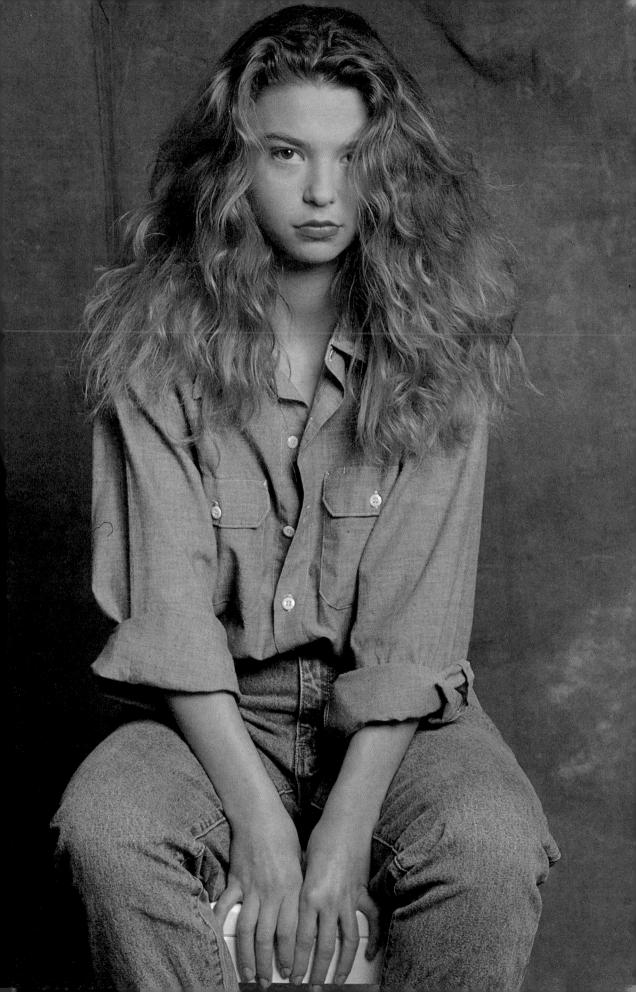

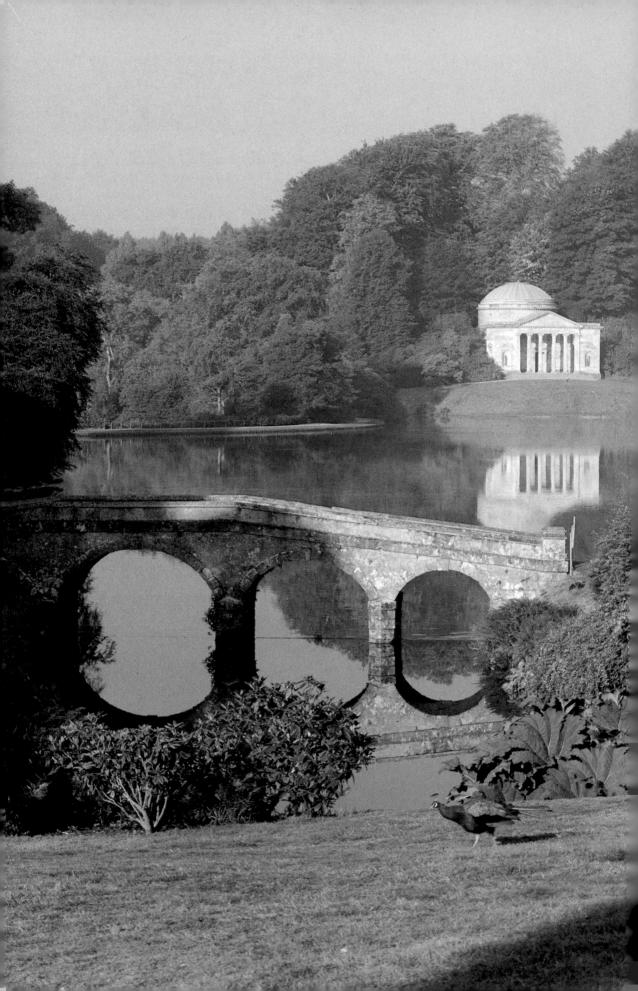

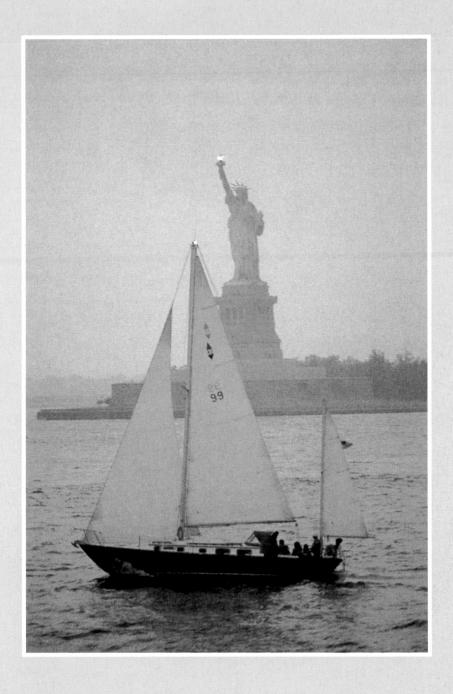

Repeating shapes While in New York I'd caught the ferry from Manhattan on many occasions, and had already worked out how I wanted to take this shot (above). The bonus, however, was the small yacht, whose mainsail seemed to be straining up into the sky, just like the torch of the Statue of Liberty behind.

Classic framing A classical garden such as this (left) demanded a classical approach to framing. A foreground sweep of well-tended lawn (with a centrally placed peacock) takes the eye to half-frames of foliage, producing a vista encompassing a magnificent arched bridge and a mock-Greek temple beyond.

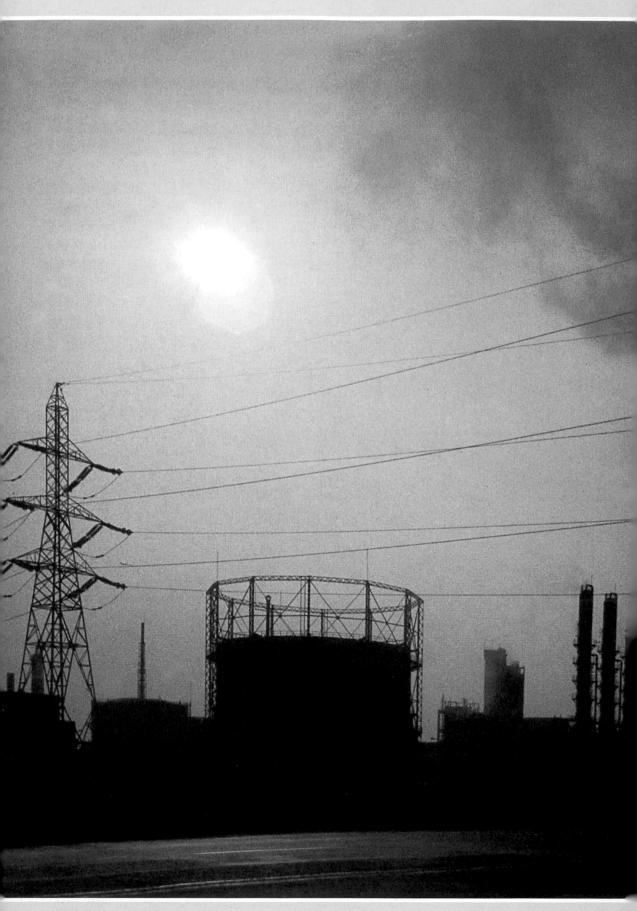

An evil beauty Despite the depressing subject matter (left), this industrial complex in Eastern Europe, spewing out its polluted waste into the air, still makes a dramatic and graphically powerful image. The pollution is made to appear stronger by shooting against the light, and also by including the sun itself, fighting to penetrate the cloying smog.

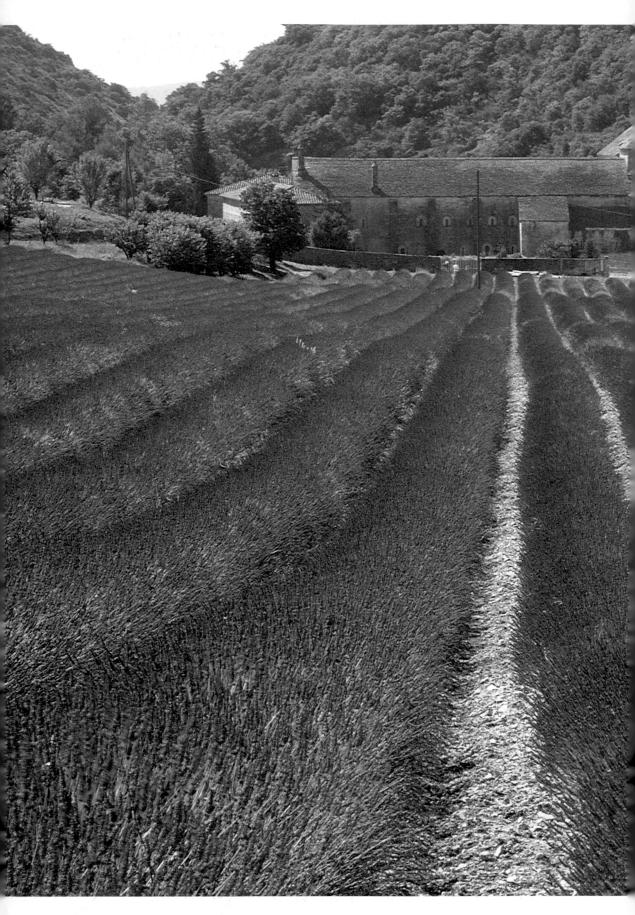

The Basic Techniques

The first step towards taking successful pictures is to choose the right type of camera for the type of photography in which you are interested. Should you choose an SLR or a compact? Should you go digital or stick with film? And how much automation do you really need? Once you are fitted out, you then need to learn about the fundamental controls that the photographer uses: lens setting, aperture, shutter speed and lighting.

Controlling sharpness The lens setting used and the size of the aperture have a major effect on just how much of a scene will appear in focus. For this shot of a field of lavender (left), a wide-angle zoom setting and a small aperture helps ensure as much of the landscape appears sharp as possible. Unfortunately, only some types of camera give you direct control over the aperture setting.

How the camera works

Despite their visible differences, and varying use of electronics, all cameras essentially work in the same way. At the front is a lens, usually with a variable opening, which gathers light to create an image; at the rear is a light-sensitive sensor, or sheet of film, capable of making a permanent record of this image.

Camera obscura Today's cameras are direct descendants of the camera obscura (meaning 'dark chamber'), a much earlier device used as an artist's

AMERAS, FROM THE most sophisticated to the most basic, share four common components: a lens, an aperture, a shutter mechanism and a viewfinder.

Light reflected from the subject is collected and focused by the lens. It then passes

through an aperture – a hole, usually of variable size - so that the amount of light passing through can be controlled. The lightproof shutter, meanwhile, opens for a timed period to allow light from the lens to reach the imaging chip in a digital camera, or the film. The viewfinder is an aiming device, allowing you to preview the image before it is recorded.

Exposure factors

Although photographs can be taken however bright or dark the conditions, the amount of light that reaches the film or sensor must be controlled. Three factors determine this exposure: 1) the light sensitivity, or 'speed', of the film or imaging chip. This is normally denoted by an 'ISO' number;

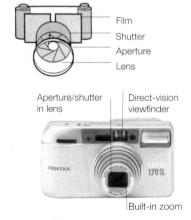

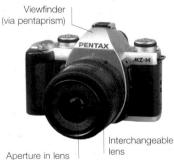

Alternative viewing systems It is the difference in viewing systems that gives compacts (top) and SLRs (above) such different shapes.

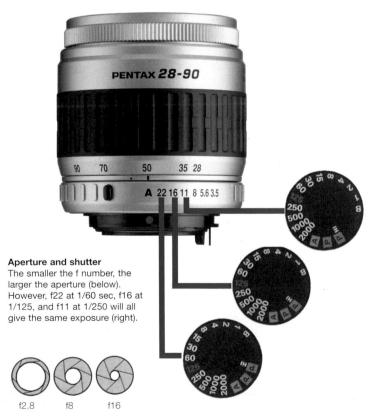

2) the size of the lens aperture (calibrated in f numbers); and 3) the time the shutter remains open (measured in fractions of a second).

Getting the right level of exposure used to be one of the most worrying aspects of photography. Modern cameras, however, have exposure systems that not only measure the exposure accurately in most situations, but automatically set aperture and shutter speed to suit. There are still situations, though, where even pros are unlikely to get the right exposure with a single shot.

However, there is not usually just one combination of shutter speed and aperture that will give an effective exposure. If you choose a camera that allows you to see, and override, the settings chosen by the camera, vou will have much more creative control over the result. Some form of manual control, or exposure override, is also useful in situations where the built-in metering system is likely to be misled, or when you want a darker or lighter result for artistic reasons.

Aperture and speed in tandem Aperture sizes are denoted by f numbers. Confusingly, the smaller the number, the bigger the aperture opening. A typical sequence is f4, 5.6, 8, 11, 16, 22. Moving from one f number to the next smallest (f8 to 5.6, for example) increases the size of the aperture and lets in twice as much light.

The shutter speed is indicated in fractions of a second. A typical sequence is 8 (meaning 1/8 sec), 15, 30, 60, 125, 250, 500, 1000, 2000, 4000. Moving the setting from, say, 250 to 125 means that the shutter will stay open for 1/125 sec instead of 1/250 sec –

Pinhole image Although not as sharp as an image formed with a lens (above right), a pinhole image (right) is surprisingly clear.

doubling the amount of light reaching the imaging sensor, or film. If the light meter indicates that a subject needs f8 at 1/125

Making a pinhole camera A reasonably clear photograph can be formed by making a camera from a shoebox. This basic camera does not use a lens but instead forms an image using a pinhole. First, cut a good-sized hole in the side of the box and tape a piece of thick kitchen foil over it. Make sure no light can enter around the joins, Next, take a pin and make a neat, clean hole in the centre of the foil (right) - it's impossible to make a clean hole in the cardboard. In complete darkness, fix a length of ISO 100 negative film to the inside wall of the box, opposite the pinhole. Put the lid on and cover the box with a black cloth before switching sec, then using twice as much light (f5.6) for half as much time (1/250 sec) will give the same exposure.

on the light. Take the covered box out into bright sunlight, place it on a level surface so that it is pointed at a static subject, and gently uncover the pinhole (below left). Exposure is hard to judge, but after around 3 sec cover the hole with the cloth and, in complete darkness, remove the film for processing.

Foil taped

to box

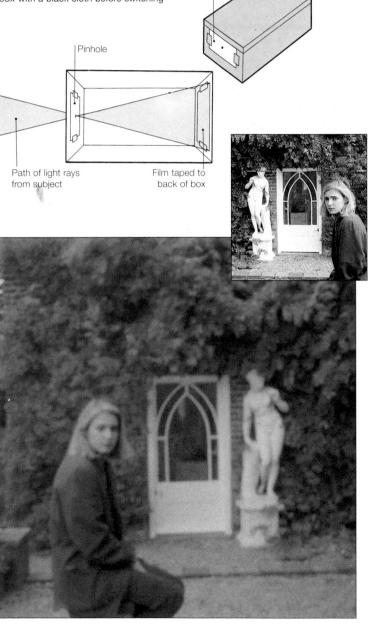

Choosing a camera

Cameras are available in all sorts of shapes and sizes, and to suit all budgets. However, when making your choice it is important that the decision is not ruled solely by convenience and style. You should also consider how much creative control the camera allows over the picture-taking process. You can then weigh up the relative merits of digital and traditional film...

ICKING A CAMERA OFTEN means making sacrifices. Not only do you have your own financial restrictions, but you must also work out to which degree you are willing to trade your photographic aspirations in return for an easy life. There are plenty of small, pocketable cameras that are easy to carry around. But although these may have built-in zooms, and a range of creative effects, there is a limit to the subjects that they can successfully shoot.

Compact or SLR?

Before deciding between a compact and SLR, first determine the type of shots you will probably take. A compact is fine for snapshots, but is unsatisfactory for many other subjects, such as sport.

SLRs are bulkier, but they have distinct advantages for those who want to take better pictures. The viewing system means you see through the lens, so you can actually see when the image is sharp. Interchangeable lenses, and other add-on components, mean that the camera can be tailored to the shot in hand – and to the type of subjects you like to tackle.

Most importantly, this type of camera gives you control over aperture and shutter speed, allowing you the creative control not only to tweak exposure, but to decide which parts of the image are

Layout of controls The design of a digital SLR (below) mimics that of a modern 35mm SLR. The main external difference is the addition of a large colour LCD screen.

sharp and which are blurred.

SLRs, and compacts, are available in forms that either record digitally or use film. As digital pictures do not need to be developed, the images can be seen immediately. To get the most out of digital cameras. it is useful to own, and be reasonably conversant with, computers. However, it is possible to get traditional photolabs to print direct from a digital memory card; and the camera can be linked to an ordinary TV to show your pictures on screen.

While most film cameras use the same 35mm film format, the quality of the electronic image sensor in digital cameras varies significantly from model to model. Some have many more light-sensitive dots, known as pixels, than others. The more pixels (see page 29), the higher the resolution of the results – allowing you to print the shots larger (see page 53).

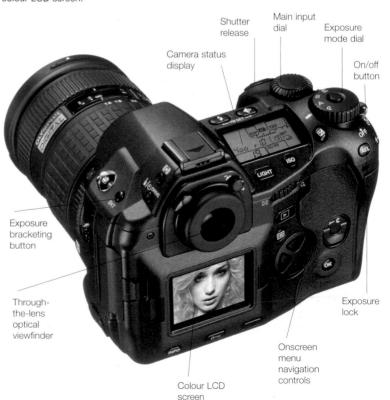

DIGITAL CAMERAS

FILM CAMERAS

Advantages

- Almost instant results; no chemicals.
- ✓ Built-in LCD monitor on camera allows you to check and review the pictures you have taken.
- Low running costs. Memory can be re-used. Batteries are often rechargeable.
- ✓ Wide range of models available, from miniature point-and-shoot models to professional SLRs with full creative control.
- Colour balance can be precisely adjusted to suit the light source.
- Pictures can easily be manipulated, edited and printed from a computer and sent to others by email.

Disadvantages

- Access to a PC, and familiarity with computers, is needed to get the most from the digital images.
- Digital cameras can be slow to react, missing pictures as they boot up and process information.
- LCD screens can be hard to use in bright light (alternative viewfinder is usually provided).
- Risk of accidentally deleting the shots you have taken.
- Batteries need to be replaced, or recharged, frequently.
- M Only top models, set at top resolution, can match quality of images possible with 35mm film.

Advantages

- ✓ High resolution results possible with even small film formats, such as 35mm & APS.
- ✓ Enormous choice of models available, from miniature point-and-shoot models to professional SLRs with full creative control.
- ✓ Extensive range of secondhand equipment on the market means that cameras, lenses and accessories can be found to suit most budgets.
- ✓ Wide range of specialist films available, including those for use in very low light.
- Technology is wellestablished and not constantly changing.

Disadvantages

- Film needs to be chemically developed before the images can be seen.
- Risk of misloading the film with some formats (such as 35mm).
- X Running costs.
- Film needs to be scanned before it can be manipulated on a computer, or emailed.
- Some light sources can produce colour cast problems, which are difficult to eliminate.
- To change to different film speed you need to change the entire roll of film (with digital cameras, the sensor's sensitivity can be changed for each shot).

SLRs

PANTAK 1789.

COMPACTS

Advantages

- ✓ Precise framing what you see in the viewfinder is what is recorded on the film.
- ✓ The range of lenses and accessories makes the SLR very versatile, as it can be adapted to shoot almost any photographic subject.
- Extensive range of camera models to choose from including digital and 35mm film versions. Many have as many automatic features as compacts.
- Full control over shutter speed and aperture used and detailed display as to current settings even when used in automatic exposure modes.

Disadvantages

- Noisier than compact cameras because the reflex mirror that directs light up to the viewing screen must swing out of the way before exposure.
- More difficult to focus in low light (whether using manual or automatic focus).
- Heavier and more awkward to use than most fully automatic compact models.
- Generally more expensive cameras to buy. Add-ons can also be expensive.
- Flash synchronisation is available with only a limited range of shutter speeds.

Advantages

- ✓ Viewfinder image is bright even in poor light.
- Available with good built-in zoom (digital models particularly).
- Compact cameras are usually small, light and easy to carry.
- Fully automatic, 'point-and-shoot' ideal for informal and candid shots.
- Absence of a reflex mirror makes the compact quiet to use.
- Lens shutter means a compact can be used with flash at any shutter speed.
- Some digital models offer almost as much creative control as SLRs.

Disadvantages

- The viewfinder shows a slightly different view than the one that will be recorded a particular problem with close-ups.
- You cannot visually check whether the camera has focused on the subject accurately.
- You cannot usually control which elements of the scene are sharp or blurred using depth of field.
- X You cannot usually adjust shutter speed to suit the movement of the subject, or for other artistic reasons.
- Lens is not interchangeable. Few system accessories.

Camera automation

There are lots of features that distinguish one camera from the next. The range of the supplied zoom, the resolution of the digital sensor, and the quality and range of exposure options are the obvious indicators. But it is often the smaller features and functions that represent the real difference between models...

HE DIFFERENCE IN PRICE between a top-of-the-range professional SLR and an entry-level basic SLR can be considerable. This differential is not just about build quality and brand. There are a number of extras for which the keen photographer is willing to pay.

Autofocus

Autofocus (AF) has become a standard feature on almost all

SLRs and compacts. However, some AF systems are much more sophisticated than others. Basic compacts use an infrared system which, although good in low light, is not suitable for use with longer zoom lenses. For this reason, AF SLRs and better zoom compacts use a passive autofocus system.

A problem with autofocus is that you still need to ensure that the camera is locking on

APS film cartridge APS film (above) is an alternative to the more popular 35mm film. It is slightly smaller in size, but is designed so that the user never sees the film – making it almost impossible to load incorrectly. Numbered symbols tell you whether the film has been fully used or processed. APS cameras are usually compacts, but SLRs are made.

to the right part of the scene. Basic models just focus on a point in the centre of the image – so if the subject is to the side of the frame, a facility called the focus lock must be engaged. Other models take multiple readings so, to some

Multiple exposure This is a facility found only on a few film and digital cameras. It allows you to combine two or more different images in the same frame for surreal or artistic effect, as in the photograph below.

degree, can guess where the subject is located.

The biggest difference in autofocus performance comes when photographing moving subjects. Some are not only quicker to react, but can continually adjust focus to track the subject sharply. The best SLRs use a predictive autofocus that will continue to tweak the focus during the delay between you firing the trigger and the picture actually being taken (which may be up to a quarter of a second).

Frame advance

Loading the camera has been a perennial problem with 35mm film cameras. If you get it wrong, your pictures may not be recorded. Nowadays, most SLRs (and compacts) have built-in motors that advance the film for you, and rewind when the roll is finished.

APS film cameras simplify film loading even more.

The difference between film transport systems is in the number of shots that can be taken per second. Some may not allow such continuous shooting, which can be useful when photographing important events or sport. The top

motordrive speed can be up to 10 frames per second (fps).

Digital cameras do not use film, but the delay between taking one shot and the next can be even greater. This is because of the time it takes to process and memorise the digital data. The maximum 'burst' rate varies from camera to camera.

Exposure modes

The range of shutter speeds available vary from camera to camera. Long shutter speeds are essential for night photography, while the fastest shutter speeds are useful for some action subjects. A good camera gives a number of different ways in which to adjust shutter speed or aperture to suit the way you work – or to suit the subject. Program modes set both values automatically. With aperture and shutter-priority, you set one and the camera handles the other. A manual mode, meanwhile, allows you to be independent of the built-in meter. It is also useful to have an exposure compensation facility for situations where the one or more metering modes found on the camera may fail.

Potential problems Some aspects of automation can cause problems. One example is that the infrared autofocus system used on some compacts cannot 'see' through glass (above). The beam emitted by the camera simply reflects back as if it had met an opaque barrier – so focus on the surface of the glass.

Depth of field control

Depth of field is a key creative control, as it defines how much of the image is sharp, and which parts are out of focus (see pages 24-25). With many cameras, the effect cannot be seen until the pictures are taken. Some SLRs have a preview button that gives an visual idea of how much of the shot will be in focus. Some models can use the autofocus system to help ensure that all the elements in the frame are kept sharp.

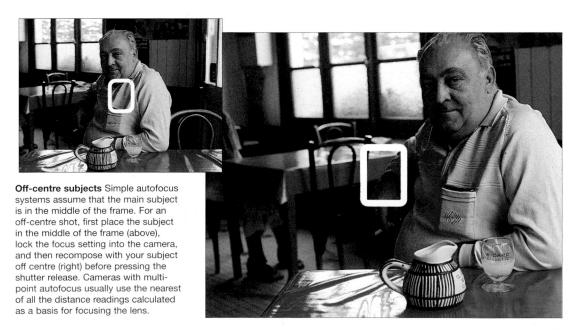

Choosing and using lenses

The ability to change the angle of view of the lens brings visual variety to your pictures. For the SLR user, a huge range of different focal lengths is available simply by fitting either interchangeable zooms, or lenses with a fixed focal length, to the camera body. Most modern compacts, meanwhile, now come fitted with at least a moderate zoom lens. All focal lengths are traditionally split into three broad categories: wide-angle, standard and telephoto.

Lens comparison As the size of imaging chips varies, the actual focal lengths of digital camera lenses are not easy to compare. For this reason, a focal length equivalent to that on a 35mm SLR is usually quoted. This digital compact model (above) has a built-in zoom equivalent to a 28-140mm.

HE FOCAL LENGTH range covered by your camera's built-in zoom, or by the different interchangeable lenses you might own, will define the type of pictures that you take. The shorter the focal length, the more you can squeeze into the shot. The longer the focal length, the more a distant subject can be magnified.

Standard lenses

For the 35mm format, the standard lens (above right) is usually considered to be a 50mm. This focal length produces the angle of view that corresponds approximately to the way the same scene would have looked if seen by the human eye.

Standard focal lengths are found within many zooms, and are great for shooting landscapes and half-length portraits. Don't use a standard lens for full-face close-ups, though, as you will need to get so close that the camera will be intrusive, and facial features may appear distorted.

As a prime (non-zoom) lens, this lens usually has a much wider maximum aperture than

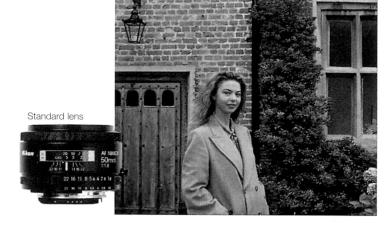

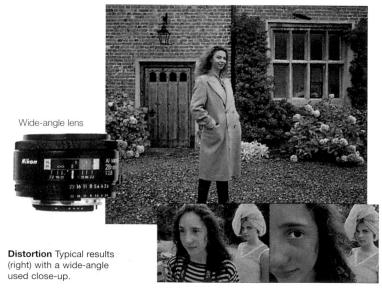

others. This produces a very bright image on the SLR focusing screen, invaluable for low-light photography.

Wide-angle lenses

These take in a wider-angled view of the subject than a standard lens. As a result, everything appears to be quite small on the focusing screen. Wide-angles (opposite, bottom) start at about 35mm and go down to about 17mm. Shorter focal lengths are available as prime lenses, but produce extreme distortion at the edges of the image.

Wide-angles lenses are ideal for landscapes, broad panoramas, impressive overhead sky effects and crowd scenes. They are also useful when working in cramped conditions indoors. Don't use wide-angles for close-up portraits, unless you want to create unflattering distortion (see below left).

Telephoto lenses

This type of lens starts at about 70mm and can go up to around 2000mm (top and above right). Many zooms give a range of telephoto settings up to 300mm – this allows you to cover a large number of distant and close-up subjects, without the lens being too unwieldy.

Telephoto lenses are excellent for pulling in distant subjects in wildlife and nature photography. They also produce interesting perspective effects because they enlarge the middle distance and background in relation to the foreground. For the 35mm format camera, many photographers consider a focal length of around 100mm ideal for full-face portraits.

The telephoto range of zooms can often be extended with the use of converters. Teleconverters for built-in zooms screw into the front of the lens, increasing the maximum focal length, typically by 150-200%.

Telephoto lens

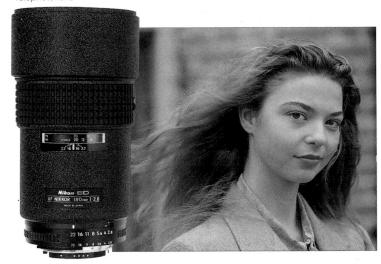

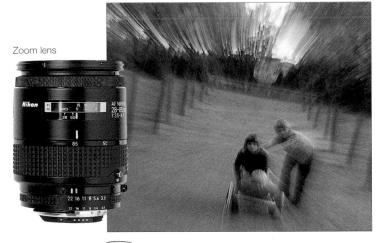

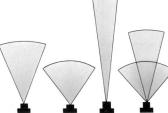

50mm 28mm 180mm 28-85mm

Teleconverters for SLRs usually fit between the lens and the camera body, and offer similar magnification.

Prime lenses

Nowadays, zoom lenses are the norm. Fixed-focal-length, or prime, lenses are generally only used for more extreme focal lengths or for specialist applications. Macro lenses, for extreme close-ups, are usually not zooms, for instance. Changing lenses The three shots of the same model illustrate how dramatically framing alters when changing lenses (top, and left). A single zoom lens, however, could give the same framing options, would be easier to carry around, and would be less expensive. An interchangeable zoom can also be used to create a special effect, where the focal length of the lens is altered during exposure (above).

Lens speed

'Lens speed' refers to the maximum aperture of the lens. This is important on SLRs, as the brightness of the viewfinder image depends on the amount of light coming in through the lens. A wide maximum aperture allows you to take pictures in dim light without a tripod. Usually, the longer the focal length, the slower the lens. Zooms are also generally slower than primes.

Choosing the aperture

The aperture of the lens, calibrated in f numbers (also known as f stops), not only affects exposure but also controls depth of field. Whenever a lens is focused, whether manually or automatically, there is always a zone of acceptably sharp focus both in front of and behind this point — this zone is known as the depth of field.

Lenses A telephoto gives a shallow picture area and depth of field (dark blue, above). The light blue area shows the greater scope of a wide-angle.

HE ZONE OF SHARP focus is a feature of every lens, but its extent varies according to the type of lens and the aperture. Wideangle lenses (below left) have a generous depth of field, and the wider they are the greater this will be. With extreme wide-angles, focusing the lens is almost redundant, since depth of field (below, far right) ensures that everything will be sharp. The longer the telephoto lens (below right), the shallower the depth of field. When using these focal lengths, you should pay extra

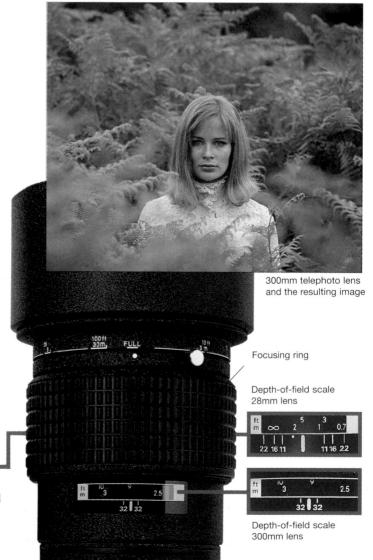

Image from 28mm wide-angle lens

attention to focusing since there is little room for error.

Aperture and depth of field The basic thing to remember is that the wider the aperture (indicated by the smaller f stops) the shallower the depth of field. The aperture thus modifies the characteristic depth of field of all the different types of lens.

Distance and depth of field Depth of field also depends on where the lens is focused. The more distant the subject on which you focus, the further that depth of field extends. For extreme closeups, total depth of field may be measured in millimetres.

Creative control

When taking a photograph, selecting the aperture (and hence depth of field) gives you the choice of where to place the emphasis. We have seen how aperture and shutter speed are related in terms of exposure (pages 16-17). So, if your subject - for example, a head-and-shoulders shot is in front of a distracting background, vou can moderate the background and make it less intrusive by focusing clearly on your subject's eyes and using a wide aperture (perhaps f4).

Opening up the aperture in this way will have the effect of putting the background out of focus and making the subject stand out. If, on the other hand, you feel that the

Telephoto A 300mm lens has given a shallow zone of sharp focus (above left).

Wide-angle A 28mm lens has given a deep zone of sharp focus (far left).

Depth-of-field scale Using the lens' depth-of-field scale and the focusing scale, you can read off the distance between the nearest and farthest points in the picture that will be acceptably sharp for the selected aperture (near left).

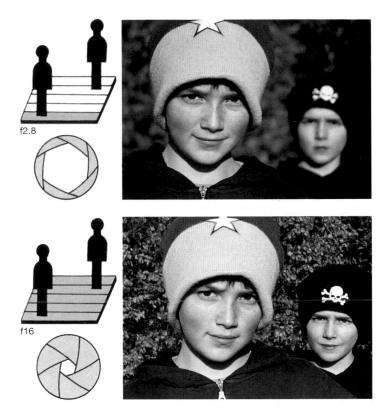

background is an important element in the shot, then stopping the aperture down – selecting a small aperture (indicated by a large f number) – to f16 will bring both the background and subject into sharp focus. But in doing so, of course, the shutter speed will have to be slower to give the same exposure.

If, however, you want to achieve a compromise effect, with the subject sharply defined and a suggestion of identifiable background, you should select an aperture of about f8. Compromise is often necessary to give a sensible shutter speed for the subject, or to avoid camera shake.

Light and film considerations

The degree of choice you have in the selection of aperture and shutter speed depends very much on the prevailing light conditions and the type of film you are using. In very poor light, for example, Stopping up and down By setting a wide aperture (at around f2.8), the subject is in focus while the background is blurred (top). However, when the lens is stopped right down (in the region of f16, say), both the subject and background are clearly in focus (above). In the illustrations (above left), the blue shading represents diagrammatically what will be in focus in each case. By setting a medium aperture, the subject would still be in focus and background detail perceptible but not sharply defined.

selecting f8 may mean that you need to use an impossibly slow shutter speed to attain the correct exposure – or, as you will see on the next two pages, to 'freeze' the movement of even a slowly moving figure.

An additional degree of control you have here is the speed, or light sensitivity (see pages 26-27), of your film or of the digital camera's imaging chip. A doubling of film speed (from, say, ISO 100 to 400) means that you can use a faster shutter speed or a smaller aperture and still get the correct level of exposure.

Choosing the shutter speed

The camera's shutter speed, usually measured in fractions of a second, combined with the size of the aperture opening, determines how much light reaches the film or sensor. More significantly, however, the shutter speed setting also affects the way moving or static subjects are recorded - whether they are sharp and fully detailed, or blurred and more impressionistic.

HE PRIMARY CONCERN when choosing a shutter speed (above right) is to select one that is fast enough to avoid camera shake, caused by moving the camera while the shutter is open.

If you mount your camera on a rigid tripod this is not a problem, even for exposures lasting many seconds.

However, when supporting the camera with your hands alone, the general rule is that

the minimum shutter speed you select should be equivalent to the focal length of your lens. In other words, with a 100mm lens use a shutter speed of 1/100 sec or faster; with a 500mm use a shutter speed of 1/500 sec or faster; and so on. This relationship exists because a slight movement with a telephoto lens causes much more noticeable blurring of the image than with a wide-angle, due to

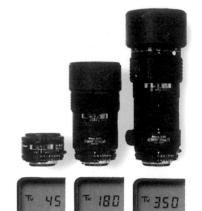

Shutter speed and lens As focal length increases it becomes harder to keep the image steady, requiring ever faster shutter speeds to avoid camera shake. A 50mm requires a speed of at least 1/45 sec, a 180mm focal length needs 1/180 sec or faster, and 1/350 sec is required for a 300mm (above).

the narrower angle of view.

Creative control

When photographing a moving subject, you can use the shutter speed in order to interpret it. For example, if vou were shooting a running figure, a shutter speed of 1/250 or even 1/500 sec might be necessary for a 'frozen', detailed image. In the same situation, with a shutter speed of 1/60 sec, the running figure

Freezing action The two ways to freeze action with the camera are either by using flash, which delivers an instantaneous brief burst of light (left), or by using a fast shutter speed. The picture below was taken at 1/1000 sec, ensuring with this subject that no movement is recorded.

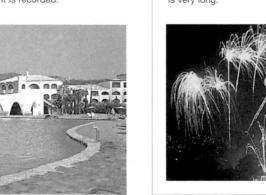

Bulb exposures For subjects such as fireworks (below), when you can't anticipate the action, and you want the exposure to last for several seconds or more, put the camera on a tripod with the shutter speed set to 'B' (which stands for 'bulb'). The shutter will stay open for as long as the release button is held down, allowing for an exposure that is very long.

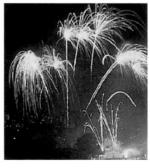

SHUTTER SPEED TO ARREST MOVEMENT (WITH A 50MM LENS ON A 35MM CAMERA)

Subject moving at	Distance from camera	Towards camera	45° to camera	90° to camera
Less than	6m (20ft)	1/60 sec	1/125 sec	1/250 sec
hour (6mph)	11m (35ft)	1/30 sec	1/60 sec	1/125 sec
	20m (65ft)	1/15 sec	1/30 sec	1/60 sec
More than	6m (20ft)	1/500 sec	1/1000 sec	1/2000 sec
hour (6mph)	11m (35ft)	1/250 sec	1/500 sec	1/1000 sec
	20m (65ft)	1/125 sec	1/125 sec	1/500 sec

Direction of travel The shutter speed you need to freeze movement depends on, among other things, the direction of travel of the subject relative to the camera (left). Movement of a fast car, for example, coming directly towards or away from the camera can be frozen by a shutter speed far slower than one needed to freeze movement directly across the lens' field of view. Also, the closer an object is, or the more it is magnified by the lens, the faster the shutter speed required to arrest its motion.

Creative camera shake This shot (right) shows how camera shake can sometimes be very attractive, giving interesting texture and highlight effects.

will move slightly across the lens's field of view during the exposure. The result: still a clearly recognisable runner, but this time showing the very blurring that indicates movement and vitality.

You always need to consider shutter speed and aperture together. To use the same example: if, at 1/500 sec, your exposure meter indicated f4 for correct exposure, then at 1/60 sec you would be using an aperture of f11, and depth of field would have increased considerably (see pages 24-25), perhaps bringing a distracting background into focus.

Panning

Another way of exploiting the creative effects of shutter speed is by 'panning' moving the camera while the shutter is open to track the moving subject. To do this, select a shutter speed of about 1/30 or 1/60 sec and swing the camera around to follow your subject as you fire the shutter. Try to keep the subject in the same part of the frame throughout. The moving subject will appear relatively sharp but all static objects (such as the background) will be blurred.

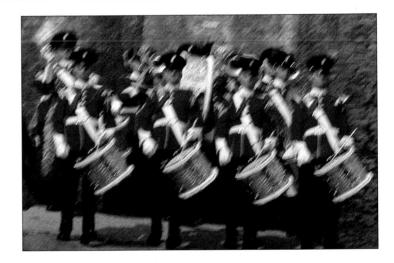

Holding the camera steady

When standing, support the camera under the lens, keeping your elbows tucked in.

When kneeling, rest an elbow on your knee for extra steadiness and support.

For slow shutter speeds, press the base of the camera against a handy vertical surface.

With low-level shots, lie flat and support your weight evenly on both elbows.

The Basic Techniques

Colour film

For the film photographer, colour is far and away the most popular medium. Because of the popularity of the 35mm camera, there is an enormous range of different film brands to choose from. Colour film is available in two basic types: colour negative film, from which prints are made; and colour transparency film (also known as reversal film) for slides.

most common film type), and took a picture lit by domestic tungsten bulbs, results would be too orange. This is because tungsten light has a lower colour temperature than daylight, with a preponderance

of 'lower' orange wavelengths. With digital cameras, an

Slow film Excellent colour rendition, soft contrast and superb resolution of subject detail, such as skin texture, are typical of a slow-speed film, in this case ISO 64 (above). An ideal choice when using studio flash.

Fast film With ISO 1000 film (below), grain is pronounced and the image is generally very 'contrasty'. However, such film allows you to take sharp pictures in lighting conditions where hand-held photography would otherwise be impossible. It also allows you to take shots with ambient lighting, without flash, helping to preserve the atmosphere. The grain can add a pleasant texture which can suit some subjects. Fine detail, however, is lost.

Colour temperature

Although we tend to talk of light as being 'white', in fact it contains all the spectral colours mixed together in different proportions. The human eye and brain are extremely adaptable, so we tend to see objects in their 'true' colours in most forms of lighting. This is not the case with colour film.

If, for instance, you loaded the camera with film designed for average noon daylight (the

Medium film Modern emulsions have improved to such an extent that an ISO 400 film (above) gives excellent results.

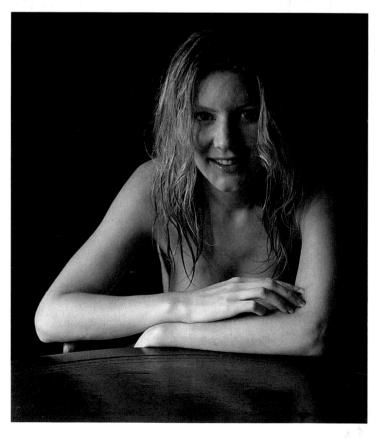

DIGITAL CHIPS AND MEMORY

How a digital camera works

Digital cameras, of course, do not use film. Instead, at the camera's focal plane, where the lens focuses the image, is a special electronic chip.

Two different types of chip – the CCD (charge coupled device) or CMOS (complementary metal oxide semiconductor) – are commonly used in digital cameras. These are made up of thousands, often millions, of microscopic light-sensitive elements, known as pixels.

Each pixel generates an electrical signal according to how much light it detects; different pixels are differently filtered so that they can additionally collect information about each part of the image's colour, as well as its brightness. This analogue information is then processed within the camera to create a digital file – using the standard binary language of ones and noughts used for all computer data.

Removable memory

These digital files are written to a memory. Most digital cameras use a small removable smartcard which will store this information. There is a wide variety of different smartcard types – so you have to ensure you use one that is compatible with your particular camera. Different cards have different capacities ranging from just a couple of megabytes up to a gigabyte and beyond. The larger the capacity

of the card, the more images you

can store.

However, unlike with film, you do not need to buy a new card when one is full.

Portable hard drive Usually has a capacity of tens of gigabytes.

Smartcards Some of the different types used by digital cameras.

The image files can be transferred from the smartcard to a computer hard disk (and then on to CD, DVD or other storage medium) using the camera and a simple connection lead. Once transferred, the files can be wiped from the smartcard, so that it can be re-used in the camera.

The number of images you can fit on a particular card will depend on a number of factors. The number of pixels used by the camera will define the maximum file size. But you can often decide the resolution and quality for each image file. By restricting the file size, more pictures can be fitted in – and maximum detail is not needed for all applications (see pages 50-51).

For long trips, where it is not possible to download images to a computer, you can either take a number of different memory cards or a portable hard drive. Such a unit has a capacity typically measured in tens of gigabytes, and acts as a portable back-up and archive for your image files.

'auto white balance' system usually corrects the colour temperature. Some models also have manual settings, so the colour balance can be tweaked to your liking.

Film speed

The speed of film is denoted by an ISO value, referring to its light sensitivity. The more sensitive a film, the less light it needs to produce a correctly exposed image. Having the right speed film in the camera can be vitally important.

In dim light with a slow (ISO 100) film, even selecting the widest aperture and slowest feasible shutter speed may mean that hand-held pictures are impossible. An ISO 400 film (four times more sensitive) in the same conditions will give you the option of selecting an aperture two stops smaller (if depth of field is important) or a shutter speed two stops faster (if subject movement or camera shake is an important factor).

On digital cameras, the sensitivity of the CCD or CMOS sensor can often be changed for each shot, if necessary (the same ISO scale is usually used).

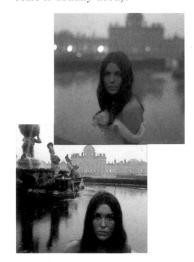

Film type and light source In these pictures, the top one was taken on tungsten-balanced slide film, designed for blue-deficient tungsten lighting; the other was shot on daylight-balanced film.

Black-andwhite film

Today, black-and-white film is categorised largely as an 'art medium', despite the fact that for more than a century nearly all pictures were shot in monochrome. The simplicity and power, yet rich variety of tones, that result mean that the black-and-white medium lends itself to many photographic subjects.

ITH THE NOTABLE exception of Agfa Scala, all black-andwhite films are designed to produce a negative image from which prints can be made.

The colour temperature of light sources will not affect the final image, unlike with colour film (see pages 28-29). This can make black-and-white film

useful when shooting pictures where there is a mixture of different light sources, or when the colour temperature of interior lights is unknown.

There are two types of blackand-white film: traditional and chromogenic.

With traditional films, the image on the negative is formed out of clumps of silver

salts. The texture this creates can be particularly pleasing with faster versions of such films. On the other hand, although chromogenic films make the latent image using silver crystals, the negative itself is created using a dye, which is released during the chemical processing stage (similar to the way in which colour negatives work).

A key advantage of chromogenic film is that it is far more tolerant of exposure inaccuracy. The film speed can be changed from ISO 50 to ISO 800 for each shot, and still be processed normally.

Slow film

This category of film ranges from about ISO 25 to ISO 100. In bright conditions, slow films produce exceptionally fine-grained results with good image detail and contrast. Consider using slow films for subjects such as natural history, portraits and landscapes, particularly when a tripod can be used.

Slow film For this photograph (above), bright studio flashlights allowed the use of slow, ISO 50, film. The resulting fine-grained image, using a traditional emulsion, has plenty of detail, which is particularly useful for depicting skin texture in a portrait.

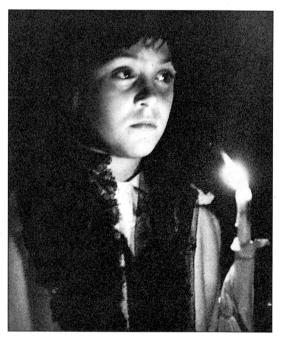

High-speed film Low-light conditions (above) necessitated the use of fast film. This allowed a hand-held camera to be used, even though the subject was only lit by candlelight. This creates a distinctly atmospheric portrait, which is helped by the grain of the push-processed film.

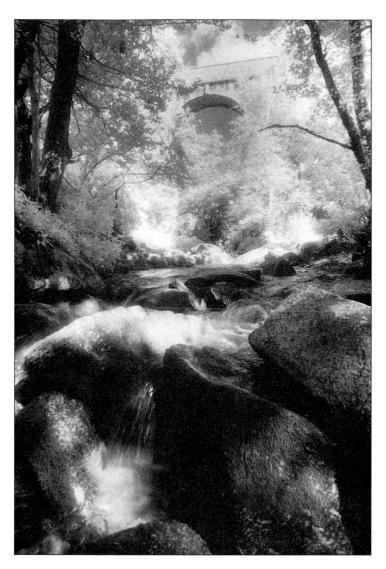

Surreal effects This shot (above) was taken using black-and-white infrared film. The foliage tones appear pale, and the overall effect is stunning. A number of such infrared films are available, but their sensitivity to infrared light varies. The most sensitive produce the most dramatic results but are notoriously difficult to handle. Those with less sensitivity are easier to use. For the best results with all such films, a deep-red filter should be used.

Medium films

Ranging in speed from ISO 125 to 400, these are the most popular, general-purpose black-and-white emulsions. The benefits from the extra speed they offer amply compensate for any slight increase in graininess. Suitable uses for this group are similar to those for slow films, but these are more appropriate for hand-held photography.

Fast films

Fast films are in the range of ISO 400 to ISO 3200. The fastest films display a distinctly grainy appearance when printed. If the subject is chosen with care, this texture can be used to enhance the image. These films are ideal for all kinds of low-light work, but especially action subjects.

Push processing

With many black-and-white films (and colour slide films), it is possible to increase the effective sensitivity of a film by giving it more development at the processing stage. Known as pushing a film, this means that an ISO 400 film may be rated at, say, ISO 1600 – and then developed for longer (or at a higher than usual temperature).

BLACK AND WHITE WITH A DIGITAL CAMERA

Monochrome mode

Digital cameras frequently offer the ability to record an image in black and white. This is often presented as a special effect, and simply allows you to swap from colour to monochrome as and when required – even for a single shot. Other monochrome settings, such as a sepia-toned effect, may also be available.

An advantage of these settings is that they allow you to see what the shot looks like in monochrome. It is not easy to visualise what a scene will look like in black and white. You need to see the tones – the contrast between dark and light.

Confusingly, two different colours, such as blue and green, can appear the same shade of grey in the result. This preview helps you to see whether the shot 'works' in black and white or not.

Computer conversion

Serious digital photographers, however, do not use these settings. Instead, they will shoot the scene in full colour and then convert it to monochrome at a later date using digital imaging software (see pages 56-57). This not only gives the option to use the shot in colour or mono but also allows precise control of the tonal range in the final shot.

Camera flash

There are two different types of camera flash: built-in units that are an integral part of the camera (found on nearly all compacts, and on most SLRs); and separate units that attach to a special mounting 'shoe' on the top of the camera (often designed for when more flash power is needed with an SLR camera).

IRTUALLY ALL MODERN flash units contain a light-sensitive cell that measures the light reflecting back from the subject to control automatically the duration of the flash exposure. Many cameras with 'dedicated' or built-in flash units (below) measure the flash light reflected back from the film itself and cut off the flash light when it is correctly exposed. Once attached to the hotshoe. dedicated units become an integrated part of the SLR

camera. They lock into the camera's circuitry, changing the shutter speed to that required to synchronise with the flash output, and they receive information from the camera on the aperture set and the film speed in order to determine how much flash light to deliver.

Red-eve

A possible problem with the built-in flash found on many cameras is known as 'red-eye' - where the pupils of people's

Basic add-on flash A simple flashgun measures the amount of light reflecting from the subject itself, using a small 'eye' at the front of the unit. The spread and angle of illumination is fixed.

Sophisticated add-on flash With dedicated guns, the amount of flash reaching the subject is controlled using metering sensors in the SLR itself. The head can be tilted and rotated.

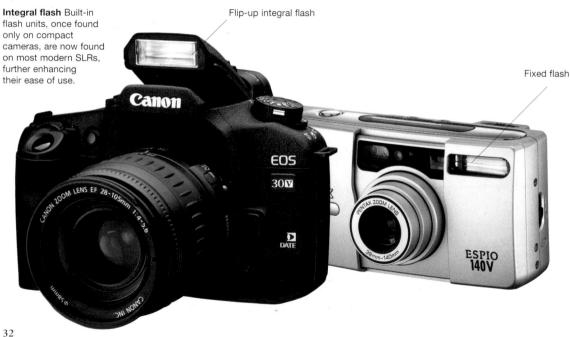

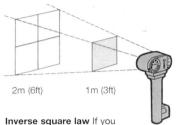

Inverse square law If you double the distance between flash and subject, illumination covers four times the area with correspondingly less intensity.

eyes show up bright red. This is caused when the angle between the lens, subject and flash is too narrow. With fixed, forward-facing flash this is impossible to correct. Many models try to reduce the problem instead with a special red-eye mode which uses a pre-flash to reduce the size of the person's irises. With SLRs, a separate gun can be used, so the distance between camera and flash can be increased to avoid the problem entirely.

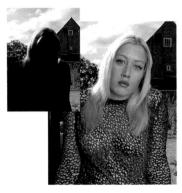

Fill-in flash These shots (above) show how flash can be used to improve balance and contrast in daylight. A fill-in option is available on most cameras with built-in flash units.

Red-eye If the flash and camera lens are too close together, red-eye often results (above).

Bounced flash

Another problem with forward-facing flash is that it produces stark, generally unattractive results. Many separate flash units (opposite) have tilting and/or swivelling heads that allow the flash light to be bounced off the ceiling or nearby wall. Results are softer and more naturallooking. Beware, though, if using colour film, since the flash light will take on the colour of any surface it is bounced off and produce a colour cast over the picture.

Flash fall-off

The illuminating power of flash falls off rapidly. Every time you double the distance between the flash and the subject, light covers four times the area and, thus, is only one-quarter as strong. This accounts for the fact that typical flash shots with objects in the foreground are

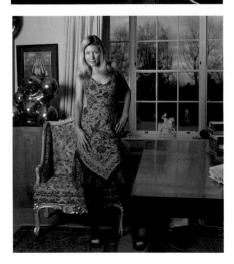

properly exposed while those farther away seem unlit.

It is wise to buy a flashgun that is as powerful as possible. This allows you to use flash at greater subject distances and to take fuller advantage of bounce and diffusing facilities. Flash power is indicated by its guide number (GN) – the higher the GN the more powerful its output.

Flash fall-off also occurs when the spread of light is not as great as the angle of view of the lens. This produces a wellexposed central area with progressively darkening edges. You either need to change lenses and use one with a narrower angle of view or use a light-diffusing attachment over the flash head. This will have the effect of spreading the light from the flash over a wider area but, of course, will also result in a corresponding loss of flash intensity.

> Bounced flash Flash used straight on usually results in unnatural illumination (below left) - with the foreground appearing much brighter than the background. In the alternative version (left), the flash was bounced off a special reflector (below), which attaches to the flash unit itself. This overcomes the problem of potential colour casts when bouncing flash off walls. The general lighting effect is now far more atmospheric and natural-looking.

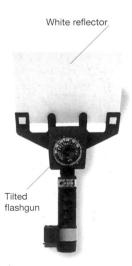

Colour through the day

Some of the best photographs are often taken at the least social times of the day — first thing in the morning, towards sunset, and even late into the night. These are the times when most of us are still in bed or thinking of putting our cameras away because there is not enough light. But light at these times has a special soft and delicate quality.

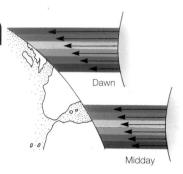

The colour of light At dawn (or dusk) sunlight strikes the planet obliquely and travels through large volumes of atmosphere. This scatters the blue wavelengths, leaving more red. At noon, sunlight is more direct and intense (above),

the most out of photography means seeing the world around you with the same impartiality as the camera lens.

Early morning light

In the first hour or so of light, the sun shines obliquely on to the earth and the rays of light must travel through a large volume of atmosphere to reach your position. It is the shorter blue wavelengths of light that are most easily scattered and filtered out on this journey, and so direct sunlight around sunrise is often tinted a delicate pinky-red. Mist, too, is common first thing in the morning, turning familiar scenes and aspects into dream-

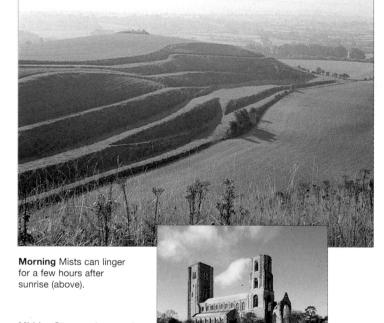

Midday Strong colours and short shadows often feature at midday (right).

After sunrise Scenes that are not lit directly by sunlight are mainly lit by light reflected off the atmosphere (above). This is known as skylight.

like visions. To capture these images you must be up well before dawn. Give yourself plenty of time to adjust to the light. Watch the effect the sun has as it creeps over the horizon: colours intensify every second as the light level increases, and shadows seem almost to race over the landscape.

Midday light

The sun in its few hours since rising has travelled more directly overhead. As a result, there is less atmosphere to scatter the blue wavelengths, giving a more normal colour balance. Contrast is now harsher and more sharply defined. Shadows are much shorter and denser in tone.

It is often suggested that this intensity of light is something that cannot be used to advantage. It is this very intensity that strengthens and saturates the colours around you. Glare from the sun can be a problem, but even this can be turned in your favour. Taking care not to point the camera directly at the sun, allow the flare from its periphery to increase contrast to such a degree that all around you is rendered as a dramatic silhouette. To do this, take your light reading from the bright sky itself, thereby underexposing everything else.

Early evening light

In the early evening, just before sunset, sunlight once more produces a warm, pinky glow. It is interesting that the more polluted the atmosphere, the more dramatic and varied these colours become. Caution is still advised here, since even the dying rays of light from a setting sun can be sufficiently

strong to damage your eyes, especially if you are focusing on them with a telephoto lens.

An added bonus at dusk is the first streetlights twinkling on or the glow of house lights. These can add welcome highlights to what are generally low-contrast scenes. Also, if shot on daylight-balanced film (or use a cloudy, manual, white balance setting on a digital camera), the lights will appear more orange than they really are. This effect may not be accurate, but is very acceptable in most instances.

Bear in mind that light levels will be changing virtually by the second. A tripod is therefore extremely useful: it is a pity to miss shots simply because you cannot hand-hold the camera at the very slow shutter speeds you are forced to use at this time of day.

Night light

In large towns and cities there is always enough light for the adventurous photographer.

Streetlighting, shop windows, fluorescent signs, illuminated billboards and car headlights all make good light sources for unusual shots. You will have to abandon any expectations of recording colours accurately, but you will be amply rewarded. After rain is often a good time for night photography – wet roads and puddles of water reflect any available light, giving interesting double images and a little extra illumination to help exposure.

Again, you will need a sturdy tripod – although it may be possible to find a solid surface on which to rest the camera for these long exposures. Use the self-timer delayed-release setting, or a special cable release, to help avoid vibrations as the picture is taken.

Do not be surprised if your exposure meter fails to respond accurately to what light there is – you will have to operate on a trial-and-error basis by bracketing exposures. This means taking perhaps three or four exposures of the same scene under different shutter speed and/or aperture combinations; using the exposure compensation dial is the easiest way to do this. Exposure times of many seconds are not uncommon, using the camera's B setting.

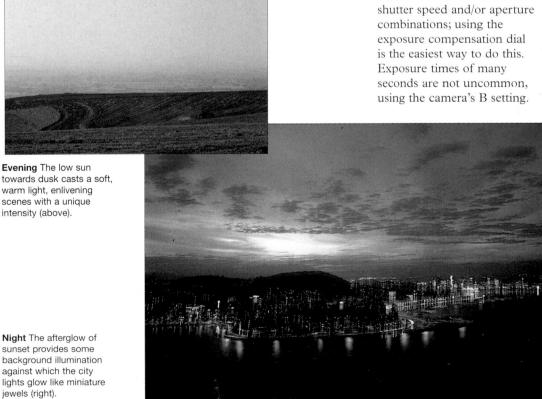

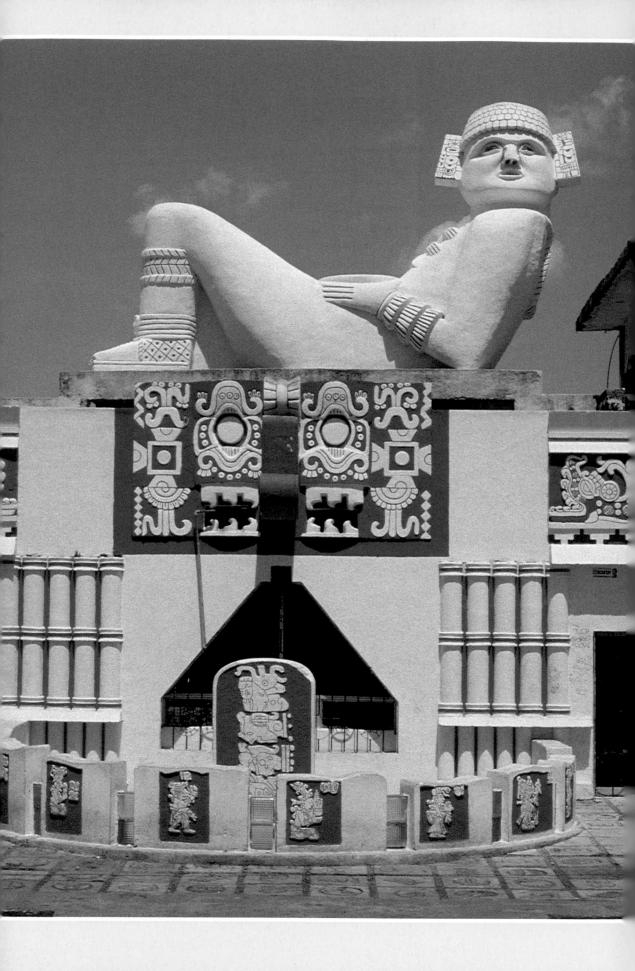

Broadening Your Scope

hether you use digital memory cards or film, buying a camera is only the start. It is the extra lenses, other accessories and software that expand your picture-taking possibilities. But whether you need studio lights or a bellows unit will depend on the range of subjects that you want to shoot. Once the pictures have been taken, the next stage of the creative process can begin – either in the traditional darkroom, or on the computer desktop.

The right equipment Most lenses and zoom settings prove useful when shooting architecture. But for exteriors and interiors a good wide-angle setting is often essential. This Mexican building was taken using a 24mm lens on a 35mm SLR.

Assembling your kit

There is no single camera/lens/accessory combination suitable for all photographic situations. Think clearly about where you will be working, what you want to achieve and how you intend to accomplish your objective. Choosing the right equipment for a project is, of course, vital when working on location. Even in the studio, especially with live subjects, pre-planning is all important.

The advice presented on the next few pages gives some idea of typical photographic kits suitable for various projects and subjects, but can be adapted in the light of your own experience.

Architecture

The basic kit for this type of subject should consist of a single camera body and two to three lenses. A range of wide-angle focal lengths are essential: for this, a good choice is a special wide-angle zoom, covering focal lengths, say, from 17-35mm. A telephoto zoom is also necessary for capturing shots of details, or

CAMERA CASE

It is best to have the choice of two different-sized camera cases. The smaller of the pair needs to be large enough for a single camera, perhaps two lenses and a selection of small accessories. The other, larger case can be reserved for trips out on location and should be able to accommodate two camera bodies, three or more lenses and all the necessary accessories.

If you were out to take shots of athletes in a cross-country race, for example, you might include a flash for fill-in; for natural history close-ups of a rare orchid, you would need a set of extension bellows (or close-up filters), a tripod and maybe a fold-up umbrella.

The main reason for using a case, or carry-all, is to protect your equipment from dust, rain

Camera bag A camera bag (right) should be just large enough to take your particular selection of equipment: too large and things will rattle around; too small and you will be cramming things in.

and physical damage – so it needs to be robustly built and have a rigid frame.

Professionals often have a case strong enough to stand on. It might be a bit heavier to carry, but that extra bit of height can sometimes give you the winning slant. If you are walking long distances, it may be useful to use one of the many rucksacks that are specially designed

for use by photographers.

To prevent the cameras, lenses and other accessories from rattling around, and hitting each other inside the case, it should have plenty of compartments and retaining straps. Many 'suitcase' types come with a solid foam interior, out of which you cut shapes that fit your equipment exactly. These offer maximum protection.

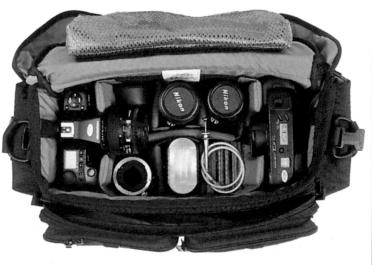

for distant views of buildings.

An expensive, but invaluable, tool is a PC or shift lens - this lets you frame the camera for tall buildings without having to tilt upwards, so vertical lines do not appear to converge.

The wide-angle lens will be particularly useful inside a building, especially if space is a little cramped, the area to be shot is extensive, or a generous depth of field is called for. For interior photography, try using long shutter speeds instead of flash where possible - using a tripod and a cable release.

For black-and-white shots, include in your kit yellow, green and orange filters for controlling the tonal values of the sky and stonework. For colour shots of the exterior, a polarising filter may be useful.

SLR camera

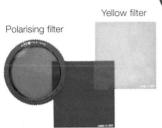

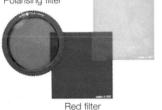

Perspective control shift lens

Ultra wide-angle lens

Telephoto lens

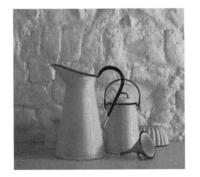

Still-life

Green filter

Indoors, time is on your side. The still-life composition can be built up patiently, element by element, while adjusting lights and checking through the camera viewfinder. A tripod is essential and, if your subject is small scale, you may find a tabletop model useful. Lighting can consist of just a couple of studio flash units, or perhaps even just a flashgun and umbrella reflector. A snoot, a conical attachment for a

Compact zoom camera

With light from a single source, some white cardboard on the subject's shadow side will act as a reflector and return a little light to lessen contrast.

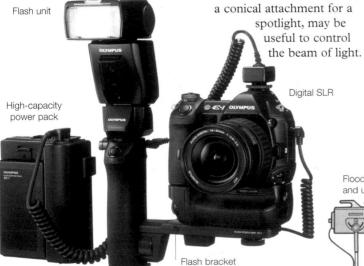

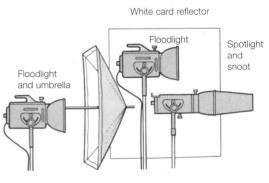

Wildlife

Animal subjects can be the most elusive as well as the most challenging.

The lens required depends very much on the scale of the subject and its distance from the camera. However, for most species a good telephoto is required. A 300mm setting on a zoom will usually be adequate for garden birds and for animals in a zoo. However, longer focal lengths may be

necessary for more timid birds or for smaller animals (or more dangerous ones) in the wild. A teleconverter can be used to give you extra magnification without too much expense.

Many of the world's species of flora and fauna are very small, so a specialist macro lens is useful.

For the nature specialist, some form of remote triggering device for the camera will be extremely worthwhile. This could be a long air tube and bulb, which allows the shutter to be tripped from many feet away. More expensive is a radio-controlled shutter release. This enables you to remain in radio contact with your camera, observing the scene with a pair of binoculars. Then, at precisely the right moment, a radio signal can be transmitted to trip the shutter.

Yet other forms of remote

release rely on the subject tripping the shutter by interrupting an infrared beam. The use of all these devices will require a sturdy tripod, with the camera pointing at a likely spot. Also useful is a continuous motordrive setting, allowing you to take a quick sequence of pictures when you finally have your subject in the viewfinder.

Many animals come out only at night, and for these a flash is essential, either mounted on the camera or clamped to a convenient branch and cabled to the camera. For shots of fast-moving insects and reptiles, a flash is also useful as a way of freezing the action.

As you will be working outdoors, it may be prudent to plan for rain. A thick, transparent plastic bag, with a hole cut for the lens, will usually suffice.

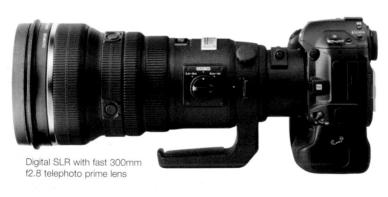

Flash unit

Teleconverter

Telephoto zoom lens

Wet weather In case of rain or heavy dew, enclose the camera in a plastic bag, leaving a hole for the front of the lens (above).

Action projects

For sport and action sequences, avoid being burdened with excessive equipment, so you can respond instantaneously, quickly bringing your camera to your eye, squeezing off a shot, and then being ready for the next opportunity. With professional, organised sport, you won't be able to get to the press photographers' enclosure; so, except for wide-angle shots of

the venue and an overview of the crowds, your main needs will be for a long lens (a zoom that extends to 300mm minimum would be ideal).

You won't be able to use a tripod if you are in the stands, but a monopod will make supporting the camera and long lens much easier and will help minimise camera shake. Alternatively, image-stabilising anti-shake lenses are available for some SLR cameras.

Amateur sports events can be better hunting grounds, since

you will usually be able to stand that much closer to the action. Even a compact camera, with a zoom lens that extends to around 150mm or more, will allow you to catch some reasonable action shots.

Compact camera with long zoom

SLR with motordrive

filter) can prevent them from

appearing over-exposed. For

a series of shots of the same

take along a tripod and cable

release, and leave your camera

set up as long as is necessary.

Many a sunny morning turns

scene throughout the day,

Don't forget an umbrella.

Image-stabilising telephoto lens

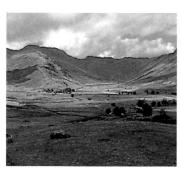

Landscape

To capture scope and breadth of a panorama, a wide-angle focal length (as found on even the humblest compact camera) is vital. The extensive depth of field of such lenses is also important. A medium-format camera with its large image area can be helpful for capturing detail.

Using a long lens to concentrate on just a portion of

Compact camera with fixed wide-angle

the scene can often evoke more atmosphere. Telephoto lenses are also useful for pulling in distant aspects that would be missed entirely with a wideangle. Skies can be another problem area, and a polarising filter or an ultraviolet filter (sometimes called a skylight

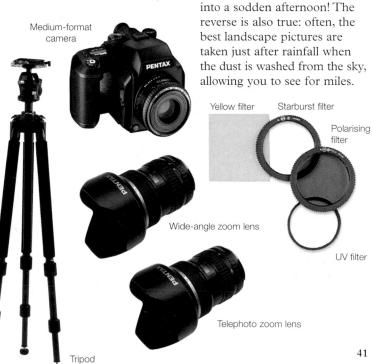

Portraits

Digital SLR with standard zoom

Pictures of people can be effective both in the controlled environment of the studio and outdoors in a more informal setting. For portraits indoors,

natural daylight might be sufficient. Direct sunlight streaming into the room, however, might be too intense and 'contrasty'. If so, filter and soften it by using a length of curtain netting or even tracing paper stuck to the glass.

Artificial lighting set-ups could consist of two studio floodlights for general illumination and maybe a spotlight for rim-lighting your subject's hair or for adding

catchlights to the eyes. Use clip-on softboxes, brollies, snoots and reflector dishes to angle and diffuse the lighting to suit the subject.

Portable flash is also suitable. either angled off a wall or ceiling or directed into a clipon softbox unit. Have a sheet of white cardboard handy to use as a reflector in case you need to throw some light into too dense a shadow area.

For the 35mm camera format, the most popular lens for portraiture, indoors or out, is a short telephoto of between 80mm and 135mm. This will allow you to fill the frame with a head-and-shoulders composition without getting too close to your subject. If you need to adjust your lighting indoors, set up the camera on a tripod. Outdoors, you will probably favour hand-holding the camera as you walk around finding the best angle and lighting effect.

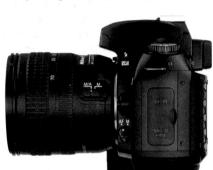

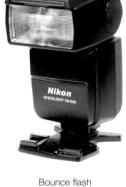

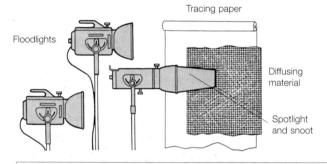

Lens care Normally. lenses need only superficial care. As a precaution, always keep a UV filter on the lens to protect its front element. If this becomes dirty, clean it with purpose-made lens tissues or a lens cloth. A lens hood and cap also give good protection. The front element of the lens can all too easily be scratched, so only use a blower brush or compressed air (from the recommended distance) to dislodge dust and dirt.

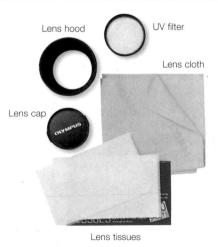

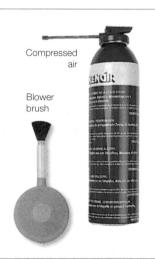

Close-ups

In this area of photographic interest, the SLR has a definite advantage over the compact.

Many zoom lenses and compacts have a 'macro' setting, but the amount of magnification this can give is limited. An SLR allows you to use a specialist macro lens, or enables normal lenses to focus closer to a subject using extension tubes or a bellows unit. These accessories are capable of producing an image

on film that is larger than life-size – even before being printed. A cheaper, but less powerful, alternative, is a close-up lens. This fits in front of the camera lens like a filter, and acts as a magnifying glass. For more specialised work, SLRs can be attached to microscopes via special adaptors.

The main problems encountered are extremely shallow depth of field (an unavoidable feature of all macro equipment) and lighting. With the lens so close to the subject, there is not much room for light to get in. In an effort to overcome the first problem, the camera must be mounted on a sturdy tripod so that minutely fine adjustments can be made to the focus control.

On location, it may be necessary to construct some form of windbreak (perhaps out of cardboard) around your subject to stop it swaying in and out of focus. A flash unit to illuminate and freeze the subject can help with the lighting problem. The cardboard used as a windbreak can also act as a reflector to return some light to the shadow side of the subject. Another useful accessory is ringflash, a circular lighting tube that fits around the outside of your lens and delivers near shadowless illumination to your subject.

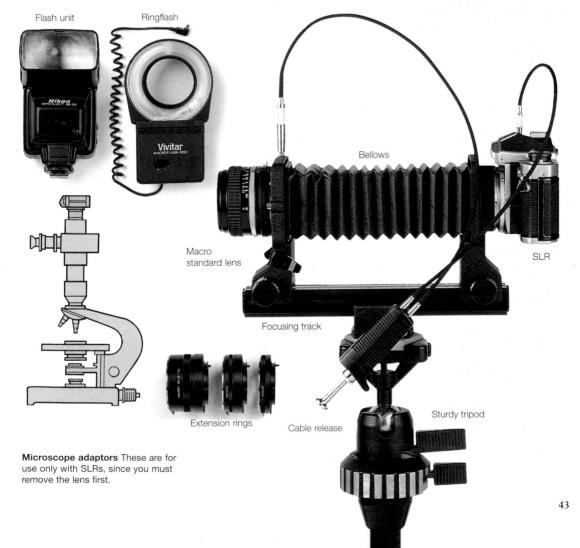

Using camera filters

There are three main classes of filters. Those for use with black-and-white film manipulate the way the various tones are recorded. Filters for colour film may be grey, pale-coloured or colourless (such as a UV filter), or strongly coloured to correct faults that occur if the wrong type of film is in the camera. Then there are dozens of special-effects filters which can be used with both film types, and with digital cameras.

CIRCULAR FILTER IS A disc of optical-quality glass or plastic that screws into the threaded front mount of the camera lens. Ensure that the filters you buy are of the correct diameter for your lens thread (which may vary between the different lenses of an SLR outfit). Square filters, which slot into an adjustable holder attached to the camera lens, are also

available; interchangeable mounting rings mean that the unit can be attached to a variety of different lenses.

Filter factors

With a few exceptions, all filters reduce the amount of light reaching the film. For most cameras this does not matter, since the TTL (through-the-lens) metering system will register the reduced

Home-made diffuser By smearing petroleum jelly unevenly on a plain-glass filter, you can create the type of dreamy effect seen here (above). Don't put the jelly directly on to the lens! Purpose-made soft-focus filters can also be purchased.

Special-effects filters There are many different types of special effects filters. Typical examples include: prism, starburst, mist, graduated colour, rainbow and clear centre spot. Use these filters sparingly, however, or the results they produce will soon become tiresome. Most of these effects can nowadays be reproduced easily using digital image manipulation software.

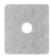

Clear centre spot A coloured filter with a clear centre can produce a fun image (above).

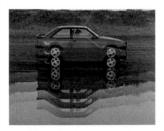

Prism Subjects with strong lines and bold colours are most suitable for a prism filter (above).

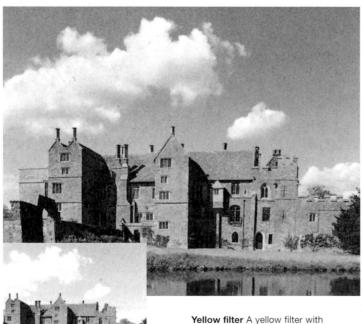

black-and-white film will strengthen sky contrast, as in these before (left) and after (above) shots.

	GENERAL-PURPOSE FILTERS			
Name/ filter factor	Exposure increase (in stops)	B&W or colour	Effects of use	
Pale yellow x2	1	B&W	Lightens yellow and darkens blue slightly.	
Yellow x2.5	1.3	B&W	Darkens blue sky. Lightens skin tones.	
Yellow/green x4	2	B&W	Lightens green, as in foliage. Intensifies mist and haze.	
Orange x4	2	B&W	Produces dramatic, dark sky effects. Reduces appearance of freckles.	
Red x8	3	B&W	Lightens cyan. Blue skies appear in extreme contrast. Shadow detail eliminated.	
Deep red x20	4.3	B&W	Daylight scenes appear as if shot in moonlight. For use with infrared film.	
UV		Both	Filters excessive UV light and improves colour/ tone rendition.	
Skylight	<u>-</u>	Colour	Extremely pale reddish UV filter used to 'warm up' colour films.	
Polarising		Both	Darkens blue skies, making clouds more prominent. Reduces or eliminates reflections from non-metallic surfaces.	
85B x1.5-2.75	0.5-1.5	Colour	For daylight shots with tungsten-balanced film.	
80A x1.5-2.75	0.5-1.5	Colour	For shots in tungsten light using daylight-balanced film.	

GENERAL -PURPOSE FILTERS

Neutral density filters This chart shows a selection of the neutral density (ND) filters that are available. All ND filters are grey in colour, and are suitable for use with both colour and black-and-white films, and with digital cameras. Their primary use is for when you want to select a very wide aperture, or a very slow shutter speed, in lighting situations where this would not be possible without overexposing the image. They allow you, for instance, to use shutter speeds of many seconds in daylight. They will not in any way affect the way that tones or hues are recorded.

		Exposure
Filter	Filter	increase
name	factor	(in stops)
0.1	x1.25	0.3
0.2	x1.5	0.6
0.3	x2	1
0.4	x2.3	1.3
0.5	x3	1.5
0.6	x4	2
0.7	x5	2.3
0.8	x6	2.5
0.9	x8	3
1.0	x10	3.3
2.0	x100	6.6

light level and increase exposure to compensate. However, this must be taken into account if using a hand-held exposure meter. Each filter has a 'filter factor' indicating how much more exposure is needed to compensate for the light lost.

Digital alternatives

Most filters can be used successfully with digital cameras, although sometimes the auto white balance system needs to be switched off. Most filter effects are more easily achieved using image manipulation software. The polariser and starburst are probably the most useful filters for the digital photographer.

Other uses of filters The filters in this chart are the more usual ones used in general photography. But there are many more in different colours and strengths. You can use coloured filters with colour film, but then you will create a colour cast corresponding to the colour of the filter used. You can use filters in combination to correct for more than one element in a scene. In this case, if you are not using TTL metering you must multiply filter factors to work out the necessary exposure increase in stops.

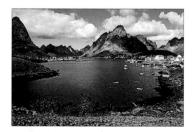

UV filter In mountain areas there is typically a lot of UV light, making a UV filter very important (above).

Polarising filter This is an ideal filter for strengthening sky colour or tone, as you can see in the shot above. It can also be used to reduce reflections on shiny surfaces, water and glass.

The home studio

A home photographic studio is the ideal place to explore the finer points of lighting technique. If you are lucky enough to have a spare bedroom, an unused garage or a converted attic, then you are well on the way. Even if one of these options for a permanent studio is not available, you may still be able to make part-time use of another room in the house.

HE SIZE OF ROOM NEEDED for a photographic studio depends on what you want to shoot. For example, if your main interest is in small natural history subjects and still-lifes, then a room of about 9 to 10 square metres (100 to 110 sq ft) should be sufficient. If, on the other hand, you are likely to be taking full-length portraits, then your space requirements will be very much greater – perhaps in the region of 18 to 20 square metres (200 to 220 sq ft).

For preference, a flexible studio should be squarish in shape, as opposed to long and thin. Working in a comfortable rectangle or square shape, you will be able to position lighting units to the sides of your subject and not just in an arc covering the front or the rear.

Also, to increase flexibility, a high ceiling is desirable – something taller than 2.75m (9ft). This will allow lights or reflector boards to be placed well above the subject, and will also permit the use of tall backdrops.

Although you would normally use artificial lighting (flash or tungsten), in a home studio natural daylight via a large window area is a worthwhile bonus. If daylight-balanced colour film and flash are used, they can be mixed with light from the window, since all have the same colour temperature. However, for those occasions when the exclusive use of artificial light is called for, shutters or lightproof blinds will be indispensable.

Although flash units are the lighting of choice for the film photographer, for the digital user tungsten lights are a viable alternative – due to the excellent built-in colour correction facilities available on good digital cameras.

The colour of the walls and ceiling is particularly important.

Storage You always need more space than you think for small accessories, props, etc. – so include as many shelves and cupboards as possible.

Make-up area This is by no means essential in a home studio, but if space and finances allow then models will find it extremely useful.

White-toned surfaces reflect most light and so, from the point of view of general illumination, are the best choice. Moreover, with white walls and ceiling you will have the freedom to bounce light on to your subject without

Floodlights Two or three floodlights have highly variable general lighting options. Soft boxes, as shown, will diffuse the light; spots will intensify it. worrying about unwanted colour casts. Never use a gloss finish paint, however, since this will produce glare spots.

Other general points you should consider are: a good, firm floor so that vibrations are not transmitted to a tripod-mounted camera; shelves and storage space; a well-lit make-up area for models; and a generous number of power points for lighting units. Alternatively, use a power distribution box and run lights from this.

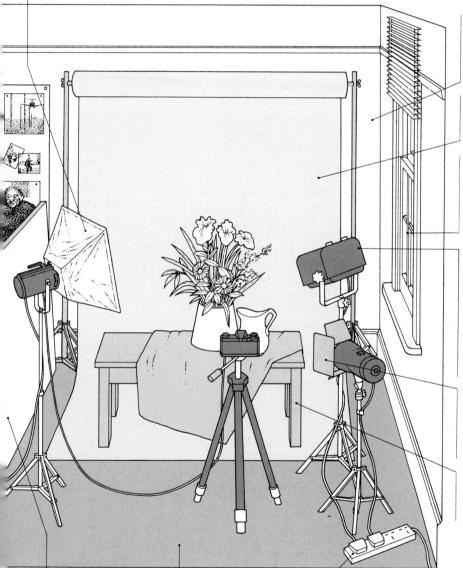

Matt-white walls and ceiling This finish does not produce glare or colour casts when used as a surface off which light bounces.

Backdrops Havo a variety of different-coloured background papers and materials available.

Window This allows natural daylight into your studio, but fit shutters and/or blinds so it can be closed when artificial lighting alone is wanted.

Studio flash There is a good choice of relatively inexpensive amateur studio flash units available. They can be operated with their own power packs or from the mains supply, and have the same colour temperature as ordinary flash.

Lighting reflectors
Different sizes and shapes
of lighting reflectors can be
fitted to floodlights to
produce different effects.

Table A solidly made table is essential for small natural history subjects and still-lifes.

Reflectors These can be simple sheets of mattwhite cardboard, or board covered with kitchen foil for a brighter, sharper reflected light. Floor A solid, non-slip floor ensures a steady surface for your tripodmounted camera and floor-standing lights. Distribution box This plugs into the mains power supply, and should have sufficient sockets for all your expected lighting needs.

The home darkroom

Processing and printing your own film gives you the ultimate control over results. All too often, meticulously framed, lit and exposed shots are sent off to commercial processing laboratories where they receive standardised treatment that in no way brings out the full potential of the image. It is relatively easy to set up a darkroom in your home.

IRTUALLY ANY ROOM IN the house can be used as a temporary home darkroom. Of course, it is very much more convenient if a permanent area can be set aside since there will then be no need for you to pack away all the equipment after each session.

DARKROOM SAFETY

Because you will be working with a combination of chemical liquids, water and electricity in a dimly lit or totally blacked-out area, you should pay particular attention to darkroom safety.

Separating your darkroom into a dry side and a wet side will help prevent many potential mishaps since this should help ensure that electrical equipment will never be handled with wet hands.

All chemicals, when not in use, should be in properly sealed containers, correctly labelled, and put out of reach of children.

Because you will often be working in dim light or in darkness, always keep the floor area free from clutter, and get in the habit of putting your equipment, paper and trays in the same position.

Many chemicals are poisonous, so eating and smoking should not be allowed in the darkroom. Furthermore, used chemicals should be disposed of in an environmentally conscious way.

Film processing

You don't even need a darkroom for film processing, just a black, lightproof changing bag available from most photographic stores. Inside the bag place your filmprocessing tank and spiral, vour intact cassette of exposed film and a bottle opener for removing the top of the cassette. Two special lighttrapped openings in the bag allow you to insert your hands and forearms. Once your hands are in the bag, all you need do is open the cassette, remove the film and load it on to the inner spiral of the film tank. Assemble the tank with the spiral inside then, once the lid is securely fitted on the tank, remove the loaded film tank from the bag and start the processing sequence. All this is done in normal room lighting.

The exact sequence of processing steps depends on the type of film being handled, but complete chemical kits are available for all types of black-and-white and colour negative films, as well as for most colour slide films. These kits come with full instructions.

For each chemical or wash stage of film processing, simply pour the correctly diluted liquid at the appropriate

Lightproof changing bag The filmprocessing tank and spiral, cassette of exposed film, bottle opener and scissors (for trimming off waste film) are placed inside the lightproof changing bag. This enables you to process film without the need for a darkroom.

temperature into the top of the tank lid, follow the directions concerning agitation and timing, and then pour the liquid out again through the top of the lid.

Printing

For printing you do need a completely lightproof room that has access to water and power. Because certain chemicals used in the process give off potentially hazardous fumes, the room should also be ventilated.

The first stage of printing involves using an enlarger to expose your processed film image on to a sheet of specially sensitive printing paper. It is at this stage that you determine how much exposure the paper requires and, for colour, how much filtration it needs.

Because colour paper is sensitive to all light, this step is carried out in total darkness (except for the light from the enlarger). Black-and-white paper, however, is insensitive to red, and can therefore be handled in the very dim illumination given off by special 'safelights'.

The next stage with colour printing is processing. The exposed paper is usually loaded into what looks like an elongated film-processing tank. With the paper inside the paper drum and the lid

Dry side/wet side Good darkroom design separates all the processes involving water or chemicals (the wet side) from the exposure and printfinishing processes (the dry side).

secure, turn on the ordinary room lights and start the processing sequence.

Traditionally, black-and-white paper is processed in open trays of chemicals, the sheets being transferred from one to the other at the end of each stage. There are, however, fewer processing stages in black and white than in colour. You must remain under safelighting throughout the entire sequence.

When the chemical processes have been completed, the prints need to be washed – preferably in running water – to avoid the print 'staining' over time.

The prints should then be hung up to dry in a dust-free atmosphere, or placed in special drying racks.

Home darkroom design The diagram below shows a typical layout for a home darkroom. The three-dimensional plan shows all the equipment necessary for processing and printing black-and-white or colour negative films, and for most colour slide films.

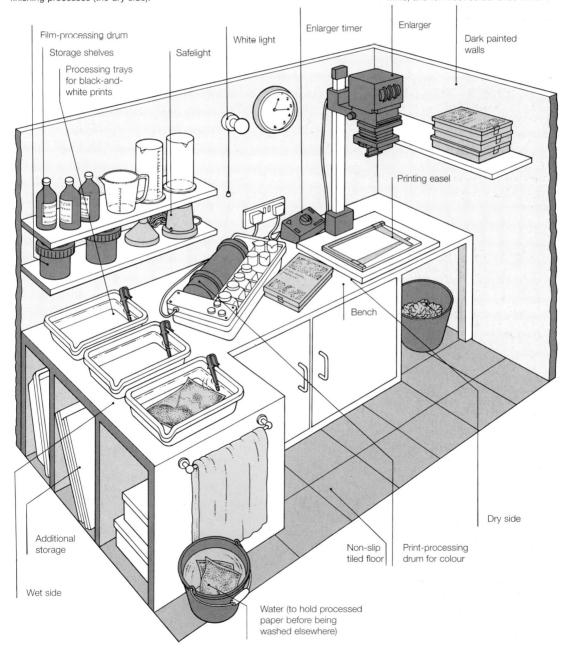

Broadening Your Scope

The digital darkroom

Once in digital form, it is possible to manipulate images, and with a degree of control, to an extent that was once unimaginable. Whatever camera you use, your images can be put into this binary form. The advantage of digitising your pictures is not just in the way they can be edited on computer; they can also be stored, transmitted and presented in various new, low-cost ways.

ersonal computers have not only revolutionised photography but have continued to expand the number of ways in which pictures can be manipulated and used.

It does not matter whether you have a digital camera or shoot with traditional film – the PC has the ability to transform your pictures in a myriad of different ways. This image manipulation is often viewed as the modern equivalent of the developing and processing techniques of old, hence the term 'digital

darkroom'. But the computer allows you to go much further, and exercise a greater degree of control, than was ever possible with an enlarger and trays of chemicals.

In order to take advantage of these new techniques, you first need to get your pictures on to the hard drive of your PC. If you are using a digital camera, this is usually simply a matter of using the connection lead supplied with the camera. With modern Firewire and USB connections, it is not usually necessary to have any special software to copy image files from one to another.

Portable hard drive If, on a long trip, it is not always possible to download your shots to a computer, a solution is to back up your images on to a special battery-operated hard drive (above), freeing up space on the camera's smartcard.

Alternatively, when you have images to transfer, you can slot your memory card into a card reader which can be left permanently connected to your PC (opposite, bottom).

If you want to put pictures, old or new, on to your computer, you need to have the photographs digitised using a scanner. This can be done at home using a normal flatbed scanner (opposite, middle), but these are usually suitable only for prints, and are best for when you require only low-resolution results (such as email or web-page authoring). For better-quality

RESOLUTION AND STORAGE

It is tempting to shoot pictures, or have them scanned, at the best possible resolution. But this is not necessary for every usage, particularly if the shot is simply to be viewed on-screen or emailed. Printing images demands much higher resolution, but the exact requirements will depend on the size of the enlargement, and by how much the shot is cropped. Digital photographers find that smartcards and PC hard drives soon fill up with

their photographs. It is therefore necessary to have ways in which to archive, and safely back up, the shots.

- Pocket hard drives are available to download shots from a camera's memory card when out on location (top).
- Recordable DVDs and CDs provide a low-cost route for storing and copying your digital picture library (below right). An alternative is a plug-in external hard drive (above right).

55Mb: TIFF from 35mm slide scanner

Resolution and file size The size of a digital image will depend on the amount of resolution available from the camera or scanner, the file format used, and the amount of compression used. A high-quality film scanner can produce a TIFF from a 35mm slide that is far larger than that produced by a typical digital SLR. But file size can be minimised using JPEG compression. For some uses, such as email and web pages, you will want to restrict the size of the file.

An alternative approach is to use a commercial scanning service. Many processing laboratories and high-street stores offer a service where your images are digitised on to CD at the time the film is processed. You can also choose to have favourite shots scanned in this way: it will be more expensive on a per shot basis, but may well be more cost-effective in the end. Note that the maximum resolution varies significantly depending on which scanning service you use.

Multi-format card reader Plugs into a PC so that files can be copied directly from a digital camera smartcard.

10MB: TIFF from digital SLR

300KB: low-quality ipeg for emailing

2MB: JPEG from digital SLR

50KB; very low-quality JPEG for web use

Flatbed scanner

35mm slide scanner

FILE FORMATS

Digital images can be stored using a number of different 'languages', but the following are the file formats that you are most likely to come across:

JPEG

Pronounced 'jaypeg', this is the format used by most digital cameras, and can be opened with a wide range of software (such as web browsers). One of the appeals of the JPEG is that it keeps the size of the file small, by simplifying the information as it is written. The amount of compression used is variable; small amounts can produce results as good as a TIFF, but taking up just 30% of the room; large amounts lead to noticeable degradation of the image (for some uses, this is unimportant).

TIFF

An industry-standard file format that uses no compression, providing you with all the information that the scanner or camera can possibly deliver. However, the large file sizes can be unwieldy.

RAW

A proprietary format offered by many digital SLRs that records the information from the imaging chip in a raw, uncompressed state. The appeal of this digital image format is that the file size is slightly smaller than that of a TIFF, but holds equal amounts of information. It needs special software to be read and translated (although this is usually supplied with the camera).

Broadening Your Scope

Printing

The advantage of having a camera with more pixels, or producing a higher-resolution scan, soon becomes apparent when printing out your pictures. The more detail you have available in the digital image, the larger you can print your pictures – and the more scope you have for cropping your images so that they look their best on paper. But the quality of results will also depend on the type of paper and printer used...

Greetings Printing your photos from your computer means they can be turned into personalised birthday cards.

IGITAL PICTURES DO not need to be printed. They can simply be viewed on a computer monitor, played from the camera on to a TV screen, or projected on to a white surface using a data projector. They can be shown to anyone around the world using email, the web or simply by copying the shots on to a blank CD.

However, most photographers will want to produce a physical print-out of at least some of their digital photographs. This is very easy to do, and it is possible to enlarge and crop your image as you'd like to see it.

Most desktop computer systems have a colour printer

that is capable of giving reasonable results. In fact, lowcost inkjet printers (right) are generally better at reproducing photographs than more expensive laser printers (which are better at text).

Inkjet models specifically designed for photographic use offer extra features such as being able to print direct from the camera's memory card, or the option of borderless, 'full bleed' prints. There are also differences in quality and maximum paper size.

Inkjet printer

PAPER CHOICE

It is perfectly possible to print your pictures on to ordinary, photocopier-grade paper using an inkjet printer. However, you will get much better results if you choose media specifically designed for printing photographs. There is a huge, and often bewildering, range of different grades and finishes available. Prices also vary greatly.

Note that some papers are much thicker than others

(typically, this is measured in grams per metre, or gsm, with typical values ranging from 100-300gsm). Most papers can only be printed on one side.

Inkjet prints are not designed for long-term survival, and will fade over a relatively short space of time. Some papers and inks with better archival properties can be bought. But as long as you back up the original file, and keep it safe, it is always possible to produce new prints.

Cropping One of the advantages of digital imaging is the ease with which you can crop your images, such as removing unwanted details from a shot or rotating the image to straighten an horizon, before printing. In this digital image (above left), I felt there was

too much empty wall in the left of the picture; this was changed in seconds on a computer (above right). Cropping an image can also have the advantage of reducing the size of the digital file.

Thumbnail print-outs Mini galleries of your digital images can be used like old-fashioned contact prints.

For results that look more like a traditional photographic print, consider investing in a dye sublimation printer (opposite, below). But note that special printing ribbons and paper are needed, so these can prove quite expensive.

A more cost-effective solution is to use a professional printing laboratory. Many of these establishments can produce images from your files on traditional photographic paper, direct from a CD or

memory card. It is also possible to upload digital images to web-based services, which then post your prints to you.

COLOUR CONTROL

A common problem when printing your own pictures is that the results look vastly inferior to those seen on the screen in front of you. This may be simply because you are using inexpensive paper, or have set the printing job up for a different type of paper.

However, a major contributing factor is the computer monitor that you are using. This needs to be calibrated to show your pictures as accurately as possible. You can use a special utility program to help you to do this. You should also allow for the fact that the range of colours (or 'gamut') that can be displayed on a screen will be different from that which can be printed.

Use a grey background, rather than a fancy desktop pattern, when viewing your shots – and keep the ambient light low, avoiding on-screen reflections.

Remember, however, that the monitor image will always look brighter and richer than the print, however well your system is set up and whichever type of printer you use.

HOW BIG CAN YOU GO?

The largest photograph you can sensibly print depends on how many pixels there are in the image after it has been cropped, whether originally scanned or shot with a digital camera. For home printing, a resolution of 200 pixels per inch (ppi) is normally used; for professional printing, 300ppi is the norm.

Print size required	Number of pixels required		
	Home printing (200ppi)	Professional printing (300ppi)	
2x3in (5x7.5cm)	240,000	530,000	
4x6in (10x15cm)	940,000	2.1 million	
7x5in (18x12cm)	1.3 million	3 million	
A4 (12x8in)	3.7 million	8.3 million	
A3 (12x16in)	7.4 million	16.6 million	
20x16in (40x50cm)	12.3 million	27.5 million	

Adjusting exposure

Although digital manipulation can never completely make up for an imperfect original shot, it can go a long way towards repairing all manner of imperfections in the image. The exposure adjustments are some of the most important as these allow you to adjust contrast, brightness and colour balance to enhance the image that has come from the digital camera or scanner.

HOTO MANIPULATION packages are available to suit every pocket and every level of photographer. But even those programs aimed at the enthusiast and professional user can offer several different ways of achieving the same sort of result, particularly when it comes to key image adjustments such as those for exposure.

It doesn't matter how accurately you expose your picture with the camera, practically every image you take will benefit from some tweaking of the tonal range and contrast. The benefit will usually be even greater with scanned pictures. And although digital techniques can rarely turn a dreadful mistake into a great shot, they can improve imperfect pictures hugely.

The simplest adjustments for exposure on most programs are basic sliders (right), similar in scope and operation to the controls found for adjusting a TV picture. Although these are straightforward to use, there are more precise, and

IMPROVING CONTRAST

Brigh	tness/Contrast	
Brightness:	+45	OK.
	-	Cancel
Contrast:	+35	☑ Preview

Contrast/brightness controls can help lift a flat picture (as above), but you generally get better results using levels adjustment.

IMPROVING FLAT IMAGES

The levels adjustment is one of the most used controls in image manipulation packages. It provides a simple way of tweaking exposure and contrast. In most cases, it is necessary to adjust the left and right arrows under the histogram only slightly – bringing them in so that they are under the extreme points of the histogram.

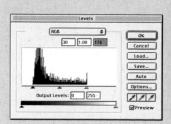

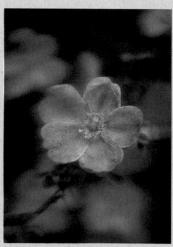

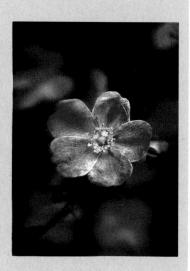

scientific, ways in which to improve your results.

Using levels

The most common of these exposure controls is the 'levels' adjustment (opposite, bottom). This effectively shows a sophisticated meter reading of your picture where the brightness of every single picture is analysed and given a score of between 0 and 255. This data is then plotted as a graph or histogram.

A good exposure of an average subject would show as a bell-shaped curve, with

low-level readings at either end (representing the extreme whites and blacks in the image), and a peak in the middle (representing the mid-tones).

If the graph does not conform, the shot can usually be improved by moving one or more of the three sliders underneath the graph. These reset the black point, the white point and the mid-grey setting for the exposure. You can spot the effect immediately in the picture but, once you get used to it, you will see that the graph shows you immediately

where your problems lie. For the beginner, an automatic level adjustment can be used.

Curves control

More sophisticated still are the curve controls, although these are found only with professional packages. Instead of analysing the picture, these provide a line graph that represents how the tones in the picture are to be processed. This allows you to brighten or darken different ranges of tone individually, by simply redrawing the shape of the graph.

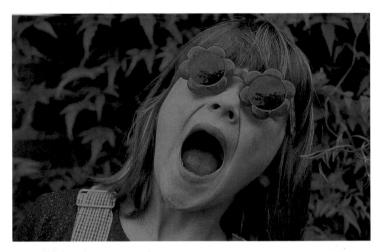

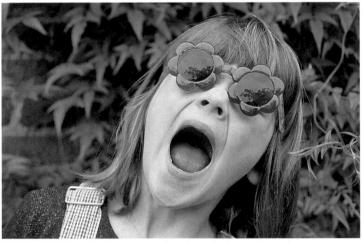

Using curves The curves control is a more sophisticated and precise way of adjusting exposure and contrast in a digital image, but is only found on professional manipulation packages. The starting point for the original picture (top) is a straight diagonal graph. By moving points on the graph (left) you can create subtle and significant changes to different ranges of tone within the picture (above).

CHOOSING A PACKAGE

Digital manipulation software does not have to be expensive. Often, good programs are bundled with digital cameras and film scanners – and trial versions of titles can be downloaded for short-term use on your computer.

It is essential, however, that you pick a program that works with your computer's particular operating system and hardware specifications. These programs can demand huge chunks of processing memory when performing certain operations, particularly with large-sized image files.

The best-known package is Adobe Photoshop and its cutdown, but powerful enough, brother Adobe Photoshop Elements. Note that you may well be able to save money (and RAM) by using older versions of these titles.

Adjusting colour

The colour controls available to the digital photographer are more akin to those of the artist than of the traditional darkroom worker. Not only can colour casts be removed, but the image can be altered in ways that would previously have required an airbrush. You can adjust the hue of elements in the shot, beef up the colour of the sky, and much more...

OOD IMAGE
manipulation
packages provide
a number of different ways
in which to change the
colour balance of an image.
They can also boost or subdue
individual hues within the
composition. This gives a
degree of control far beyond
that provided by the filters
used by film photographers.

Colour casts are a particular

problem for the conventional photographer, as most film is simply designed to provide accurate colours during average midday light. The orange cast typical of pictures taken under bulb lighting can be removed or softened to give a more natural result. Similarly, the blue tinge associated with overcast days can be toned down to give outdoor landscapes a warmer

LOSING THE COLOUR

As well as adding colour, image manipulation software is very good at stripping this information from your shots to create a monochrome image.

Turning a shot from colour to black and white is a simple, one-step process. For this reason, many digital photographers shoot everything in colour, then convert it to monochrome when necessary on computer (see example opposite).

For more precise conversions, it is possible to mix the different colours in the original in different proportions. This changes the tonal balance within the shot in the same way as if a coloured filter had been used with black-and-white film.

tone. A sunset can be made more dramatic by increasing the red content in the image. These adjustments can equally be used to correct white balance mistakes made when using digital cameras.

Colour can also be added

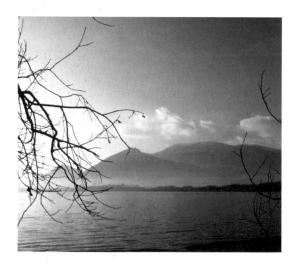

Colour balance adjustment There are a number of different ways to tweak the colour balance of a picture using a program such as Adobe Photoshop. These allow you to make small or large adjustments to the tone. In this landscape (above left) the misty conditions have created a pleasing

blue-toned waterscape on daylight film. However, it is easy to convert this into warmer hues, once digitally scanned, using the Colour Balance slider controls. Here, rather extreme adjustments have been made (as you can see from the values in the control box, shown right).

as a wash to the sky of a landscape picture, recreating the effect of a graduated filter, but with the benefit that you can specify exactly where the gradation begins and ends – and the precise hue used.

Just as useful are facilities

to tweak particular colours within a picture. Using the hue/saturation control, for instance, it is possible to boost the orange hues in a still-life shot without affecting the blues or greens. Usually this can be done

without even having to select the particular area you want to work on: you simply define the range of colours you want to adjust. It is also possible to change completely the colour of a single element of a composition.

TONED IMAGES

Editing software usually also provides fast ways of producing toned images, including traditionally complex duotone and tritone effects. Here, a duotone of a colour image has been made.

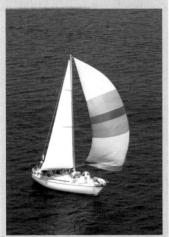

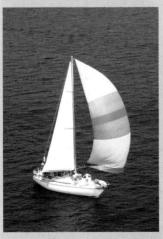

Watch my lips As well as making global changes to colour, it is possible to make alterations to the hue of just small areas of the digital image. This can be done by selecting the area of the image you want to work on or, better still, by using a mask to blank out sections of the image that you want to remain unaffected (this has the

advantage of allowing the selection to be refined at a later date). In this shot, only the lips of the model and one of her fingernails are altered, creating a surreal effect. This technique is widely used in fashion and beauty photography: make-up need not be painstakingly applied for the shoot, but can be added later using the computer.

Monochrome conversion To make a black-and-white image from a colour original, traditionally you had to re-photograph it. But once

digitised, the picture can be turned to black and white in a second (above right). It is sensible to keep a copy of the colour original.

The benefit of using layers

Layers are essential to good digital manipulation. They allow you to make your alterations in steps, which you can then go back and change individually. Using them helps you to ensure that small errors of judgement do not mean hours of wasted effort. They also help you check the progress you are making with the image worked on, by turning completed layers off and on.

HEN MANIPULATING a digital image it is always sensible to work on a copy, rather than on the original file. Picture-editing software will usually provide a number of ways to go back one or more steps if you feel that you have made a mistake: however, it is always worth keeping a clean version of the original for future use.

Better image manipulation packages have a sophisticated way in which you can keep different groups of adjustments separate. This allows you to switch different corrections on and off to see the effect they have on the picture, and so that you can discard them without affecting the original background picture.

These 'layers' are an essential part of good digital darkroom practice. You start off with the background picture, but rather than working on this directly you work on copies of this image which sit on top of the original. Layers can be opaque, obscuring the layers below, or have different degrees of transparency; layers can also be blended together so that the pixels in

each combine in ways that can produce useful and interesting pictorial effects.

Adjustment layers

Many of the standard alterations to an image can be made using an adjustment layer (see right). This records the details of the levels, or colour correction, say, made to an image – but allows you to go back and change or discard the settings at a later date. Masks can be used with adjustment layers, so that the effect is applied only to specified areas, and to different degrees within the image. Again, the advantage of a mask is that it can be edited at any time in the future.

Layers are also essential when using digital manipulation to combine two or more images in the one photograph. Each of the elements can then be edited separately, with its own layers, before the final composite is produced.

Advanced image manipulation packages allow you to work on each of the prime colours of the picture separately. These are depicted as separate layers, known as channels.

Adjustment layers In this sequence, the above landscape is manipulated using layers. This allows us to alter or discard any of the steps at a later date.

Adjustment layer 1 Hue/saturation adjustment creates a psychedelic tangerine scene.

Adjustment layer 2 Brightness/ contrast adjustment is used to strengthen the blacks in the image.

Adjustment layer 3 Colour balance adjustment is used to strengthen the warm tones of the scene.

Final adjustment The number of colours used in the image is further restricted using the posterise effect.

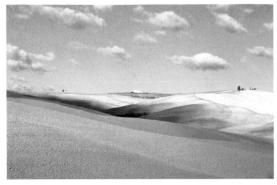

Photomontage Layers provide an ideal way of combining different elements from different images, so that you can create a composite. If you make a mistake, you need to correct only one layer, rather than having to start again. A

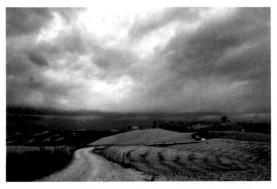

simple example of the process is when adding a new sky to an existing landscape. Here, we are going to use the moody, overcast sky of one landscape (above right) to replace the fluffy clouds and blue sky of another landscape (above left).

Selection The area of sky that we are going to use is roughly selected using the marquee tool. An exact selection is not necessary.

The mask We must define precisely the area of sky we are replacing. Use a mask, created using the 'paint brush' tool; the 'eraser' corrects mistakes.

Adding the sky The new sky is then simply copied into the mask layer: it shows through only the white, unpainted parts of the mask.

Adjusting the curves To make the two halves of the shot work together seamlessly, we first need to adjust the exposure. For precise control, we use Curves on an adjustment layer.

Adjusting the colour balance With the exposure tweaked, we now adjust the colour balance of the bottom half of the picture. Again, a separate adjustment layer is used to do this.

Colour gradient The colour gradient layer works like a traditional graduated filter. However, you have precise control over where the colour begins and ends, and how quickly it graduates.

Final colour adjustment We have now hopefully adjusted the image so that the two halves look as if they match perfectly. But as we have used layers for each step, we can always go back and make further adjustments without starting again. The final step is to tweak the colour balance of the image as a whole, to produce our finished montaged landscape (right).

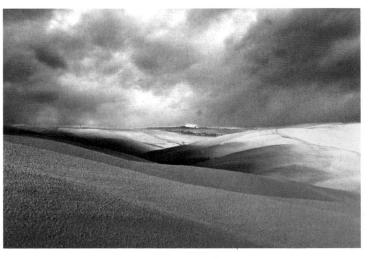

Digital doctoring

However hard he or she tries, the photographer rarely finds the perfect picture. If you look closely there is always a hair out of place in a portrait, or an unwanted passer-by walking through your architectural study. But, with computer retouching, such 'imperfections' can be removed with a couple of clicks of a mouse...

HILE DIGITAL manipulation enables you to redraw your image in miraculous ways, it is the small improvements it allows that are often the most useful. Retouching used to be a very specialist skill that was carried out only if absolutely necessary on particularly important pictures. With a computer, it is possible to spot out small areas of the picture extremely easily.

Dust and scratches are a particular bane of the film photographer, and need to be dealt with on practically every scan. However, these marks can be removed simply by 'cloning' material from a neighbouring area, and painting it over the mark using a spotting technique. As each correction can easily be undone, you can change the brush's size and softness, and the area you sample from, until the correction is completely unnoticeable.

This same method can be used to make a multitude of small compositional changes to a picture. You can use it to remove telephone wires and TV aerials from your shots, for instance. You can lose people

who obstinately stand in front of the building you are trying to photograph. You can even make those unfortunate spots and cuts on a child's skin vanish. You can remove litter, graffiti and advertising hoardings, as well as repair those bare patches in the lawn.

This technique can be used to improve most pictures, and to rescue older shots that you had previously considered failures. But it can also have an effect on your picture-taking. Why move half a mile to ensure the crane is blocked from view when you know it can easily be moved later using Photoshop?

The ease with which these offending elements can be removed will depend on how easy it proves to replace the missing material using other parts of the image. With practice, however, it is possible to remove quite large subjects from a scene.

A tip is not to crop the picture until you have retouched the shot, as this allows you to sample from a bigger canvas. It may also be useful to look at other shots from the same sequence to see if these can provide material that can be patched into the improved picture.

some of your slides and negatives will inevitably get scratched over the years, while all film attracts a certain amount of dust and dirt. This shot of a backpacker in the Australian Outback has been severely damaged, and it is

Removing dust and scratches
It does not matter how careful you are:

hamburt of dust and durt. This shot of backpacker in the Australian Outback has been severely damaged, and it is only the relatively recent arrival of digital image manipulation that has allowed me to salvage the shot by scanning it and then using simple cloning techniques.

Simplifying the scene Practically any outside scene will benefit from some tidying up on the computer. In the original (top), the flue and light clutter the composition but can be removed by cloning suitable areas of sky and wall (above). The same technique was used to remove the plant pot (right).

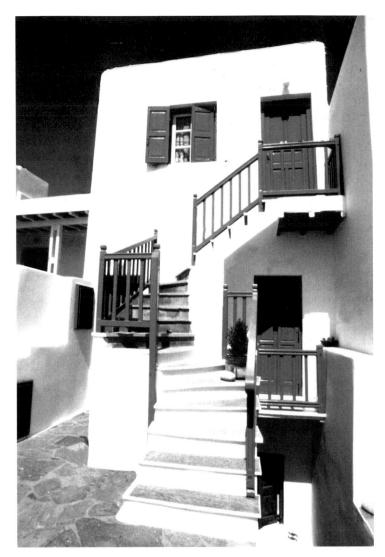

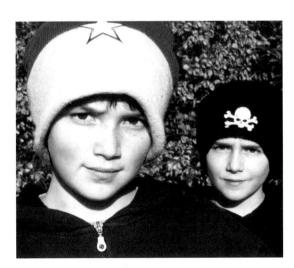

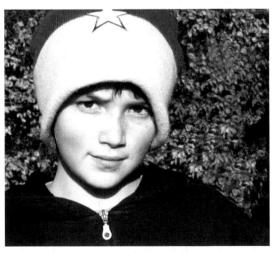

I wanted to remove the boy in the background. In this case, deciding what would replace him was relatively easy – painting other sections of the brown hedge over him (above right). However, each step needs to be analysed carefully to ensure that what you have done looks believable.

Broadening Your Scope

Simple effects

Digital image manipulation is not just an electronic darkroom; it is also a way in which photographs can effectively be retaken. Commonly used tools allow you to sharpen areas of your picture and throw others out of focus, just as if you had used different lens settings when you originally took the photograph.

ANY OF THE EFFECTS that a digital editing program provide are drawn from traditional darkroom techniques. You can lighten and darken areas of the image using dodging and burning tools, for instance. But even though the picture has already been shot, a number of camera techniques can also be used.

Gaussian blur

One of the most useful of these is the blur tool. 'Gaussian blur' allows you to throw parts of the image out of focus so that you can effectively change the amount of depth of field in a picture, just as if you had used a wider aperture. This lets you make a distracting background unidentifiable, and in fact you can achieve far more blur than would be possible with a camera alone. However, it is essential that the effect is applied less heavily to some parts of the image than to others, recreating the gradual loss of sharpness associated with depth of field.

Unsharp mask

It is also possible to sharpen pictures; however, it is not possible to restore detail to elements that are completely unsharp. Sharpness controls work by increasing contrast, particularly at the edges of elements. The most useful is the USM, or unsharp mask, control; this should be used on most of the pictures on which you work. Although a digital camera or scanner can electronically sharpen the image when the image is digitised, it better to leave this effect off and use USM later.

The unsharp mask is the last thing you do when manipulating an image. The amount of sharpening you use will depend on what you are using the image for, and on the subject matter. Printed pictures tend to need more sharpening than those that are to be viewed on-screen. Sharpening an image tends to make it look more grainy, so it is important not to over-do the effect unnecessarily.

Change of perspective

As well as allowing you to crop your image, manipulation packages can also change the picture in other ways. You can rotate the image before cutting, for instance, to correct wonky horizons. You can also distort the image in a number of ways.

Most usefully, you can correct for converging verticals

Sharpening the image In this before and after shot, you can see the effect of using an unsharp mask. The original shot is not out of focus, but the car is tending to blur into the scenery (top). Using the USM adjustment, the car stands out far more clearly. Notice how the blurred foreground has also been made to appear sharper. The USM adjustment, in fact, provides three separate sharpness controls which are used in tandem to produce the effect.

caused by using a wide-angle lens from a low-angle viewpoint (see opposite). This is done by stretching the top of a building and squashing the bottom, so that the vertical lines run parallel again. This correction is much more cost-effective than using a perspective control shift lens (see page 39).

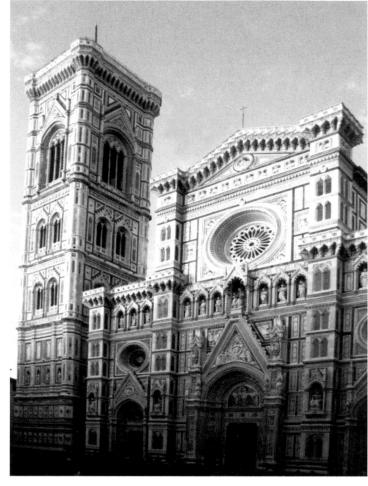

Correcting converging verticals Because you need to tilt the camera upwards, converging parallel lines are inevitable when using a wide-angle lens to shoot a tall building. This makes the building look narrower at the top than it actually is, as

with this shot of a church (top left). Using digital image manipulation software (above left), you can stretch the top of the building. The result is a final image (above right) in which the vertical lines of the church run parallel again.

Blurring the background Although you can control depth of field in your picture using aperture, focal length and focused distance, there are times when the limits of your lens or the lighting conditions mean that it is impossible to get the background as out of focus as you would like. The backdrop in

this portrait (above left) is far from sharp; however, it still contains recognisable shapes that prove a distraction to the central image of the girl and her floral tresses. By using Gaussian blur, and carefully selecting the area to which it is applied, the background has become far less of a distraction (above).

Special effects

As with most computer programs, you will find that you rarely use more than a fraction of the controls and effects found on image manipulation programs. In fact, many features are not even provided for the use of the photographer. However, there are some effects, such as a few of the many 'filters' available, that may occasionally help in improving your pictures.

Photoshop are capable of producing all manner of weird and unusual effects. At their most extreme, you can see them as tools that allow you to rebuild pictures from scratch: painstakingly merging elements from different shots, and painting in elements freehand.

Such work can produce highly original work, but in order for the final result to work it is essential that the joins do not show. This often relies on equal amounts of artistic talent, patience and practice. The secret is to use new layers at every juncture so that you can go back and make small corrections to an earlier stage without having to trash everything you have done since then.

Fortunately, many of the more spectacular manipulation effects involve little more than a oneclick operation from the photographer. Many of the 'filters' that come with

STITCHING IMAGES

Digital manipulation packages can be used to join together two or more pictures showing slightly different views of the same scene so that you get one seamless image. This procedure is particularly useful for panoramas, allowing you to capture the whole view without the need for an extreme wide-angle lens and without wasted image area. However, the technique can be used for practically any subject. As you are effectively using more pixels to capture the image, you get more resolution than would have been possible with a single shot (see pages 176-77).

Some packages have special tools for helping you to align the different shots, and to help stretch individual shots to allow for the slight changes of camera position between shots. However, for best results it is necessary that the pictures are taken with this purpose in mind. Special stitching software is available, but standard manipulation programs can also create these mosaics.

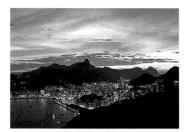

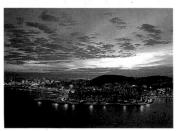

Rio at night The two shots (above) were taken from the same spot. They were joined together digitally (right) to give a better panoramic view.

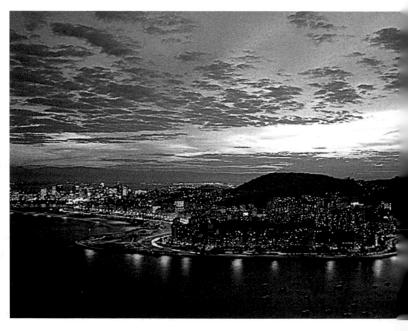

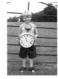

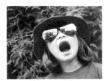

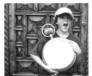

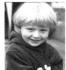

MONTAGING

Photo manipulation software can be used to create the sort of collages that traditionally were made using scissors and glue. In this example, four family portraits (above) were combined into a single image (left), putting each on a separate layer of the same file so that they could each be worked on and adjusted separately. Marquee and eraser tools allow figures to be cut out with precision - and if you make a slip, you do not ruin the photograph.

these programs, or which are bought as 'plug-ins', provide artistic transformations of the image. They may make the shot appear like an oil painting or a stained-glass window. They might be used to add elaborate outlines or

frames to the image, or to distort the shot as if it were on stretched rubber.

Filters can also be used to provide easy access to older photographic effects such as infrared film, solarising a print or deliberately developing a film in the wrong chemicals. However, such effects can often be achieved and managed more accurately using the basic colour and exposure controls: employing levels, curves and hue adjustments in unusual ways.

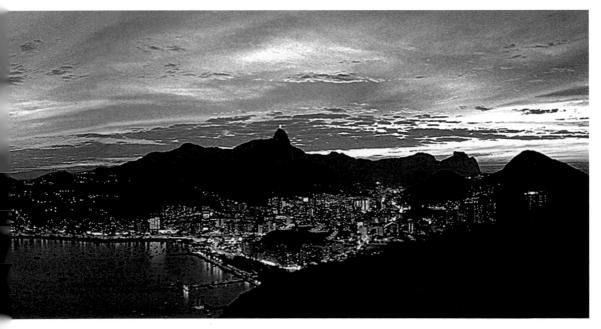

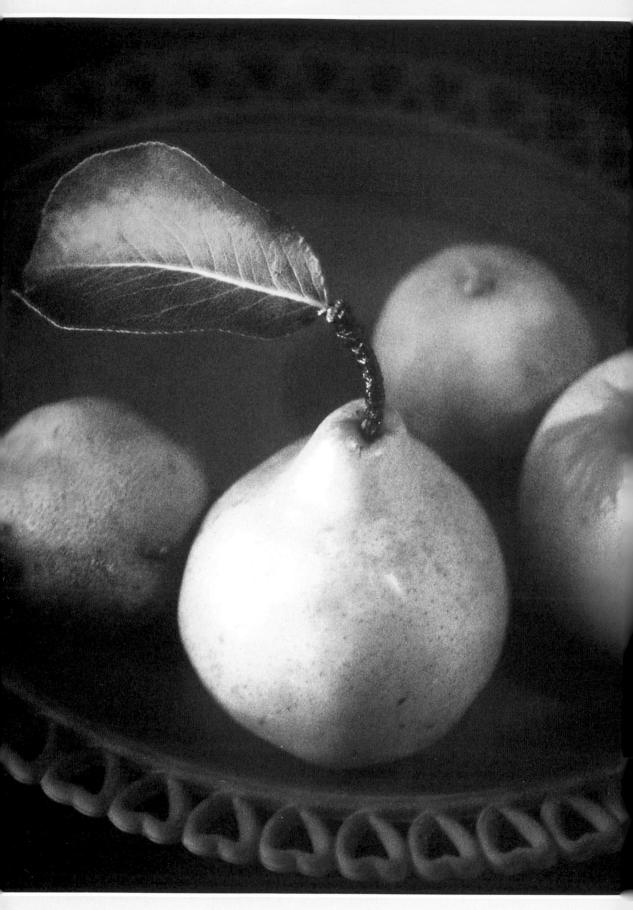

The Essential Elements

The projects in this chapter aim to provide familiarity with a core of basic photographic techniques. These include: accurately recording the shape, form and surface characteristics of objects; the many different types of colour usage; perspective to give depth and distance; and composition to lend structure to photographs. The basics of black-and-white photography are covered for those more used to working in colour.

First steps Learning to convey the three-dimensionality and tactile qualities of your subjects with a two-dimensional medium are some of the first steps in photography.

The power of shape

Of all the essential pictorial elements, shape is the most basic to our understanding of objects and scenes. From a distance somebody can be recognised by shape alone, because a figure once robbed of its form, texture or colour is reduced to its most powerful element – that of a silhouette, which is pure shape.

HE FIRST STAGE IN THIS project is to produce a silhouette, of a person or of any object that has a strong and interesting shape.

One of the so-called 'rules' of photography is that you should always have the sun at your back when taking pictures. For a silhouette, you must do the opposite, placing your subject between the light source and the camera. For the effect to work properly, take your light reading from the highlight, locking the exposure to that needed for the bright background alone. In this way, the side of the subject facing the camera will be massively under-exposed and thus reduced to shape alone.

When working outside, your light source will be the sun, but this technique is just as effective indoors where you can use studio photofloods or even domestic tungsten lights to give you the extreme contrast needed.

The second part of the project requires you to take a set of photographs in which shape is the dominant element and where the other elements play a subsidiary role. The examples shown here include a mixture of subjects, but notice that in three of them the figure or object has been

set against the skyline. This is a simple and effective way of emphasising shape against an uncluttered background.

Where shape is part of a general scene, it needs to be very powerful or it may well end up becoming submerged.

Outdoor silhouette For the outside shot (above), a light reading was taken from the sky adjacent to the sun.

Studio silhouette For the portrait picture (below,) two studio flashlights were directed on to the backdrop, while making sure no light spilled on to the model.

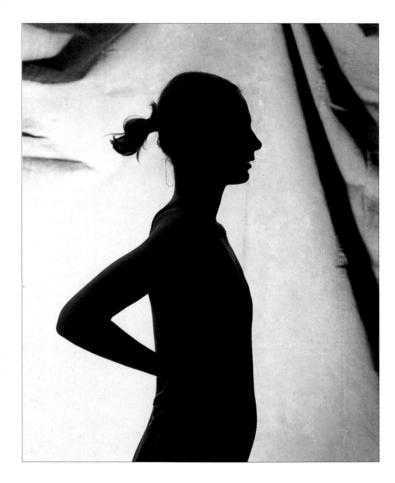

Geometric shapes I was attracted by this Normandy windmill (above) because it is composed entirely of strong geometric shapes. A low viewpoint ensures that these are seen clearly against the open sky.

Dynamic shape In this strongly patterned setting (below), the figure could easily have been lost. However, the diagonals of the model's legs and torso created by the unusual pose have produced a dynamism that pulls her out of her surroundings.

limited in area. Had this man's shirt also been bright, the impact of shape would have been lessened.

tremendously powerful (right), yet

Shape versus pattern Overcast light in Rio (below) helped to suppress the impact of the pavement mural, allowing the portly policeman to dominate.

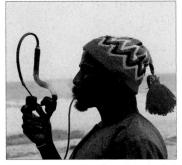

TECHNICAL TIPS

- For silhouettes with autoexposure cameras, take a reading from the brightest highlight, store the reading using the exposure lock, and then recompose your shot for the strongest effect of shape.
- With some cameras, the easiest way to ensure that the subject appears as a silhouette is to under-expose it, setting the exposure compensation dial to around -2.
- Don't look directly at the sun, as this may damage your eyes.

Form that gives substance

Whereas shape can be effective as a two-dimensional description of appearance, form adds the third dimension. It gives depth and, hence, reality. The appearance of form depends on the way light strikes an object; the transition from highlight to shadow that produces roundness and solidity.

Directional sunlight To take this portrait (below), I positioned myself on the subject's shadow side and asked her to turn her head so that the sunlight lit one side of her face. Hence form and texture are both very well described.

Contrasting techniques In this stilllife (right), the gentle graduated tone between wall and windowsill still produces a strong indication of depth. Meanwhile, the subtle play of light and shadow on the cup accentuates its cylindrical shape.

HE FORM, or threedimensionality, of a subject is a function of shading, either of colour or of tone. An area of flat colour or tone has no impression of depth. It must be graduated.

In this project you can use either natural daylight or domestic or studio lighting to produce studies highlighting this essential picture element.

One common mistake many people make is to overlight subjects, which has the effect of killing form. So keep lighting simple and not multidirectional: a single light will often be extremely effective.

Gentle form With this marrow flower (above), the gentle veining of the tightly curled petals needed equally gentle sidelighting.

TECHNICAL TIPS

- The important factor in this project is the lighting. To see if the lighting has produced the effect of form and solidity you want, you must view the subject as the camera sees it, by looking at the subject through the viewfinder.
- Start with a single light source to the side of the camera. Slight changes in the angle will affect the shadows, and the feeling of form.
- If contrast is too strong, use a reflector to bounce light back into the darker side.

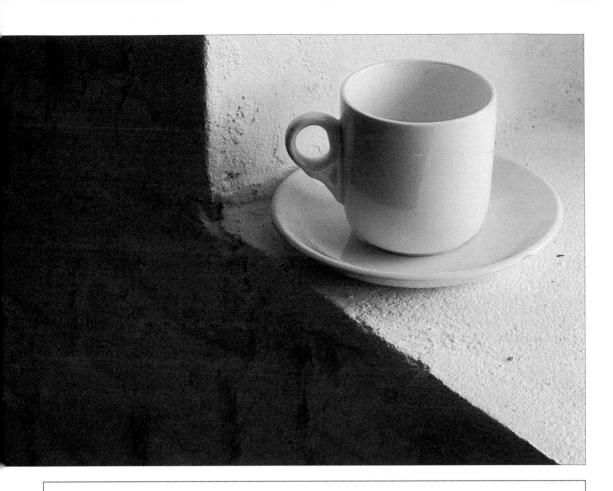

Lighting direction For the first shot of this model (right), lighting was frontal, with the light pointing in the same direction as the camera. Shape is well defined but there is little impression of form. Next (below right), the light was moved to one side, creating better three-dimensional modelling. For the final shot (below), the model turned so that the light struck her at about 45°, thus combining form with a much stronger feeling of shape in this picture.

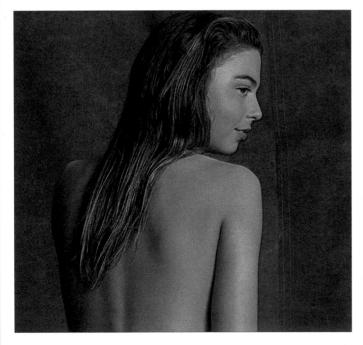

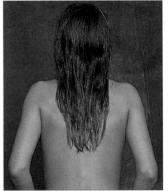

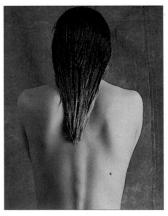

Texture in photographs

Texture is the visual interpretation of the tactile surface characteristics of objects. It gives an idea of what surfaces would feel like, so has an important role to play in many successful pictures. Because touch is so fundamental to our everyday experience, strong texture in pictures helps to form part of the two-dimensional illusion of reality that is photography.

APTURING TEXTURE is the first real refinement of the image, so at the completion of this project you will have reached an important staging point. Texture is the quality of an object's surface, and shows you what it is made of and therefore adds a tactile quality to a photograph.

The appearance of texture is dependent on the angle of light striking the surface. Low, raking light will illuminate high points brightly, while casting shadows into dips and hollows. This will allow the real texture of surfaces to be seen, rather than just flat areas of colour. This is true both for small areas of isolated detail and

Lighting direction These wooden boards (above) looked smooth in midday sunlight. As lighting became more oblique towards dusk, however, shadows formed in the hollows, thus emphasising texture.

for broad panoramas. Many of the best landscape photographs, therefore, are taken by the light of a low morning or evening sun.

Contrasting textures For this picture (right), shallow depth of field was used to accentuate contrasting textures. First, there is the smoothness of the arm and stalks; then the roughness of the man's fingers; and, finally, the silkiness of the ring and seed heads.

Subduing texture The flat, restricted light from an overcast sky (below) has reduced this highly textured image almost to pattern. It is described by colour differentiation alone.

TECHNICAL TIPS

- We rarely notice texture in objects in a visual sense, but by isolating it in the lens you can turn an everyday object into an interesting picture.
- One of the best ways of doing this is to get in close to the surface so that the grain of the wood, say, or the rust of the gate fills the frame.
- With some subjects, you may need a macro lens or other specialist close-up equipment in order to do this (page 43).

Texture in context Scenes such as this are not difficult to find (right). The different surface textures dominate without question, conjuring up an almost nostalgic quality associated with a sturdy old building that has finally succumbed to the elements. Here, overhead lighting creates the greatest contrast over the surface of the crumbling masonry.

Seeing and isolating pattern

If you look back through pictures you have taken and pick out the ones you find most pleasing, a large percentage of them will probably feature some aspect of pattern. There is a type of instinctual recognition of pattern around us, both natural pattern and pattern in artefacts and in the man-made environment.

HIS PROJECT explores the use of pattern to bring order to potentially chaotic images. By selecting angle of view (through your choice of lens), camera position and even lighting quality, you will be able to present visual information in a selective way.

When researching locations for this current set of pictures, bear in mind that pattern is more than a simple repetition of shape, such as in a line of hills, an avenue of trees or the massed formations of roofs in cities and towns. More subtly, pattern exists in colour usage and in tone distribution, in the detailed structure of plants or in people's faces all turned in the same direction.

Sometimes, in order to recognise pattern, a new camera position must be adopted: right down low, perhaps, to capture a shot of legs in a crowded street; or up high looking down from a balcony to see the repeating shapes of the tables and chairs of the cafe below.

Focal length, too, is significant: a telephoto cutting away the clutter to isolate a small area of pattern; or a wide-angle used close, so that identical objects appear different sizes within the frame. As with lenses, so with lighting: often it is the arrangement of light and shade on an object or landscape that helps accentuate the pattern.

Nature's patterns Nature does not use pattern arbitrarily (above). Using a zoom's telephoto setting from close distance shows how a palm frond channels rainwater down to its roots.

- Digital cameras sometimes offer the facility to crop the image after the shot has been taken. This may allow you to draw out detail, such as pattern, which was not obvious when the shot was originally framed.
- However, it is better to recrop your digital pictures on the computer. Standard software will allow you to experiment with a variety of different ways of reframing the original shot.

Repeating shapes The two pictures (above and right) demonstrate the importance of camera position on pattern. For the larger picture (above), I stood on the bonnet of my car to isolate the flock of geese.

The overhead view focuses attention on the repeating colour patterns provided by their orange beaks and black eyes; this is far less evident in the alternative shot (right).

Manmade pattern Strongly evident here (left) is the pattern created by linear perspective, with the parallel lines of plants seeming to converge at the other end of the field. This effect is strengthened by the broad front encompassed by a 28mm lens.

Bright colour and contrast

Colour contrast is most readily understood when you juxtapose the primary colours: red, blue and yellow. Another type of colour contrast occurs when you place a primary colour in close association with its complementary: blue with orange, red with green, and yellow with magenta, for example.

RIGHT, CONTRASTING colours can create a carnival-like atmosphere in photographs. There is a vitality, giving pictures a feeling of movement and gaiety, a spontaneity often lacking in images composed of more sombre colours.

Find as many examples of colour contrast as you can.

Good hunting grounds are often amusement arcades, market stalls and street murals, but don't overlook the possibilities inherent in rows of parked cars, houses, window displays and clothing. Often, a long telephoto lens will pull together in the one frame different hues that otherwise would not be seen together.

TECHNICAL TIPS

- Colours usually look their brightest when photographed with frontal lighting (with the sun behind you).
- To intensify colours, particularly of bright, polished surfaces, use a polarising filter.
 This will remove the reflections that water down the hues.
- With a digital camera it is possible to get warmer colours by deliberately using the wrong manual white balance setting.
 Using a cloudy setting, instead of sunny, say, will make your shots slightly redder in tone.

Come and buy Manufacturers use imagery and bright colours to attract children (right). This photogenic French slot machine attracted my attention, if not my money!

Contrasting primaries It was the contrasting red and blue (below), that caught my eye, but it was the cut-off legs that provided an intriguing focal point for the composition.

Project 6 The Essential Elements 6

Colour for impact

The manner in which colour is used in photography is a personal choice. Restrained use of colour may sometimes be desirable. However, there are times when bright colours can make an emphatic statement, draw attention to particular elements of a composition, or create an air of flamboyance and even extravagance.

N NATURE, WE FIND IT easy to accept all manner of colour combinations. Any colour of foliage can be combined with virtually any colour of flower, and we will probably not think the juxtaposition at all gaudy or unattractive.

However, with our clothes, wall coverings and furnishings, we all tend to have an instinct, derived from culturally defined notions of taste, as to what colours look good together. Most of us would probably agree, for example, that red and green don't sit happily

together, whereas red and yellow have a certain affinity with each other.

But what is of vital importance is the relative strength and proportion of these colours when they are seen together.

Interestingly, our perception of the strength of a colour has much to do with the colour of its surroundings. In general, a colour seems more intense when surrounded by a darker, contrasting colour; less intense when surrounded by a paler one. This is an important factor to remember in colour photography.

In this project it should be interesting as well as instructive if you use a model, as in the sequence of pictures below. Dress your subject in bright, contrasting colours and then position him or her in as many, widely varying coloured surroundings as you can find. Then compare the results.

Exercise in colour This sequence of shots of four different models in different settings shows the impact of colour. In the first shot (left). the red clothes leap forward. while the blue background tends to recede. In the second picture (right), the brightness of the yellow glasses attracts our attention, while the backdrop is chosen to tone with the model's skin. Sometimes, you do not want bright colours to dominate a shot. Using a plain, natural background. such as the swimming pool (below left), means that the bright colours of the costume work. Finally, by cropping in tight to exclude the background entirely (below right), and using subdued lighting, the colourful material does not detract from the portrait.

Contrasting primaries The vivid blue and red backgrounds of the needlework (above) contrast effectively with both the green of the grass and the black clothes.

Colour framing As well as framing the boy's face (right), the jacket colour is bright enough to stand out against the brilliant blue sea.

- With digital manipulation software, it is very easy to change the shade of a colour in the shot, or even change the hue entirely, to suit the composition.
- On the computer, you can therefore eliminate unwanted colour clashes or change the colour of an object so that it is more prominent in the shot.

A touch of colour

Colour does not have to dominate the frame in order to be effective. The degree of impact a small area of isolated colour has depends to a large extent on the hues surrounding it. For example, in the shot of Shakespeare's gravestone on the opposite page, where sombre tones dominate, the single red rose, small in the frame, demands the viewer's attention.

oLOURS LOOK MOST striking when placed against a muted background hue. This might be the natural property of the background itself, or due to the fact that it is positioned

in deep shade.

Changeable weather conditions will often provide the alert photographer with a wonderful opportunity for this type of colour usage. A sudden gap in heavy cloud, for example, may allow a narrow corridor of sunlight to illuminate a small area of the landscape below, contrasting brilliant colour against dark surroundings.

For this project, keep a lookout for good examples of small areas of commanding colour within large images. Having found a likely subject, work your way around it, checking in the camera viewfinder all the time to see how the effect you want can best be accentuated. Perhaps you will need to search a considerable distance to find the right angle of view in order to exclude extraneous colours or objects that would lessen impact. A zoom lens can also be of great help: use it as a cropping device, all the time refining and honing the composition.

TECHNICAL TIPS

- Red is the colour that tends to attract the most attention in photographs. Other vibrant shades, such as pink, orange and yellow, can also work well.
- You can make colours appear more saturated. With slide film, use half a stop less than your meter suggests.
- Digital image programs allow you to alter the saturation of different hues independently.

Colour contrast In this photograph (below), the eye is irresistibly drawn to the vibrant colour of the young man's pink headband, which contrasts well against his dark face and hair.

Colour within colour A small area of white around the windows within a larger area of red, all set against muted grey (above), makes this a composition of colour within colour.

Nature's paintbrush For this subject (above), I used the widest aperture available with the telephoto lens setting to diffuse the background and so force attention on the robin's breast.

Symbolic colour Resting sadly on the grave marker set in the church floor (below), this single red rose speaks volumes of love, warmth and remembrance.

Restrained colour usage

All things bright are not necessarily beautiful, a point well worth remembering when shooting in colour. In certain circumstances, a restrained, muted and harmonious palette of colours creates a more evocative mood. It is more appealing in nature than an ill-planned cacophony of dazzling hues.

OLOUR SATURATION is noticeably lessened in low-intensity or diffused light. When the sun is low in the sky, colours tend to merge and harmonise.

In mist, fog or rain, too, when everything is viewed through highly diffused light, colour range is softer and more restricted.

For this project, in addition to using appropriate weather conditions to produce quieter subject colours, you will need to take comparative pictures of the same subject in bright light and shadow. Looking at the results will allow you to see the changing effect this has on the colours within the scene.

TECHNICAL TIPS

- Fill-in flash can be used to adjust the colour range and saturation in a picture.
- Used in bright conditions, firing the flash in daylight can reduce contrast, helping to reduce the intensity of heavy shadows. However, the effective range is limited.
- In overcast conditions, using flash will boost the colours of nearby objects.

Deep shadow The extremely low light levels (right) meant shooting at 1/30 sec for this picture of feet under a table. Light reflecting from the surrounding wood has imparted a warm colour cast.

Sun and shade Whether you opt for bright sun and high contrast or the more subdued effects in shady conditions depends on the type of picture you want: there is no one correct way. In the first version (below left), direct sun has

brought all the colours alive but the shadows obscure much more of the facial detail. In the next version (below right), I placed the model in dappled shade; colours are subdued and harmonious, and expressions relaxed.

Sunlight and fill-in flash Using flash in daylight can frequently be a great way of improving the colours of subjects in the foreground of your picture. In overcast conditions, for instance, it will improve colour saturation.

In strong sunlight (below left), however, it is shadows that often ruin a portrait, obscuring colour and detail. The use of flash balances the illumination (below right) to provide a much more pleasing exposure.

Diffused colour

The extent to which colours are diffused, or saturated, is not just dependent on weather and lighting conditions. Colours can also be made weaker by other factors such as focusing and exposure. The less sharp an object is in the frame, and the more over-exposed it is, the softer the colours will appear.

OLOUR CAN ALSO appear diffused because of the surface characteristics of the subject. For example, a matt or textured surface will scatter light falling on it and so dilute the impact of the underlying colour. Conversely, a gloss surface will reflect light without materially affecting the subject's inherent colour.

Another important factor affecting the sharpness or

diffusion of colours is focus. Check this by looking at a nearby area of colour. Then, if you view the scene through your SLR viewfinder out of focus, you will see the colour begin to spread and merge with neighbouring colours. Set a small aperture on your lens, say f11-16: then, as you depress the SLR depth of field button, you will see on the viewing screen that all colour in out-of-focus areas

All-weather photography In sunlight, the colours here (above) would have jarred, but the flat, overcast light has produced harmony.

immediately becomes sharp.

As well as taking advantage of naturally occurring examples of diffused colour, photograph at least one pair of comparative pictures: the first with subject and background sharply focused; the next with the same background colour out of focus. Also take shots of brightly coloured subjects at different exposures, so that you can see the effect different settings have on the colour.

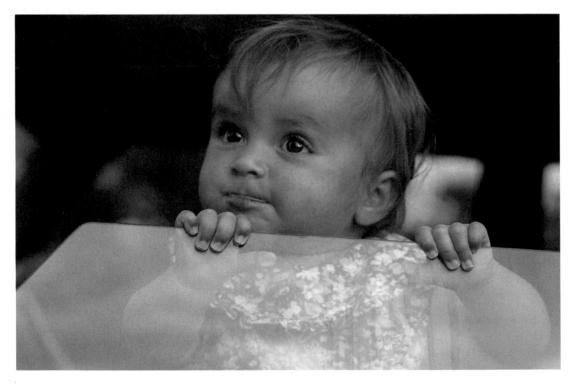

Reflections Shooting this baby sheltering in a car (left) results in a double exposure, as the window superimposes the reflection of the sky over part of the image. The colour of her dress is thus completely subdued.

Early morning light The low light of early morning (above) accounts for the subdued colouration. However, without the dusting of frost, the darker rope would have segmented the image more strongly.

Shadowless light Overcast conditions for this aerial shot (below) have produced an almost shadowless landscape composed entirely of distinctly different yet harmonious shades of green.

- In order to preview the effects that focus has on colour, it helps to be able to have a camera that allows you to preview the amount of depth of field that you have.
- Some SLRs have a depth of field preview that lets you see which elements are out of focus at a particular aperture.
- With digital cameras, the image on the LCD shows depth of field. In crucial cases, take the shot, then review the result, zooming into key areas to see if they are sharp.

Tone as a picture element

You are most likely to come across tone in the context of black-and-white photography, where it refers to the range and strengths of greys in an image between solid black and pure white. Tone, however, also applies to colour and its various hues, shades and tints. It can be used to great effect in your pictures.

HIS PROJECT AIMS TO show that tone is yet another layer of communication between vourself and the picture's audience. Just as texture, for example, tells the viewer how an object might feel if handled, so the selective use of tone communicates not only form but sets the mood or atmosphere for the composition. The secret to its use and effect is in the balance between light and dark within the frame.

In this project, you will need to produce a set of pictures that, because of their tonal content, achieve a wide range of different moods.

Images composed predominantly of dark tones, for example, can often be read as enclosed, sombre, threatening – even furtive and 'not really intended for your eyes'. These are known as 'low-key' images.

On the other hand, pictures full of light tones can be regarded as candid, spacious, open and relaxed, and are known as 'high-key' pictures. High-key and low-key pictures can be taken both in the studio (below) or outdoors with natural lighting (right).

High and low key With tone, as with colour, you do not necessarily want a 'perfect' exposure.

Over-exposure in transparencies (below left) can further lighten and brighten a high-key shot, while under-exposure (below right) can cause shadows to become more

dense for a low-key effect. You will notice that where the model's face is hidden in shadow, you start to become more concerned about her situation than her mere physical appearance. In contrast, the high-key image concentrates your attention on the face.

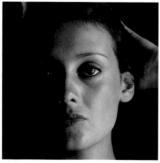

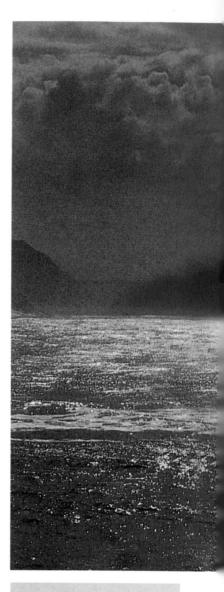

- Tone needs are interpreted by the camera, using factors such as exposure, lighting direction, surface qualities of the subject and the contrastrecording abilities of your film.
- With black and white, colour is reduced to shades of grey, hence your main ally is the juxtaposition of tone. This can be manipulated with filters, strengthening or subduing the effect and making highkey/low-key images.
- In the digital darkroom, the tonal range of the whole image, or just parts of it, can be adjusted.

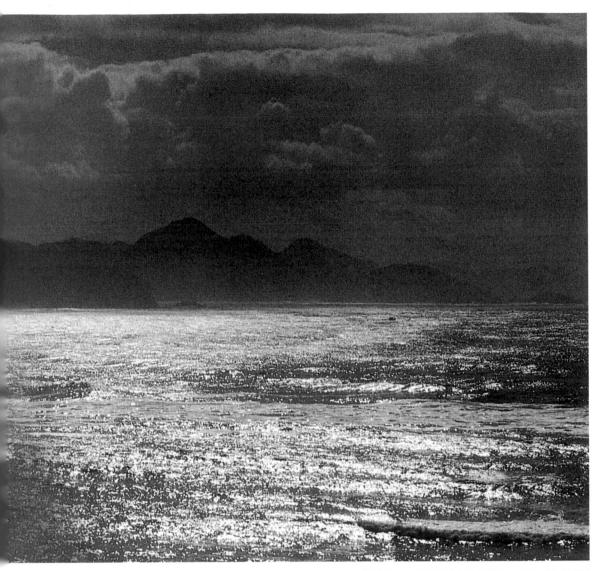

Tonal contrast In some respects, this was a lucky shot (above), taken with an automatic compact camera. For an instant only, the sun broke through the heavy clouds, producing these intense highlights on the ocean waves. Had I had more time, I might have zoomed in further on the foreground, producing a seemingly bright, sunny picture. Had I concentrated on the land and clouds, it could almost have been taken at night. It is the tonal contrast that has given the scene power and drama.

Muted tone Early-morning mist over the Egyptian desert (right) has softened and subdued further an already limited range of tones. The feeling of depth and distance is heightened by the gradual lightening of tone towards the pyramids in the distance. This effect, known as aerial perspective, is created by dust and mist diffusing the light as it heads to the camera.

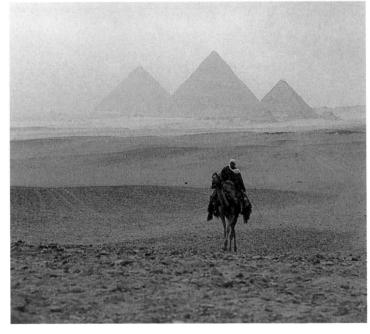

Black and white or colour

Colour photography is undoubtedly the most popular medium, although there is still an extensive range of black-and-white films being produced. Unfortunately, most people when buying a camera for the first time automatically choose colour film and therefore never explore the enormous creative potential offered by the black-and-white medium.

Colour version Seen in colour, this Yorkshire farmhouse (below) has an inviting quality; the surrounding countryside, though rugged, seems open and invites thorough exploration.

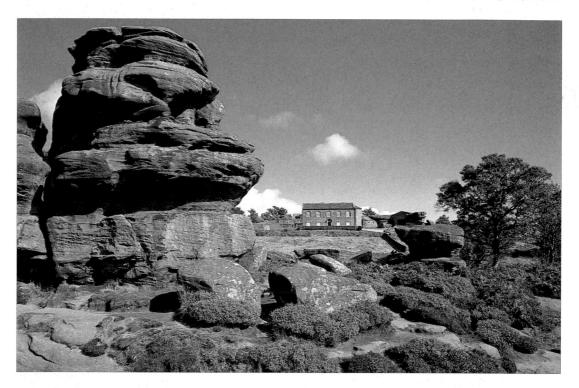

OLOUR ADDS REALISM to a photograph. We live in a world of colour; our thoughts are in colour; and we use colour symbolism to denote moods and emotions. So why does black-and-white photography, either shot on film or created with digital means, still have so many enthusiasts?

The easy answer, ironically, is that it removes that very quality of realism that is so

often thought desirable in photography. With colour gone, the picture is a mere interpretation of the scene.

Photography is all an abstraction; it is a two-dimensional illusion of a three-dimensional world. Shooting in black and white takes this process a stage further, allowing the photographer to interpret rather than record.

For this project, you will require a roll of colour and a

roll of black-and-white film, or a digital camera that offers a black-and-white shooting mode. If using film, you will ideally need two cameras.

Shoot colour and mono pictures of the same scene. In the colour shots, take care to balance the colours; and with the mono versions, try to increase the drama of the picture using the shadows and highlights to create maximum tonal contrast.

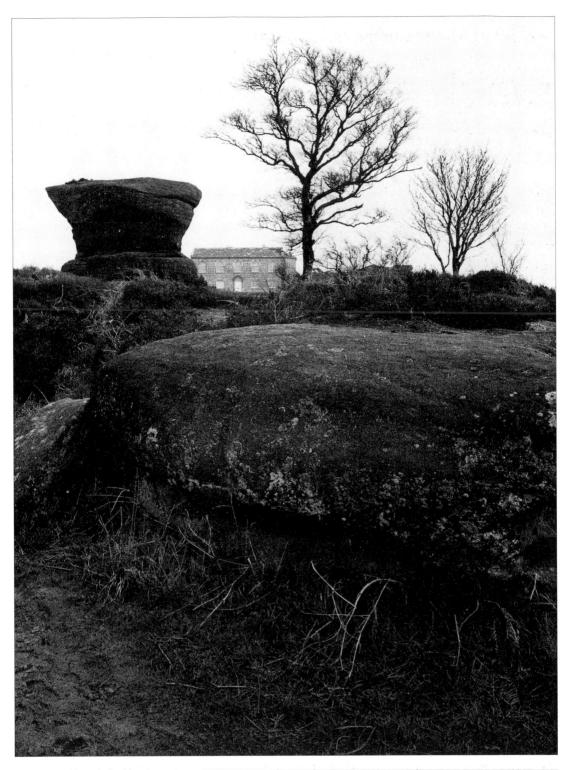

Black-and-white version Here is the same farmhouse (above), this time in winter and from a different angle. The scene has now taken on a sense of drama, almost of malevolence. Also note how tonal contrasts, such as the dead foreground stalks against the dark tone of the grass, assume far more importance.

- Black-and-white photography can be hard to get used to, as you need to visualise what the scene will look like devoid of colour.
- Squinting at the scene can make the tonal balance more visible, or special filters can be used to help. With many digital cameras, you can preview the image using their black-and-white mode.

The tonal range

In black-and-white photography, the term tonal range refers to the variety of greys between pure white and black. Many large photographic stores stock a specially printed grey scale, which shows the complete range of tones. Each tone on this scale represents one f stop of exposure as you go from black to white.

UR PERCEPTION of tonal value, and film's response to it, is determined not only by the intensity of light, but also by its direction and by the surface characteristics of the object it illuminates: in other words, how much light the surface absorbs or reflects.

If you are inexperienced

with black and white, this project is a very important teaching tool.

Using a high-contrast subject, you should make three exposures: one using a meter reading taken from the highlights; one using a shadow reading; and, finally, an averaged reading of the two previous results.

TECHNICAL TIPS

- In order to take highlight and shadow readings successfully, you need to know which type of metering system your camera has. For accurate readings from a particular section of the scene, a spot meter (or partial meter) is ideal.
- The subtle tonal differences between your project pictures will be seen much more distinctly if you use a slow, fine-grain film.
 Fast film provides highercontrast negatives.
- Tonal range can also be controlled digitally.

Full-tone Although predominantly dark, the image of a milk pail (right) contains a full range of well-separated tonal values between black and white.

Low-key In this case, the picture (below) consists mainly of tones between mid-grey and black, giving an overall effect that is much darker. In such scenes, our attention is automatically drawn to the lightest parts of the picture: in this case, the whites of the man's eyes.

High-key In this photograph (above), tones registered range from white to mid-grey. This has created an image containing mostly light tones and is, therefore, generally referred to as high-key. This is achieved by taking an exposure reading from the shadows.

Using light tones

Just as colour and its intensity can determine mood and atmosphere, so, too, can the choice of tones used in a black-and-white photograph. By restricting the tonal range so that the mid-grey and lighter tones dominate the frame, it is possible to imply brightness, warmth, openness, candour and space.

N THIS PROJECT, IT WILL be useful to enlist the assistance of a person to act as your model. The objective is to produce a set of pictures with a restricted, high-key tonal range. Persuade your model to dress in white or pale colours. If they have dark hair, cover it with a white scarf or

light-coloured hat. Lighting should be bright, diffused daylight or diffused studio lighting. Take your first exposure as recommended by your light meter; then another, one stop over-exposed; and then a third exposure two full stops over-exposed. Compare the results.

Back lighting Although my subject, the artist Marc Chagall (above), was wearing dark clothes, I took a shadow reading so the result was high-key.

Reflected light Strong sunlight reflecting back from the wooden boards (below) gave soft, detail-revealing illumination to this group portrait.

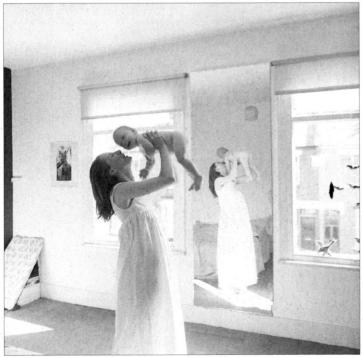

Reflective surfaces Surrounded by light, reflective surfaces, this boy's first haircut (above) was certainly a high-key affair. The white towel played a crucial role in restricting the tonal range.

Over-exposure One-stop over-exposure (left) ensured that all tones were high-key.

- Although fully automatic cameras may not allow you to override exposure, many have a backlight button which will add a stop more exposure.
- Instead of using the exposure compensation dial, you can also use the ISO dial on a film camera to override the meter. To overexpose an ISO 100 film by one stop, you would set the film speed to ISO 50; or to ISO 25 to over-expose the same film by two full stops.

Using dark tones

As demonstrated in the previous project, restricting the tonal range of a photograph tends to generate a particular mood. By allowing mid-grey to black tones to predominate, it is possible to impart a feeling of foreboding, confinement of space, mystery and menace to your photographs.

should be becoming apparent that there is no single 'correct' exposure for any particular scene and lighting conditions. An image is too light or too dark only if its appearance does not conform with the photographer's interpretation of the way it should look.

This exercise is to produce a set of photographs with a restricted, low-key tonal range.

As before with the high-key project, you will need a model, but this time dressed in dark, sombre-coloured clothing.

Illumination should be muted but directional (not diffused), using daylight or studio light. Take the first shot using the settings recommended by your meter; the second, a stop under-exposed. When printing, use high-contrast paper and print darkly to make the picture appear more dramatic.

Dramatic lighting Here the aim was to show form and modelling (left). The intention was to emphasise drama within the form using directional lighting to create plenty of contrast. The technique produces a very dark cavelike effect in the cup of the hand, while the shadows make almost gully-like indentations in the surface of the skin.

Age versus youth A close-up of an ancient, gnarled root and trunk (above) has isolated a largely low-key subject. Looking beyond these, however, the saplings seen against a pale sky seem to be signalling their youth by being presented in a comparatively high-key way. This juxtaposition adds another dimension to the picture.

- In the conventional darkroom, soft grades of printing paper are capable of reproducing more tones of grey than hard grades, thus helping to manipulate the mood of the image.
- For full control of tonal range with a digital camera, take the shots in colour. Then use the colour mixer utility found in some editing packages to tweak how they are transformed into black and white.

Perspective in photographs

Perspective is the key indicator of depth for the photograph as a whole. In essence, perspective helps give the visual impression that you are looking at a three-dimensional scene. The five main types of perspective used in photography are linear perspective, aerial perspective, overlapping forms, diminishing scale and differential focus.

Differential focus For this effect (above), I used the widest aperture available and closest focusing distance possible with the lens. This has projected the sharp bloom forwards while pushing the others back.

of five photographs, each one making strong use of a different type of perspective, is required.

In aerial perspective you make use of the fact that colours and tones appear lighter as they recede. With overlapping forms, objects that are closer to the camera partially obscure ones that are farther away. With diminishing scale, things appear smaller as they recede. Linear perspective is most evident when you see lines you know to be parallel (railroad tracks, for example) appear to converge or even meet in the distance. For differential focus, depth of field is manipulated so that objects in the distance are less sharp than the subject.

Diminishing scale The largest element in this picture (above right) is the foreground head. This leads us back to the seated monks, and then to the two figures in the background. The size of the faces gets smaller the farther they are from the camera, even though we know that in reality they are approximately the same size.

Linear perspective Although this picture has many varied patterns (right), it is the linear perspective created by the central path that dominates. The effect has been heightened by using a wide-angle, which makes the parallel lines seem to converge more steeply.

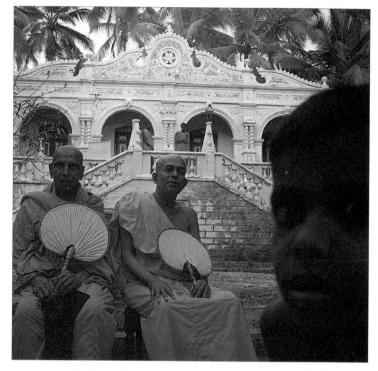

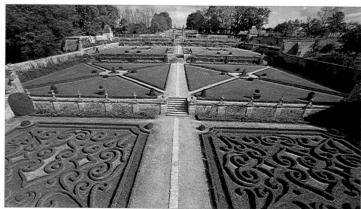

Aerial perspective The progressively lightening tones in this photograph of the Swiss Alps (above) subconsciously informs us that each successive peak is farther away than the last.

Overlapping forms Here the overlapping forms of the tombstones and church doorway (left) tell us that the picture has depth. Some differential focus is also apparent. You will find that two or more forms of perspective are frequently found in most pictures.

- Linear perspective is completely dependent on the viewing position. But wideangle lenses, because they are used closer to the foreground of the picture than telephotos, exaggerate the feeling of depth.
- To maximise the feeling of depth with a wide-angle, ensure you place a key compositional element as close to the lens as possible.

Project 16 The Essential Elements 16

Fore, middle and background

This is the first of four projects on photographic composition and, as such, deals with the most basic compositional element, that of foreground, middle ground and background. These image planes are, like perspective, powerful indicators of depth and distance in the two-dimensional photograph.

omposition is all about how you arrange different elements within the frame to get a picture. The first assignment dealing with this important subject involves producing at least three photographs that stress, individually, the foreground, middle ground or background of your shots.

Think of the three image planes as areas in which you

can place subject elements to create a deliberate effect or to highlight a particular part of the frame. It is usually best to have only one dominant element in a picture, with all others having subordinate, yet supportive, parts to play. In this way, one image plane is immediately assigned a dominant compositional role.

The first thing a picture needs to do is to attract the

TECHNICAL TIPS

- All manner of compositional devices are at your disposal when defining image planes, and none is dependent on equipment.
- First, there is subject placement: on which plane do you place the main subject?
- Next, you can use focus and depth of field to draw attention to a particular plane.
- Colour and lighting can also be used to make a plane appear less, or more, dominant in the composition.

viewer's eye. Then, if as a whole the subject matter warrants it, the eye is led around the image planes, taking in the detail. Therefore, placement of the dominant feature is vital.

Background Establishing a foreground gives a sense of depth, but the poles in no way distract from the church in the background (below). The middle-ground gondola adds atmosphere without competing for attention.

Foreground Here, the girl is obviously the subject (above), but looking past her we can still see the supporting players in the middle and background. An aperture of f4 on a 50mm lens ensured that the zone of sharp focus was limited to the foreground.

Near middle ground The diagonal lines formed by the car (above), plus that of the wall, firmly fix attention on the dog and also seem to thrust it deeper into the frame. Colour harmony then takes the eye to the bowls players farther back.

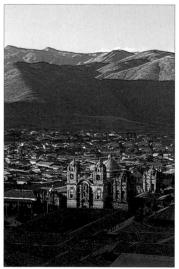

Middle ground Sandwiched between two dark image planes, this cathedral and township in Peru (above) seem almost plucked out of the frame by the intensity of the light. The well-lit background hills complement, rather than compete with, the subject matter.

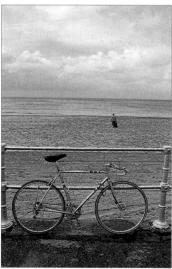

Horizontal slices The image planes in this shot (above) are a series of horizontal slices. Foreground, middle ground and background are well defined, but since they all contain only simple subject elements there is still some sense of unity.

Using frames in photographs

Another compositional element that plays an important role is framing. In fact, most of us instinctively use frames of one sort or another when composing pictures. But frames can also be more positive than this, and more subtle, and can be of immense help in placing greater emphasis on the main subject.

OR THIS PROJECT, YOU will be expected to use your imagination and, in separate photographs, show the use of as many different framing devices as you can. These frames-within-theframe could be something apart from the main subject, such as a branch of a tree or an archway. Equally, a frame could be a hat or coat collar used to encircle a face.

In most cases, you will want the frame to complement and support your subject, rather than distract from or conflict with it. Think of ways in which you can use lighting, exposure and colour to ensure that it is the subject itself that is dominant, and not the frame.

TECHNICAL TIPS

- · A frame can be a good way of creating depth in a landscape - a break in the trees creating a foreground for the distant scene beyond.
- · A doorway can be used to hide an unwanted foreground, such as traffic.
- · A frame can be simply a way of breaking the monotony that can be created by the fixed shape of a rectangular image.

Frame as subject In this composition (below), the frame itself has become the by the leg being sharp, and the car in the distance being out of focus.

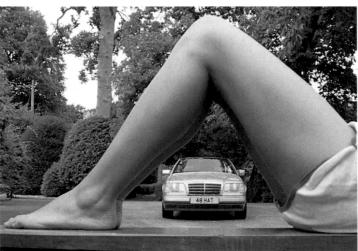

Windows Doorways and windows make simple framing devices. Here, the sash window is also the light source (below), creating a silhouette that emphasises the shape of the head.

Frames for depth The effect of this framing device (above) is to draw you deep into the photograph. Minor detail gives interest without overly distracting from the main subject.

Abstract patterns The effect of using the lines of the window as a way of breaking up the foreground (below left) has created an abstract composition that suits the architectural subject.

Window This is a conventional framing device (below right), but one intended by the designer of this garden in Kashmir. Seats are provided so that the garden can be viewed as a living picture.

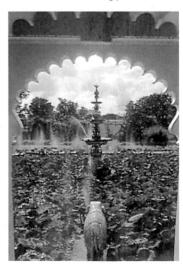

Using unusual viewpoints

Without even realising it, the vast majority of photographers take nearly all their pictures from much the same viewpoint: that is, from a normal standing position. With only a little thought about the height at which the camera is used, you will often be able to give a new and arresting insight into very familiar situations.

TECHNICAL TIPS

- Get in the habit of exploring subjects from as many different angles as possible. Find hills, chairs, balconies, and so on, that provide an elevated viewpoint. This may show the subject in an unusual way.
- Similarly, don't be afraid of getting down on your knees or even stretching out prone on the floor in search of an interesting angle.
- When buying a tripod, pay close attention to the minimum and maximum height at which the camera platform can be set.

OR THIS THIRD composition project, you need to produce a set of pictures, each one taken from a viewpoint that either introduces an unusual association with, or that challenges our normal perceptions of, the subject. Looking from above gives a plan view, for instance, and can make things look smaller and less significant than they really are. Looking up at a subject, particularly from a close distance, makes a subject appear more dominant.

Illusion Here, the backdrop creates the picture (right), making you think that the woman has appeared from the canvas.

Part view You can produce an unusual viewpoint (below) by what you leave out rather than by what you include.

Shooting from below These two pictures (above and left) illustrate the effects of using low viewpoint. In the shot of the interior (left), the wide-angle lens has pulled in subject elements that might otherwise be missed. In the backlit portrait (above), the low camera angle helps to make the masked model look taller and more threatening.

Centre stage By way of contrast, this seemingly straight viewpoint (right) says something obliquely about the subject, the painter Graham Sutherland, whose own work is so characterised by human figures in isolation.

Emphasising elements

One of the ways of emphasising specific areas of your composition is to position significant subject elements using the 'rule of thirds'. If you divide your frame vertically and horizontally into thirds, then anything positioned on one of these lines, and particularly where the lines intersect, will have additional impact.

NSTINCTIVELY, MANY OF US follow the rule of thirds when composing photographs. We may naturally ensure that the horizon is one-third from the top or bottom of the frame instead of dead centre. Or we might place a tree or building so that it is one-third into the shot from the left or right when acting as a frame for a subject.

The perverse thing about rules, however, is that you can also make a positive statement

by deliberately breaking them.

For this project, find an open area with a broad sweep of largely uncluttered horizon. First, take a picture with the horizon centred in the frame; then another with it one-third from the bottom (emphasising the sky); and, finally, with the horizon one-third from the top of the frame (emphasising the ground). Now, be bold and take a shot that is nearly all sky, or nearly all land. Comparison of

TECHNICAL TIPS

- There is no need to be slavish over the rule of thirds. It is easier just to ensure that key components within the frame are arranged so that they are off-centre. This approach tends to create a dynamic composition.
- There are occasions when it is worthwhile placing the subject dead centre in the composition. This can help to stress the symmetry of the scene, for instance; or it can be used to help give a sense of peace and harmony (which can suit some rural scenes).

the finished images will give a good idea of the different atmospheres that can be created by the judicious placement of the important subject elements. Which will work best will depend on the subject matter: a picturesque sunset may suit an approach with more sky; but one with grey clouds may not.

Central horizon I saw the scene (below) as an abstract arrangement of shape and colour, an impression reinforced by the central horizon.

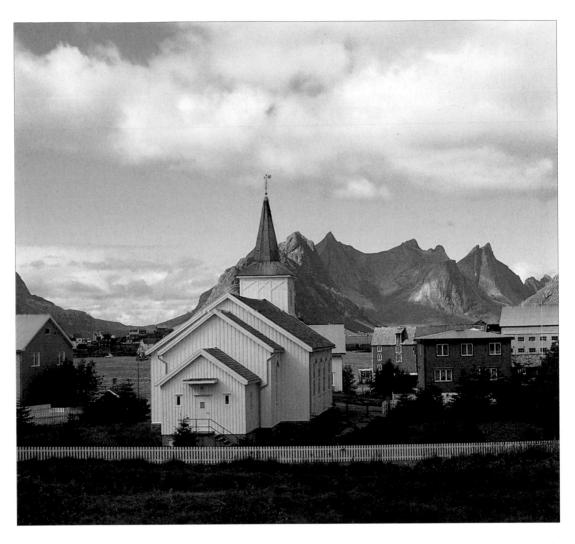

Intersection of thirds The cannon (below) is strategically placed at an intersection of imaginary vertical and horizontal lines that break the frame into a 3x3 grid. Notice how this composition is dominated by circles.

Shape as emphasis In this Norwegian scene (above), there is a rhythm created by the church gables and distant peaks. The single eyecatching splash of red is one-third into the frame, from both the right-hand side and the base.

Central figure This is an example (below) of placing an important feature in a more central position so as to foster a slightly unrealistic air. The surroundings give the appearance of theatrical props.

People

Of all the areas of photographic interest, taking pictures of people must rate as one of the most popular. Projects in this chapter build on the techniques learnt in the previous one, and are applied in practical situations, such as: using natural light and artificial light with single figures and groups; the use of props; photographing children; and street portraits. Throughout this chapter, the emphasis is on learning to interact with the subject in order to record something more than a mere physical likeness.

A painterly light A vital component of portrait photography is lighting quality. Here, parts of the image appear bright only in contrast with the poorly lit stairway. More intense illumination would have pushed contrast up and caused the subject, the Surrealist painter Eileen Agar, to be uncomfortable and upset the balance of composition.

Portraits in natural light

Portraits demand careful lighting, and daylight is often the easiest and most appealing light source to work with. The pioneering 19th-century portrait photographers depended almost exclusively on daylight in their studios: the best produced powerful studies that are still considered hauntingly beautiful today.

LTHOUGH PERHAPS NOT immediately obvious, there is more than one type of natural daylight. Sunlight from a clear midday sky entering a room from a small window, for example, acts as a spotlight, brightly illuminating one side of your subject. Conversely, indirect light entering through a large window (or a small window diffused with tracing paper) gives a more gentle effect. There will still be light and shade on your model, but contrast will be less extreme.

This project is designed primarily to allow you to discover the different lighting effects achievable using natural sunlight.

You will need to take a number of shots in different qualities of light: sunlight diffused by clouds (or through diffusing material over windows); direct sunlight; and direct sunlight bounced off reflectors made of various materials (such as white sheets and mirrors).

To gain an understanding of how different lighting suits different people, practise on several models – old and young, male and female. Use a variety of poses, in both hard and soft lighting, to see which approach works best.

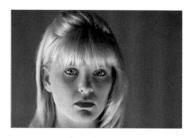

Full face For this portrait (above), I positioned the model in direct light and then used a reflector under her face to provide a little uplighting.

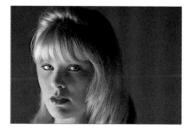

Three-quarter By simply turning the girl's face to give a three-quarter view (above), form and modelling are immediately made to appear stronger.

Profile A variation of pose that can be used on any subject to show the shape of the head and facial features (above). Experiment with various lighting and viewpoints to get the liveliest pictures.

- The type of reflector used makes a vast difference to the quality of the light that bounces off it.
- A reflector made of matt white cardboard gives a soft, diffused effect, while one made of kitchen foil gives a much crisper, brighter light. A mirror can be used to provide a spotlight effect.
- Shop-bought reflectors come in a number of different finishes (and sizes). They are generally circular, and can be folded up so that they can be carried easily on location.

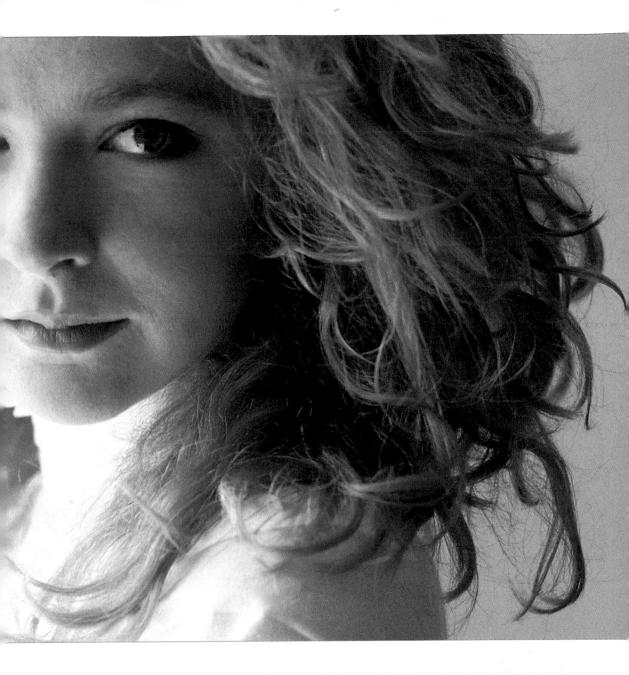

Direct and diffused light For the first shot (below left), I placed the tripod-mounted camera between the model and the window. To avoid blocking the light with my body, I fired the shutter while standing off to one side using a long cable release. In the next shot (below right), I moved the model back

farther from the window and used reflectors either side of her face for a flatter tonal effect. In the large version (above), I moved in close to crop out most of the background. She is now positioned to one side of the window with a reflector placed to the other side of her face to soften the shadows.

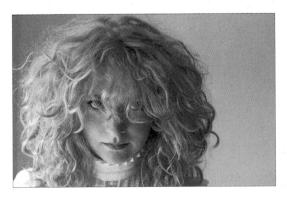

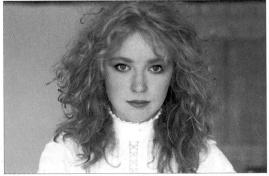

The figure in available light

Many of us buy a camera primarily to take pictures of people, in order to have a record of friends and family over the years. You should try and ensure that the vast majority are taken with available light. This is defined as either natural daylight or light normally available indoors, including ordinary domestic tungsten lighting.

HE COMPOSITION OF your picture is partly determined by the colour, shape and form of your subject, which are affected by the direction and quality of your lighting. But giving life to the picture very much depends on the mood and expression brought out by the interaction between subject and photographer.

There are two main ways in which to approach a portrait. You either show the person in isolation or within their surroundings.

First, by using a close viewpoint, a telephoto lens or a very restricted depth of field, you can focus attention on the figure and exclude extraneous parts of the environment. Interest will then be exclusively concentrated on your subject.

The second approach is to show a single figure in an environment of some sort. You can achieve this by adopting a more distant viewpoint, using a wide-angle lens or selecting an aperture that gives an extensive depth of field. However, you must ensure that elements that appear in the foreground or background work in a positive way, giving the photograph added impact. The extra information should either help the picture compositionally, or it may be included to show something of the person's way of life - giving a peek at their home, say, or their workplace.

TECHNICAL TIPS

- The ideal focal length for portraits shown in isolation is around 80-120mm (for 35mm format). This lets you stay close to the subject, and gives a slight flattening of the facial features that can be flattering.
- For showing a person within his or her surroundings a wide-angle lens (a 28mm or 35mm is fine) is usually used. To avoid problems with distorted features, keep the person at the centre of the frame, and not too close to the camera.
- Longer lenses (200mm or 300mm) are ideal for taking candid pictures.

Reflections A sheet of mirrored plastic creates an interesting background that reflects the main subject. The orange colour comes from using daylight film with household bulb lighting.

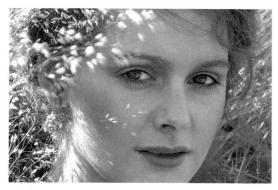

Isolated figure When I selected the setting for this model (above), I was motivated by trying to avoid using strong, direct sunlight. In order to capture her soft skin texture, I needed to shoot in diffuse light. I achieved this by positioning her so that most of her face was in a patch of shadow, and cropped tightly to avoid including too many bright highlights.

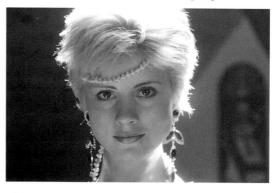

Available light indoors Here, I was shooting indoors in a large room, and the main source of illumination was from a skylight in the roof. I therefore positioned the model so that this became a backlight, rimlighting her blonde hair, and then using a white reflector to bounce some of the sunlight into the features of her face.

Facial expression In this picture of a Romanian shepherd (above), facial expression tells us much of his character: good-humoured, open and expressive. Even while I was taking his picture, he told me numerous funny stories through an interpreter about his life and work.

Perspective It is linear perspective (right) created by the bench seat and back that takes the eye to the elderly farm worker. Only after taking in her form do we start to explore the rest of the setting, which adds to our mental picture of a rural scene.

Composing group shots

Everybody who uses a camera has at some time tried to compose a group photograph: a family gathering, a group of friends, the local football team, and so on. Often, the results are little more than record shots, with personnel arranged simply to allow everybody to fit within the confines of the camera's viewfinder.

OU WILL NEED THE cooperation of a few willing subjects for an hour or so. This should not be too difficult. Many local groups (drama societies, for example) are always on the look-out for useful publicity stills.

The object is to take three or four pictures of this group in a variety of poses, each one displaying how composition alters their apparent relationship to each other and to their surroundings. The idea is to get right away from the usual line-up of bodies stretching across the frame.

You will find it easier to create an impact with your pictures if it is immediately apparent when somebody looks at them why you took the shots in the first place. To achieve this, your pictures will need to have a dominant theme.

Once you have this theme, you should be able to find a logic in the different arrangements of personnel for your project pictures. You'll find that the most powerful shots are often those in which some people appear much larger in the frame than others.

Interest through depth Using lines of people going away from the camera (right) has introduced a feeling of depth to the arrangement, and also strongly implies status.

First steps To show an unthinking approach (above right), I asked these people to form a line across the grand hall. By contrast (right), the varied heights and positions make you more inclined to study each figure.

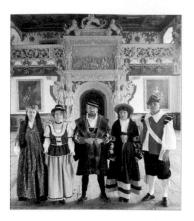

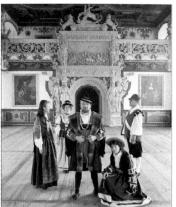

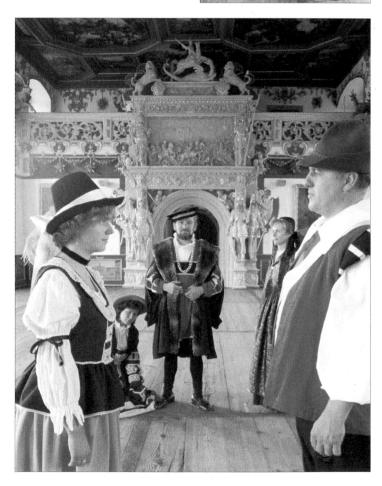

Tighter cropping This version (right) requires a considerable amount of patience and control, carefully arranging people so that each can be clearly seen. Increasing the apparent shooting height also focuses attention very firmly on the decorative walls.

The group in context By changing to a wide-angle lens (below), pulling farther back, and placing the group off to one side, emphasis has shifted. This makes the hall as important a part of the composition as the people.

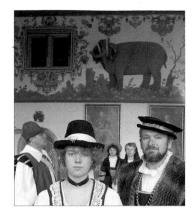

TECHNICAL TIPS

- Shoot lots of pictures. The more people in the shot, the more chance that one of them will have their eyes closed.
- You need to stay in firm control of what the people in the portrait are doing. Give clear instructions, and speak (or shout) so everyone can hear what you are saying clearly.

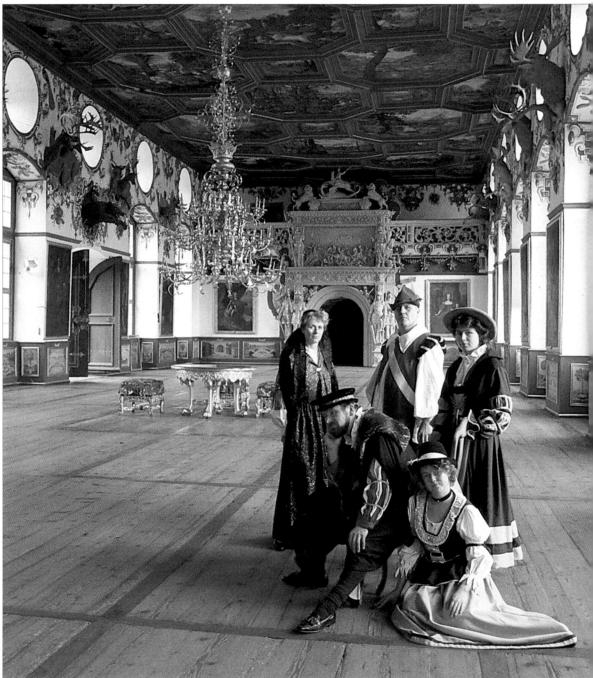

Using screens and reflectors

For the most part, photography is concerned with representing reality, so when you present images of objects treated in an obviously unreal way, it is possible to trigger all manner of reactions. These reactions are often heightened when the image is only subtly different from the conventional treatment.

HIS PROJECT IS concerned with using devices, such as screens, reflectors and mirrors, to produce interpretations of subjects, rather than simple representations of their physical appearance.

Because we associate so strongly with images of people, and have such fixed ideas of the way people should appear, images will have additional impact if you use people as your foil in these photographs.

Mirrored surfaces

It is worth bearing in mind where the lens is focused when taking pictures of reflections. The reflection of somebody in a mirror is, in fact, twice the subject-to-mirror distance from the subject: if your subject is 1m (3ft) from the mirror, then the reflection is 2m (6ft) from the subject. So, focusing on the mirror's surface will put the reflection out of focus unless your depth of field is sufficient.

Autofocus can present problems here: passive systems have a tendency to focus on marks on the surface of the glass, and infrared signals will bounce off the mirror. Use manual focus if you see there is a problem. Mirror images In these two pictures (top right and above right), you can see two treatments of mirror images. In the first, the reflected image looks like a painting. By positioning the girl off-centre in the second shot, I deliberately destroyed that illusion and also gave more information about the setting.

Reflections The etched glass reflections (right) have worked very well, making it hard to tell without careful scrutiny what is shadow and what is etching.

Screens By shooting through the veil of a hat (below), a feeling of depth is added to the scene. The face becomes partly obscured, forcing the viewer to peer hard to see the person beyond the patterned screen.

Watery illusion Reflections from the rippled water's surface cast dappled light over the whole frame, and across the girl's body (above).

Surreal imagery The mirror-topped table (below) reflecting an image of a seemingly disembodied head gives a disturbing, surreal quality to the picture.

Double profile In this portrait of the sculptor Ralph Brown (below right), his reflection makes a double profile. This echoes the three-dimensional medium in which he works.

- Although they have their uses, mirrors (and other highly reflective surfaces) can create a number of different problems.
- It is normally impossible to shoot a mirror straight on without the reflection of you and your camera appearing in the shot. A solution is a shift lens. The camera is placed to the side of the mirror, and the lens' coverage is shifted across to give a straight-on view.
- Flash on reflective surfaces don't mix, as the burst of light creates an intense, unsightly highlight on the shiny surface.
- Polarisers can remove or reduce reflections from glass and other surfaces, but they can't filter out reflections from a silvered mirror.

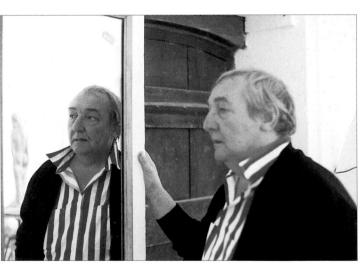

Position and associations

One aim of creative portraiture is always to attempt to go beyond simple physical likeness. We can learn much about character from facial expressions, as you will see in the next project. However, much can also be implied, real or otherwise, about relationships and status from how figures are positioned in the frame.

DVICE IS OFTEN GIVEN to photographers along the lines that a composition should have only one dominant subject or theme, and that giving too much information will distract the eye and diminish the picture's impact. However, it is also true that objects and other people included in the frame can tell the viewer a lot simply by association. The viewer sees links between different elements just by what is included. The aim of this

project is to produce a series of shots in which composition draws an implied relationship between people or between people and objects.

The elements that you can make use of to strengthen association include line, shape, form, perspective, colour or tone, and framing.

Bear in mind that physical proximity, a camera angle that produces a visual alignment of people or objects, or similarity of expression can all imply a relationship.

Framing and colour By using the boy as a half frame, creating a lefthand border to the picture (right), all the other figures appear 'shepherded' to one side of him. This seems to imply a family relationship, despite the fact that this was a communal pool shared by a number of villas. Colour also unites the composition: the blue of the pool water is echoed in the padded chairs, the man's costume, towels, umbrella and the summer sky.

TECHNICAL TIPS

- When you have two figures in the frame you must be particularly careful when using autofocus. Most AF systems assume the subject is in the centre of the frame, but on this occasion this might not be the case.
- Use the focus lock so that the right part of the shot is sharp, or use manual focusing. Some autofocus SLRs can target offcentre subjects, but check visually that they get it right.

Person and object In this hotel in Jaipur, India (above), there is an implied relationship between the waiter and the figure in the mural, created by the similarity of their appearance. The effect is slightly surreal.

Colour harmony These two Peruvian figures (above) are strongly linked by colour. The eye travels from the smaller figure diagonally across to the taller figure. It helps that both are looking in the same direction.

Viewpoint The alignment of these two figures (right) and their apparent isolation, created as a result of careful camera viewpoint, makes it seem reasonable that some sort of relationship exists between them.

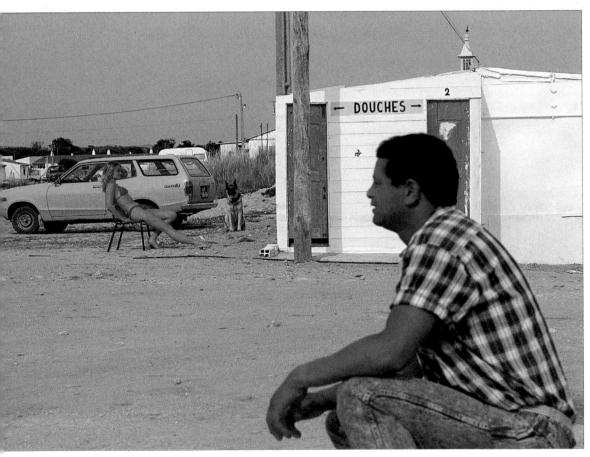

Character and expression

One of the hardest jobs of the portrait photographer is to capture character and expression on film. Many people, unless they are professional models, tend to freeze when confronted by the camera, so a vital part of your job is to make them relax and draw out those qualities that bring life and vitality to a portrait.

OR THIS PROJECT, YOU will have to find three different subjects. Your aim is to take portrait photographs of each that tell the viewer something of their personalities through the expressions you have captured.

Your subjects here could be friends or members of your family. However, there is nothing to stop you being a bit more adventurous and asking somebody you do not know well to pose for you.

Nevertheless, for this particular project it is important that these are properly posed shots and not simply candid portraits that are taken without the subjects' knowledge.

Although these must be posed pictures, you do not need a formal studio setting. From my own experience, people unused to the limelight are often far more relaxed having their picture taken away from a studio where everything can appear

Forceful personality J. B. Priestley (above) was a very forceful subject. In my view, the shot captures his character perfectly, with a pipe clenched firmly in his mouth.

rather strange and formidable.

Another tip you might find useful is to talk to your subjects constantly, not necessarily about the photographic session but about the things they enjoy doing. Once you have them talking freely and starting to enjoy themselves, you are half way there. And, if you are lucky, your subjects might turn out to be natural performers, actually relishing their time under the scrutiny of the camera lens.

In the workplace You can often say something extra about your subjects by posing them where they work. This was certainly the case with the sculptors Eduardo Paolozzi (below) and Elizabeth Frink

(below right). Both these people were far more relaxed and natural when posed 'at home' in their own studios. Each shot was taken in natural window light using a 90mm short-telephoto lens.

Changeable moods For my session with the writer William Golding (above), I needed to be alert. His moods could swing in an instant from extremely serious to uproariously funny. To allow the use of fast shutter speeds in natural daylight so that I could support the camera by hand, I used ISO 200 film.

Thoughtful pose This is another example of the benefits of photographing somebody in his own workplace (left). Here, the artist David Hockney was thoughtfully examining one of his own works and, despite my frontal position, was only partially aware of my presence.

TECHNICAL TIPS

- When framing up head-andshoulder shots with the sitter looking towards the side of the frame, it is best to place them off-centre so there is more space in front of them than behind them. This convention is known as 'looking space'. Also, try to leave some room above the top of the head.
- Try to frame the sitter's body so that the bottom of the frame doesn't cut through one of the joints such as elbows or knees. Otherwise, the shot seems to end too abruptly.

Informal street portraits

Unposed street portraits are not necessarily candid, since the subject might well be aware of the camera's presence. The difference with this type of portraiture is that the subject is not directed by the photographer. Rather, you must be alert to likely faces and situations, frame up quickly and then shoot.

aking revealing studies of people in and around the streets has as much to do with your own personality as it does with that of your prospective subjects. The more relaxed and outgoing you are, the more likely you are to receive a positive response.

However, it is important to bear in mind that reactions to the camera are often culturally determined. These may range from indifference or mild embarrassment in the West to strong religious or moral objections in other parts of the globe. It will be in your own best interests to do a little research before starting this project, unless of course you are planning to work locally.

To fulfil this project, produce at least four studies of different people. The pictures should be fairly close-up, trying to capture their facial expressions and characteristics rather than showing the surroundings.

Because you will be working

TECHNICAL TIPS

- Digital camera users may make new friends, and create more willing models, if they show subjects the images they have shot of them. The LCD screen is a great way of breaking down barriers.
- In poorer parts of the world, people might expect a small payment if they are photographed. Ensure you know whether this is normal practice, as in other regions people may be offended.
- Email means that copies of digital images can be sent to the sitter at little or no expense to yourself.

quickly, it is best to pre-focus the camera manually (or lock the focus at an appropriate distance using autofocus). Ensure the camera is turned on, and completely ready to shoot. You will then draw less attention to yourself, and even have the picture in the bag before the subject actually realises that you are there. This type of portraiture can produce very rewarding results.

Curious onlooker This Romanian farm worker (below) had come into town for the weekly market. He was very curious about all the activity, and about me and my camera. When I turned to take his picture he was extremely pleased. Because of the language barrier, not a word passed between us, but his consent was obvious.

A moment's reverie I was immediately taken with this Asian man's far-away expression as he sat at an outdoor cafe (below). Not wanting to disturb him, I pre-focused the lens and set exposure before lifting the camera off my lap. I took many more pictures of him afterwards with his consent, and then found I couldn't stop him smiling!

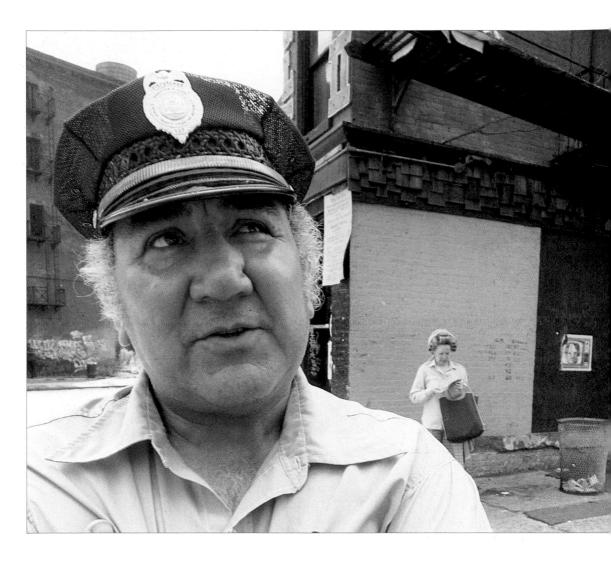

Rapt attention A moment before taking this picture (below), I had been shooting the big top going up at a circus. Then, out of the corner of my eye, I spotted this workman standing tensely watching the operation.

Good-natured indifference I took many close-up pictures of this postman in Manhattan (above) using a wideangle lens. You often find that public officials are used to their role as 'local colour' for visiting photographers. Pearly child I was taking pictures of the Pearly king and queen when I noticed that their daughter (below) seemed a bit left out. She was pleased to be the subject of this picture, but a bit shy in front of the camera.

Portraits in black and white

The prime requisite of a good portrait, whether in black and white or colour, is that it reveals something of the nature of your subject. Just as colour can be used and selected to express mood or personality, the many different tones between black and white can fulfil much the same function.

T CAN BE LIBERATING TO change from colour to black and white. In a garden setting, for example, a portrait can be spoiled by over-intrusive or discordant flower or foliage colour. In the studio, the choice of

the appropriately coloured background paper can cause endless headaches while you search for the one that evokes the most effective atmosphere for a shot.

Black and white simplifies the composition, allowing

TECHNICAL TIPS

- Black-and-white film can be particularly useful when using ambient light indoors as you don't have to worry about the different colour temperatures of the various light sources.
- Spots and skin blemishes tend to be accentuated when shot in colour: in black and white, these unwanted details are suppressed.
- Black-and-white film is available at super-fast speeds of ISO 3200, ideal for handheld, low-light photography.

you to concentrate on facial features, pose and expression.

Drawing on experience from the previous projects, you will be using lighting, focal length, character and expression, but adding the dash of drama that suits black and white so well.

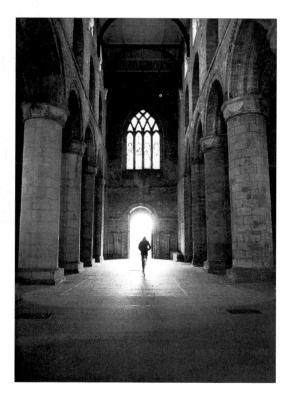

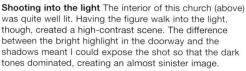

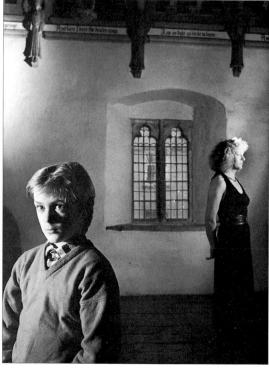

Body language After taking a series of traditional poses of this mother and son (above), I tried a more unconventional approach. I arranged them at opposite sides of the room, looking away from each other. Immediately, an undercurrent of tension is introduced into the photograph, making the portrait much more interesting.

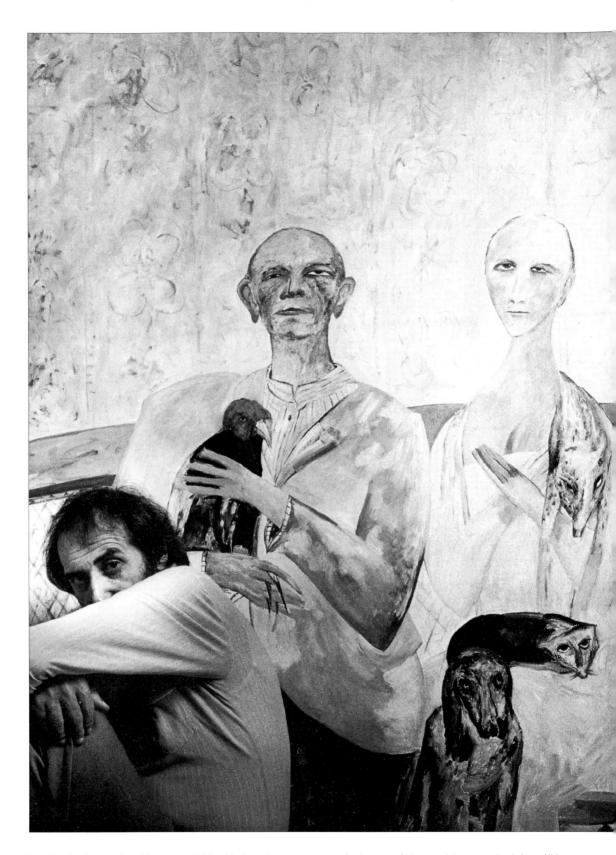

Matching background and foreground Using black-and-white film does not relieve you of the responsibility of selecting an appropriate background, even though the lack of colour means that you do not have to worry about the backdrop clashing with something the sitter is wearing. In this portrait of the painter John Bellany (above), I took the obvious

course of using one of his own pictures as a backdrop. All I really needed to do then was to pose him in such a way that his expression and posture echoed those of the figures behind him and, in particular, of the dog to his right. This has the effect of linking him with his work in an unusual way, and has created a striking image by careful juxtaposition.

Taking portraits of children

The secret of children's portraits is informality. When taking portraits of adults, it is feasible to use a tripod as your subject will probably stay within the scope of your lens. With children, however, I recommend hand-holding the camera, loading a fast film, using a telephoto zoom lens, and setting the fastest shutter speed that is feasible.

TECHNICAL TIPS

- For natural shots, kneel or even lie down to get the camera to the child's eye level.
- Higher viewpoints, though, are often useful for simplifying the background or to make the child appear vulnerable.
- A lower viewpoint will make the child appear more imposing and independent.

Floods of tears Young children (right) can dissolve into tears for no apparent reason. The session had probably gone on too long and he was simply overtired.

HIS IS PERHAPS A MORE difficult project than it initially appears. You will need to put together a set of four portraits of different children, with each going beyond a mere physical impression of a child at a particular point in time. It is part of your task to show something of his or her mood and personality as well. These are not strictly candids, since your subjects will to a degree be aware of the camera's presence.

A basic mistake people often make when photographing children is to stand with the camera at adult eye level, thus shooting down at them. It is better to squat down so that the camera is level with their eyeline.

On the whole, most children enjoy having their picture taken. They are also naturally curious, and it may be a good idea to let them look through the camera viewfinder so that they become familiar with what you are doing. The attention span of children is notoriously limited. However, if you are not too intrusive, they will soon forget all about you and get on with their own activities. This is when you can really get to work.

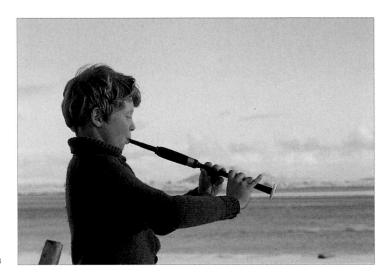

Lost in music This unposed image (above) was taken on an island in the Outer Hebrides, Scotland. The evening sunlight captures perfectly the tranquillity of the lonely setting, while the plain backdrop emphasises shape.

Quick reactions This is very much a snatched shot (below), taken in Romania. Cameras in that country were not a particularly common sight, and the boy with his bicycle was obviously very pleased to be my subject.

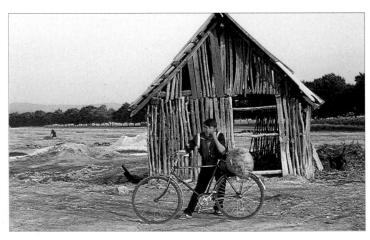

Colourful framing The bright red towel (above) acts as a dramatic frame for the child's face.

Paper seller I took this shot (below) in the Gambia, and the miniature paper seller seems rather overawed.

Contrast and surroundings In these two shots, the young girl obviously posed for the camera in her favourite dress and bonnet. In the first (below left), she wanted me to take a picture that included her dolls but I chose instead to pose her in a doll-like position

to give an ironic emphasis to that desire. In the next picture (below right), she was acting out her own interpretation of the fairytale *Little Red Riding Hood*, and I like the contrast of the delicate child and the fierce-looking family dog.

Children at play

Many of the problems associated with taking portraits of individual children discussed in the previous project disappear once children are at play with their friends. No longer do you need to worry about them becoming bored with the photo session, distracted or even wanting to know what you are doing.

TECHNICAL TIPS

- When photographing children at play, you have to allow for their movement when you set the exposure. A shutter speed of 1/250 sec or faster should ensure that most of the action will be caught crisply.
- A fast shutter speed will also mean that you will be using one of the wider apertures available with your lens. This has the advantage that the background will be thrown out of focus, helping you to concentrate the composition on the children themselves. Depth of field can be further restricted by the use of a longer telephoto lens setting.

HIS PROJECT is in two parts. The first involves photographing a group of children at play: use a semicandid approach to show how they interact with each other through their games. Some will want to perform for the camera, but don't encourage them to pose, even though good pictures may result.

The alternative approach is to set up your own sequence for a group of children. Provide toys or props for them, and just see what fun develops. A selection of masks, hats or colourful balloons, for instance, can help you produce a fun portfolio.

Studio shot Having assembled this schoolgirl quartet in my studio (above), I concentrated on shape using back lighting to make a fun silhouette.

Street scene Never be shy about this type of shot (right), taken in a street in Naples. It is not difficult to see who is leader of this little band!

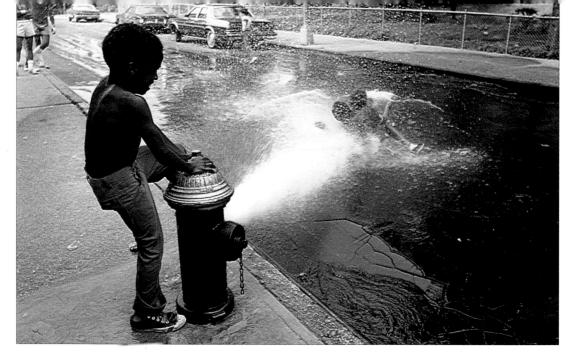

Water fight This is an extremely common sight on hot summer's days in New York (above). It was so simple to take, since the boys could not have cared less about the presence of passers-by or the camera.

Concentrated attention I took this picture (right) in a school playground in Spain. What attracted me most to it was the look of concentration on the little girls' faces.

Zoom movement These two children (below) came running up as soon as they saw the camera. To increase the sense of movement, I zoomed the lens during exposure.

Group portrait Initially, one of these Romanian children (right) climbed on to the horse: in seconds, it was littered with them, producing a formal yet spontaneous picture.

A day at the coast

The sun shines, light levels are good, people are relaxed and happy, bright colours abound, and the scenery is often spectacular. These are just some of the many factors that make a photographic project at the beach a fun activity. Some precautions are necessary, however: salt spray and sand are deadly enemies of delicate camera mechanisms.

their inhibitions with their clothes. They come to the beach in order to enjoy themselves, stretch out on the sand, doze in the sunshine, windsurf, play football, paddle in the waves, and ride donkeys.

Best of all, nearly everybody brings a camera, making the beach one of those locations where you can blend in to the surroundings, put your camera to your eye and capture relaxed, natural shots of people enjoying themselves.

When taking shots for this project, use the open space offered by a beach setting. Even on a popular and crowded beach, there will be plenty of freedom to move around a subject, perhaps to isolate a figure or group against the backcloth of the sea or sky, or to shoot from the other direction to show them against any attractive land features behind.

Against the light Shooting into the sun darkens the scene, but the translucent sail of the windsurfer (above) is an eye-catching image.

With the light This shot (above) shows the difference when shooting with the light. Colour and detail are clearer, but impact can be lessened.

Beach panorama A distant viewpoint and 135mm lens give a good-sized image (above). Back lighting subdues colour and simplifies the picture, turning the hundreds of beach-goers into an army of silhouettes.

TECHNICAL TIPS

- Put a UV or skylight filter on the lens. Make sure the lens is capped when not in use, and keep the camera in its case.
- Brush off sand and wipe off water spray immediately.
- For better weatherproofing, put the camera in a clear plastic bag when shooting. Splashproof and underwater housings are available for many types of camera. Disposable underwater cameras are also available.

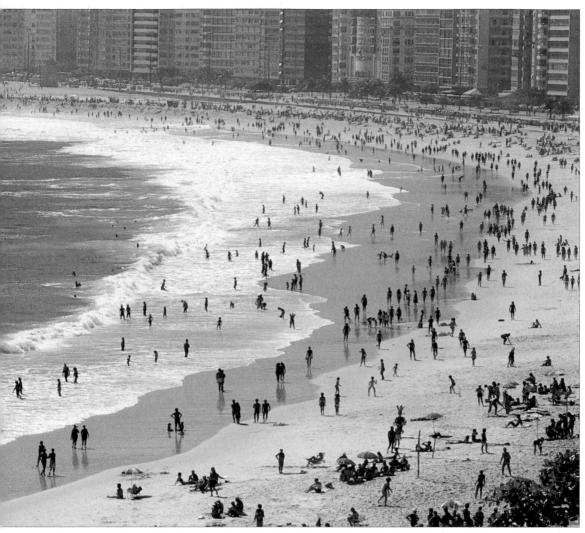

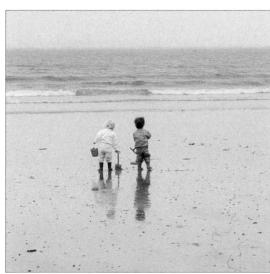

Beach football The slowly dipping late afternoon sun has drenched these two beach football fanatics in a golden glow of detail-revealing light (above). A low shooting angle ensured that the immediate foreground was in contrasting shadow, heightening the impression that the young men are playing under floodlight.

Photographing a wedding

How you approach an important assignment, such as photographing a wedding, depends on whether you are to be the chief photographer or simply a guest taking supplementary shots. If the responsibility is yours alone, then bear in mind that for the couple these could be the most important pictures of their lives.

ITH A WEDDING, you cannot afford to make mistakes. There are no second chances, so check camera, flash and lenses thoroughly. Make sure your batteries are fresh and that you have enough spares. Pack more than enough film or memory for the job.

Work on the wedding pictures should start well before the big day. Talk to the couple and agree on the shots required.

Weddings follow a predictable order of events, so the shooting should not be hard to compile. Some brides like informal shots before they leave home, or you could start with the bride arriving at the church. If you want to shoot during the ceremony, get permission

beforehand. At the same time, you could scout the best shooting positions. Obvious shots are the couple at the altar and signing the register. Afterwards, you will need pictures of the couple alone, then with the best man, bridesmaids and pages, with both sets of families and with friends. Shots with all the guests and pictures of the couple departing may also be required.

At the reception, cover the speeches, reaction shots of small groups of guests, and the cutting of the cake. But, very importantly, stay alert to amusing or revealing picture opportunities. These will occur throughout the day; there may be a touching moment between the couple, for example.

Informal preview Shots of the bride at home before the ceremony (above) are popular. Here, the old mirror behind gives the gown an antique look as well as showing the lovely lace bodice to its best advantage.

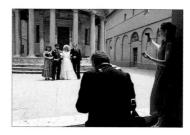

Reducing contrast When the sun is intense and high (above), use flash to lighten shadows and reduce contrast. Fill-in can also be used to improve colouration in dull, overcast conditions.

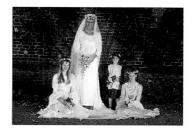

Set pieces These two pictures (above and left) are just two of the many set pieces expected of wedding photographers. For the bride and her bridesmaids, find a suitable plain, unobtrusive background. Make sure the sun doesn't cause your subjects to squint. For the picture of the couple at the altar, there was ample natural daylight available. In dimmer conditions, you will need a tripod and fast film.

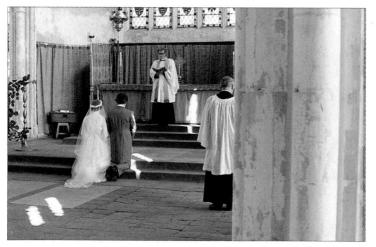

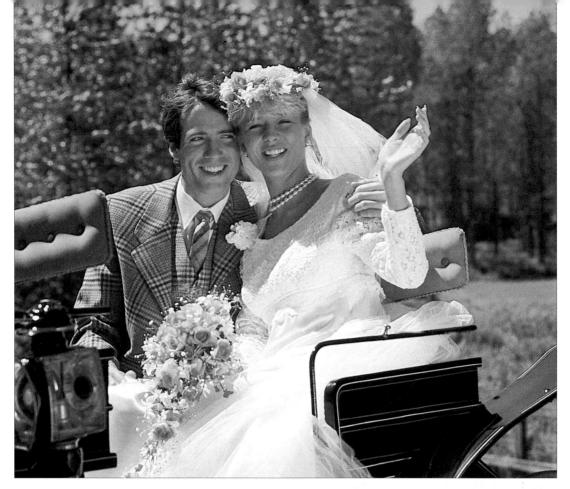

Eye-catching conveyance A shot of the couple leaving the church (above) is a must, and is enlivened if the vehicle is something unusual like a horse and carriage. Fill-in flash helped reduce the facial shadows cast by a high sun.

At the reception Outdoor receptions (right) make your job easier. As well as being well lit, people tend to be more relaxed and natural.

TECHNICAL TIPS

- Digital cameras have significant advantages over film cameras when it comes to photographing once-in-a-lifetime events. In particular, you can see your shots, allowing you to check expressions and poses before moving on to the next set-up. Shots can therefore be retaken before it is too late.
- Back up your pictures on to a portable hard drive as you go.

Detail Small details, such as the cake decoration (right), can be very significant to the happy couple and possess great sentimental value for them. Bear in mind that wedding pictures are stored-up memories preserved for the future.

Photographing a public event

When photographing a performance or event, especially an indoor one such as a circus, there are certain things to consider. You may need permission from the organisers, especially if you want to use flash. You will also have to find a good vantage point, from which you can avoid interfering with the proceedings.

O FULFIL THIS PROJECT, select some sort of public event or performance. This could be the local drama society's play, a street theatre or a choral or orchestral performance. Whatever the choice of subject, the aim should be to give complete coverage. This will encompass not only capturing the event as it is finally seen by the audience, but include some behind-the-scenes shots as well. These could include actors putting on make-up and costumes, or circus animals being fed.

For shots not ordinarily available to the public, permission may be necessary, as for these circus shots. It was happily given on the understanding that I did not spoil the view of members of the audience, block the aisles, or use flash where it would interfere with the performers.

With any performance, your chances of good shots are vastly improved by doing some homework beforehand.

This often means seeing the show first to scout out the best shooting angles, and to determine light levels, colour temperature and which lenses will be the most useful. This will allow you to return on a subsequent night well prepared. Street performers At many popular tourist destinations you will find musicians and entertainers, putting on mini-performances in exchange for tips from the passing crowds. When photographing these, your main problem will be to simplify the scene so that passers-by and busy streets

TECHNICAL TIPS

- Try to avoid using flash with stage performances and other indoor events whenever possible. Flash has a limited effective range, and will often kill the atmosphere of the show.
- Use fast film (ISO 1000-plus) or set a high ISO sensitivity on a digital camera.
- Rest the camera on the back of a seat or safety railing to give extra stability, as slower than usual shutter speeds may prove necessary. A monopod is useful for giving the camera support in crowd situations.

do not clutter the background of your shot. In the shot of the African group (below), the fields at the side of the road provided an ideal backdrop. At the famous Brazilian carnival (bottom), on the other hand, a shop doorway created a people-free set in which to capture my two masked subjects.

Comic relief The pictures on this page were taken at a circus. Before the show began I got permission from the owner to wander around the site and photograph the show-people rehearsing. The performers were busy preparing for their acts - with the clowns running through their juggling routine (right). However, they were willing to pose for a more formal portrait portrait (below right). In these situations, it pays not to be shy - people will often move into better positions or strike a more suitable pose if they are politely asked. This approach helped me to secure the amusing portrait of the show's strongman (above).

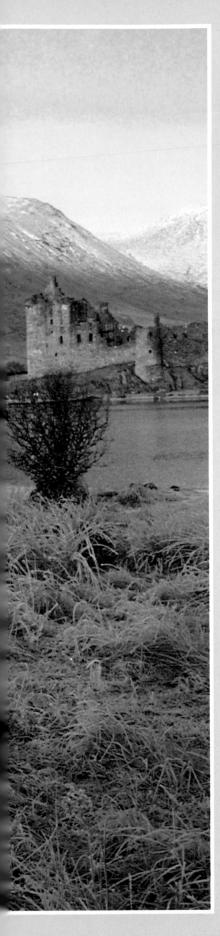

Places

any of the projects in this chapter involve taking a series of pictures using a variety of angles and/or lenses in order to reveal different aspects of the same landscape or building. Since light forms the basis of all photography, many of these assignments also concentrate on the changing pictorial qualities of daylight and how these affect colour, mood and atmosphere.

Building up the layers One of the main difficulties that a photographer must overcome is how to create a flat picture that looks three-dimensional. In this landscape (left), the feeling of depth is largely created by framing the shot so that the trees partly obscure the mountains in the background. An additional level of depth is provided by the textured foreground.

Improving the image

Pictures of places rate high on most photographers' list of priorities. In most instances, a successful scenic picture is the result of a planned approach, where the photographer has gone to the trouble to find promising or unusual points of view or has patiently waited for favourable changes in the light or weather conditions.

o ILLUSTRATE THE MANY different approaches possible with a single subject, I have used Mont St Michel, off the Normandy coast of France, for my example. For your project, the scene does not necessarily have to include a building, although there should be a prominent feature of some description to act as the focal point for your work. This could be an interesting rock formation, a waterfall or a gnarled, old tree.

With an imposing building or any place of great natural beauty, you will need to make an early start in order to avoid the almost inevitable influx of visitors in their cars, caravans and coaches.

Another reason for an early start is the often spectacular lighting conditions found in that short period after sunrise. Dawn can provide wonderful light and colour: mists that create a delicate pinkish haze, which momentarily turns to gold as the sun breaks through.

You might also find locals going about their business who would add a colourful human element to your picture but who, like those early-morning mists, will have disappeared by the time the first tourists start to arrive later in the day.

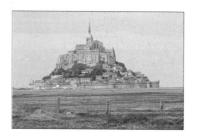

TECHNICAL TIPS

- When using a wide-angle lens, you will often find that there is too much uninteresting foreground. You must search for something to fill this space.
- A wild flower or an unusually shaped rock, shot from a low viewpoint, can often do the trick.
- Use natural frames, such as gateways, breaks in the trees, and so on, to hide unwanted parts of the foreground.
- Position paths or rivers to lead the eye into the distance.

Wrong viewpoint It is easy to see what went wrong with this picture (left). My viewpoint has robbed the medieval abbey, poised dramatically on its pyramid of rock, of all of its isolation and much of its grandeur.

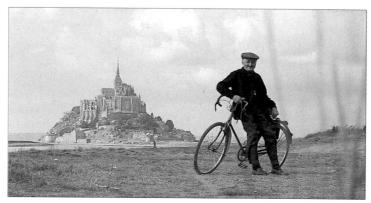

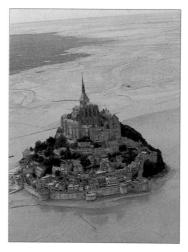

Local colour This viewpoint (above) gives a better idea of Mont St Michel in relation to the coast. I noticed the cyclist posing in such a way that his body shape reinforced that of the mount behind, giving stronger interest and impact.

Bird's-eye view From a few hundred feet up (left), you can see most of the buildings. Aerial shots often give fresh views of well-known places. The cost of the sight-seeing plane trip was equivalent to just a few rolls of film, and was well worthwhile.

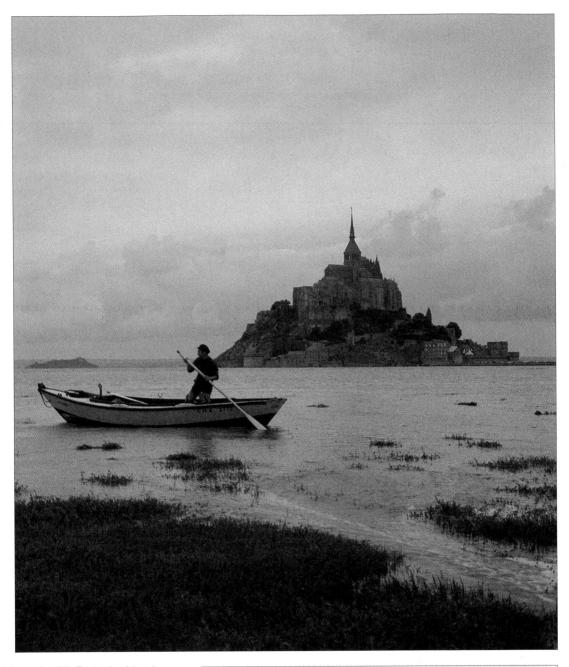

Incoming tide By evening (above), the mud flats seen from the air were transformed into a seascape. The man in his boat, like the cyclist, is a useful element of human interest.

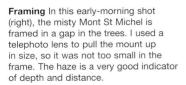

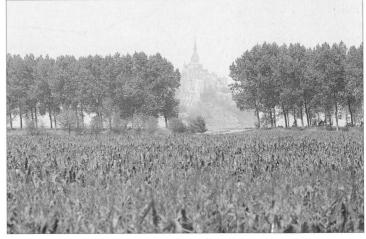

The time of day

No matter what area of photography you are most interested in – landscape, natural-light portraiture, architecture, still-life or wildlife – the time of day you choose to shoot can really have a startling effect on results. These varying lighting conditions help to create very different images of the same subject.

T IS NOT JUST THAT AT different times of the day the quality of light changes, as it certainly does (see pages 34-35); there is also something less tangible. Different times of the day seem to have their own rhythms.

For the natural history or wildlife photographer, early mornings hold the promise of dew-jewelled spiders' webs or frost-encrusted leaves. Colour may be more diffuse at this time, whereas an hour later the warming sun will not only have intensified hues, but may also have coaxed some hungry insect predator in front of your camera.

Portrait or candid photographers know only too well the importance of time of day: the leisurely pace of early morning, when people have time to talk and to pose, crumbles under the onslaught of daily routines.

For the landscape or architecture photographer, a knowledge of how the subtle play of light affects the subject throughout the day is vital. In the right light, even the most unpromising scene can be turned into a successful, photogenic picture.

The photographs here are entirely dependent on the relationship of highlights to shadows and the juxtaposition of colours or tones.

As a guide, I have included a range of subjects taken from early morning (below) to early evening (far right). What you need to do for this project is to set aside a full day to record the same general scene, showing all the important changes that occur throughout the daylight cycle. The end sequence of pictures may well be quite fascinating.

5.15am The overriding feeling from this shot (below) taken in Norway is of tranquillity. Not even the lone fisherman disturbs the calm, clean water.

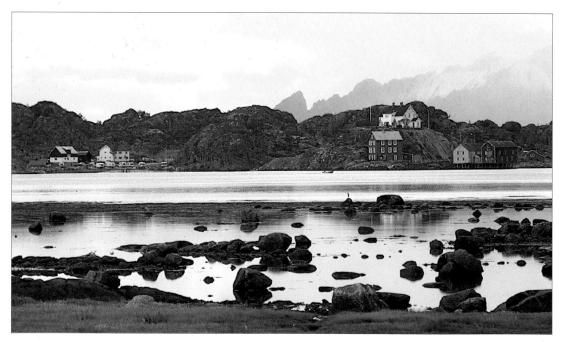

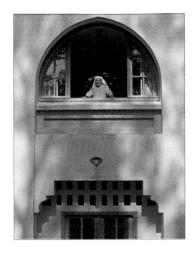

I0am I intended this (above) to be a straight architectural picture at a hospital in Morocco, but just as I had framed up the shot, a curious nun appeared at the window.

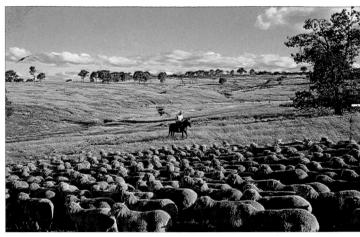

6pm There is not much movement (above) in the full heat of an Australian summer's day. For this shot, therefore, I waited for evening. The rimlight created by the low sun suits the sheep well.

8.45pm This redbrick Tudor gatehouse in Essex (below) has caught the last rays of sun, creating a warm-coloured composition. The low summer sun has also suppressed foreground dotail.

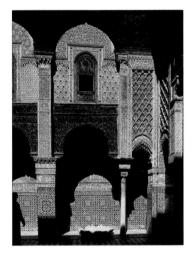

12 noon This mosque in Cairo (above) is simply splendid. The harsh, high, midday sun has brought out the texture of the ornate facade. Exposure was taken from a highlight reading.

TECHNICAL TIPS

- A tripod is invaluable late in the day (or at dawn), as it allows you to take pictures in lighting levels under which successful hand-held shots are impossible. The tripod also allows you to pick the most suitable aperture for the depth of field required, rather than compromising to get a sensible shutter speed.
- Some SLR lenses and digital cameras have image stabilisation systems that allow you to use slower hand-held speeds than normally possible.

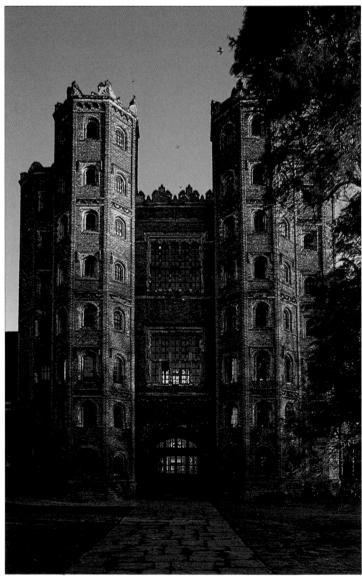

Shooting around a facade

You should never be satisfied that any given subject can only be done justice from a single point of view. It is possible with a building, for example, to show it from many different angles. Moreover, buildings, like any other subject, project mood and atmosphere depending on when they are photographed.

or THIS PROJECT, YOU will have to locate a detached building standing in its own grounds. This will give you the opportunity to shoot it from a great variety of angles.

The building itself need not be grand or even be of any particular architectural merit. An ordinary house will do.

What should come through in your photographs is how varied a single facade can appear when you use different parts of its setting to project different moods. Try to start early in the morning to ensure minimum interference from people or cars.

TECHNICAL TIPS

- There is no time limit for this project. You might revisit your chosen site on a few different occasions and at various times of the day to see if the building's character changes dramatically.
- You may also want to return to the same place in other seasons to see how the location changes in summer, winter, spring and autumn.

Foreground feature Making use of a powerful foreground feature (right), in this case the stairs and floral planters, has given a marvellous feeling of grandeur, depth and setting.

Conventional view Here is the conventional view of this Tudor stately home. It shows a good sweep of the drive and the house's immediate surroundings, and would normally be quite acceptable, but that important element of depth is all but missing from the picture.

Off-centre For this version, I pulled back just a little and moved to the left. Accordingly, the house has diminished in size, but a single urn is included to counter the bulk of the now off-centre house. This more interesting composition also effectively conveys a greater feeling of depth.

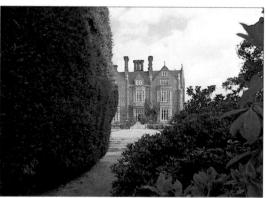

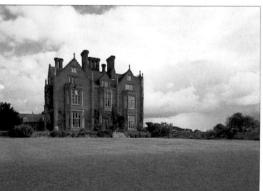

Changing weather Although I spent less than an hour at this house, the weather started to become stormy near the end of the visit. Instead of putting my camera away, I took this last shot low down to isolate the house against the darkening clouds, giving it a rather foreboding look.

A sense of place

Your approach to any large-scale, outdoor subject, such as the magnificent Schwetzingen sculpture garden in Germany shown here, must be influenced to a considerable degree by the prevailing weather conditions. No matter how adverse they are, it is still possible to capture a sense of place.

or THIS PROJECT, YOU need to research an outdoor location. You could, for example, choose as your subject a church and churchyard, or a farmhouse and its surrounding buildings.

What you need to show through your pictures is sufficient information about the man-made and natural features to give a complete and balanced impression of what it was actually like to be there at the time. Bear in mind that the weather is neither for you nor against you. It is simply a factor you have to

House and setting You nearly always need an establishing shot (below) in your portfolio, which shows the house and its setting in a single frame. Here, I chose a view where strong foreground contrast offset an expanse of dull sky behind the house. work around. So don't put your camera away because it is raining: just look for a different approach to the subject. While you might concentrate on colour and form on a bright day, it might be better to hunt out tone and pattern in overcast conditions.

Details By concentrating your lens on details (above), you can almost completely omit any indicators of weather. The bright green hedges and light lavender colours give the impression that they were shot in much sunnier weather.

Behind the scenes For this photograph (below), I worked my way behind this statue and shot upwards, using overhanging foliage to mask the sky. The eye-catching red colour of the Virginia creeper gives a lift on the dullest of days.

And the rains came down Gardens are designed to be seen in all weathers, even in the rain. In this picture (above), I particularly like the apparent lack of interest shown by the passers-by in the high drama being depicted in the marble statue behind them.

TECHNICAL TIPS

- Keep looking for different vantage points from which to shoot the subject. Watch for benches and mounds that will give an elevated camera position.
- Look out for balconies and towers that may give you a bird's-eye view of the location. Use your charm to gain access to these positions.

Close and closer still

For the first picture of this balustrade (right), a standard 50mm lens setting was used. The impact of the sun symbol has been diluted by the view behind, and especially by the overcast sky. For the next shot (below right), I moved viewpoint to show the gold leaf against heavy shadow, and used a 135mm telephoto setting. In fact, with this subject, the dull conditions helped by giving very even lighting without overly bright highlights.

Landscape in monochrome

The term 'monochromatic' is often mistakenly taken just to mean black and white. In fact, the term really describes a photograph predominantly made up of a single colour or shades of a colour. This could be the many shades of green of a tree-filled, grassy landscape, or the acres of red roofs that characterise the urban sprawl on the periphery of cities.

PART FROM THE examples above, where the elements of the composition themselves determine the colour of the scene, it is often the quality of light and the prevailing weather conditions that work together to produce a monochrome effect.

Colour film allows you to be very selective in what you include in the image, and for this project selectivity is the key. Certain weather conditions, such as mist and snow, act as a filter, subduing the colours of objects and making them appear as shades of the same hue.

Time of day also has a major influence on colour perception. At sunset or sunrise, whole landscapes can be suffused with pinks and reds. In fact, low-light conditions generally have the effect of merging colours into a single hue. At dusk, bright colours always appear much more subdued, for example.

Storm conditions can also work favourably. For example, the steely blue-grey of a turbulent sea and the colour of billowing storm clouds are so similar that distinguishing the water from the sky can be very difficult, if not impossible.

TECHNICAL TIPS

- Faster film softens colours, and adds grain that can suit monochromatic scenes. With digital images, saturation and colour range can be reduced on the computer, and grain added.
- The duller the weather and the more diffuse the light, the weaker colours become.
- White and black are neutral colours, and can feature in any monochromatic scene.

The great leveller In terms of colour rendition, heavy snow (above) really is the great equaliser, turning winter scenes into delicate, almost black-and-white, images.

The colours of autumn This shot (left) was taken on the edge of a pine forest. The pine needles littering the floor precisely echo the autumnal hue of the sentry-like trunks.

Selective view For this Tuscan landscape (right), I used a long telephoto lens to concentrate on the fresh green of the young sunflowers and the grassy slopes behind.

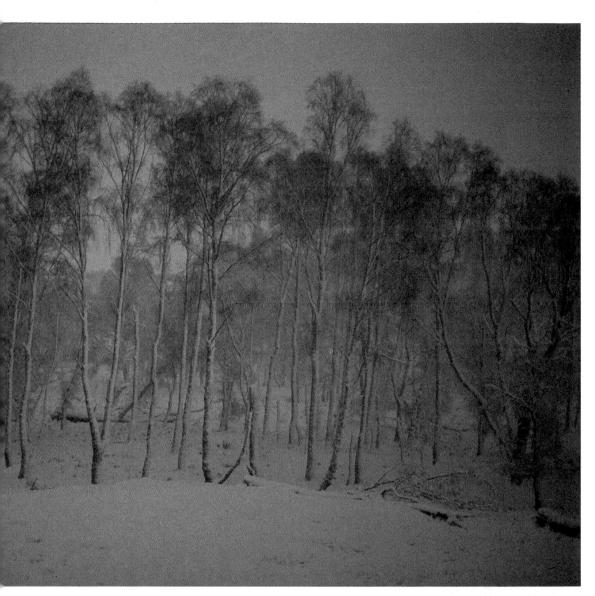

The black-andwhite landscape

The approach taken to the black-and-white landscape is often very different from that used for colour, with the myriad shades and hues that help to define shape and form, texture and pattern. In black-and-white photography, you will need to become familiar with the way colour translates into tones of grey.

N GENERAL, PHOTOGRAPHERS find the representation of reality offered by colour film easy to accept and work with. For instance, a mixed group of trees all have subtly different shades of green that will be apparent in the finished picture. In black and white, this type of distinction may

be lost as different hues may end up appearing the same shade of grey in the resulting photograph. Instead, however, you could find a bonus in the form of a stronger graphic content and a very different atmosphere.

Exploiting the different moods of the black-and-white medium forms the basis of this project.

TECHNICAL TIPS

- A red filter (Wratten 25) can be used to turn practically any sky into a dramatic, high-contrast cloudscape.
 An orange filter (Wratten 16) has a similar, but slightly less powerful, effect.
- A yellow filter (Wratten 8) is worthwhile using with all landscapes as it helps to record skies as we actually remember them.
- A yellow-green filter (Wratten 11) lightens the tone of grass and other foliage, giving it a more natural appearance.

When choosing possible views, look for strong line, bold contrast and dramatic skies. Filters specifically designed for black-and-white photography (see pages 44-45) can be particularly useful, allowing you to change the tonal values of parts of the scene to create a different, more dramatic image.

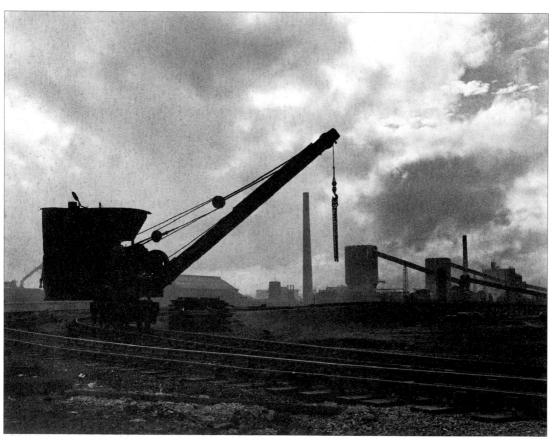

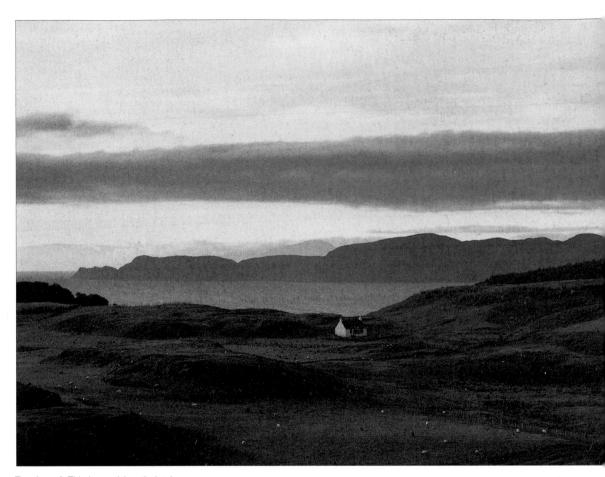

Tonal wash This image (above) clearly demonstrates some of the qualities of black and white. First, the foreground shows form well, through alternating dark and lighter tones. The sheep and the farmhouse are in good contrast against the overall darker tone. The sky is simple and strong, having the appearance of being applied in rather a painterly wash.

Silhouette Shape tends to be strengthened when rendered in black and white (left). Shooting against the sun, this industrial scene has produced powerful graphic shapes silhouetted against a massing sky.

Linear perspective In the shot of a frost-covered moor (right), the power of line is apparent, with strong linear perspective leading the eye straight up towards the horizon.

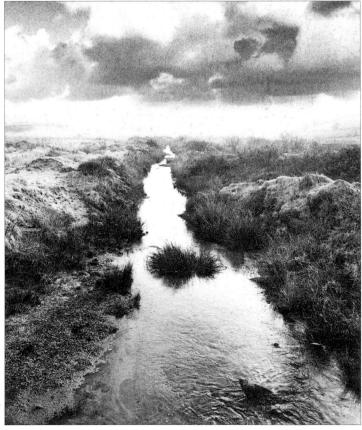

'Drawing with light'

Natural light is ever-changing and always unpredictable. One moment it shines from a clear sky, endowing every feature in the landscape beneath with a wealth of detail. Then, suddenly, it shafts out of storm-heavy clouds, brilliantly spotlighting some features while throwing shadows across the once-familiar terrain.

HE WORD PHOTOGRAPHY means literally 'drawing with light'. It is one of the never-diminishing fascinations I have with photography that no matter how many times I shoot a particular landscape or location, it can always appear subtly different. All that it requires is to take the time to really look, and to see.

The best type of day to undertake this project is one holding the promise of rain, when you can expect to see some dramatic and rapid changes in lighting. If all goes well, and you are in the right place at the right time, you should aim to take a series of shots within a short time – say, about five minutes maximum – with each shot in the sequence portraying a different mood.

Pay attention to how the moving clouds create a pattern of shadows across the landscape, with areas of brightness in between. If you pick a focal point for your view, you can then wait for the moment when it is spotlit.

Also look out for the intense lighting conditions that can come before or after a storm. The juxtaposition of a sunlit foreground with a dark, threatening sky will always make a powerful picture.

Restricted time span Taking landscapes is thought to be rather a sedentary pursuit, but when you have a powerful sun, wind and clouds, the landscape changes so rapidly that before you get the camera to your eye that particular scene is gone for ever. In the large image (right), the energy of the sunlight seems almost enclosed and protected by the surrounding sweep of mountains. Seconds later (below), the clouds moved apart and I zoomed the lens back to encompass this new lighting effect. And, again, within what seemed only a moment later (below right), the clouds descended once more over the valley.

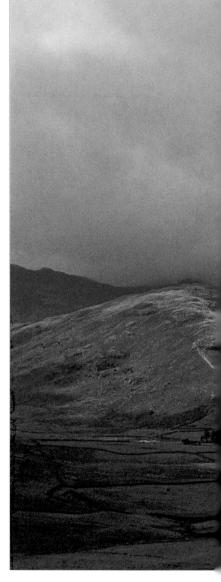

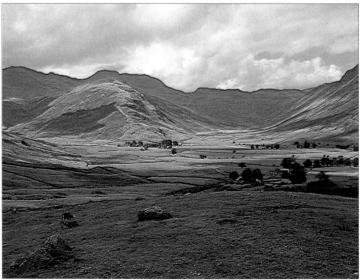

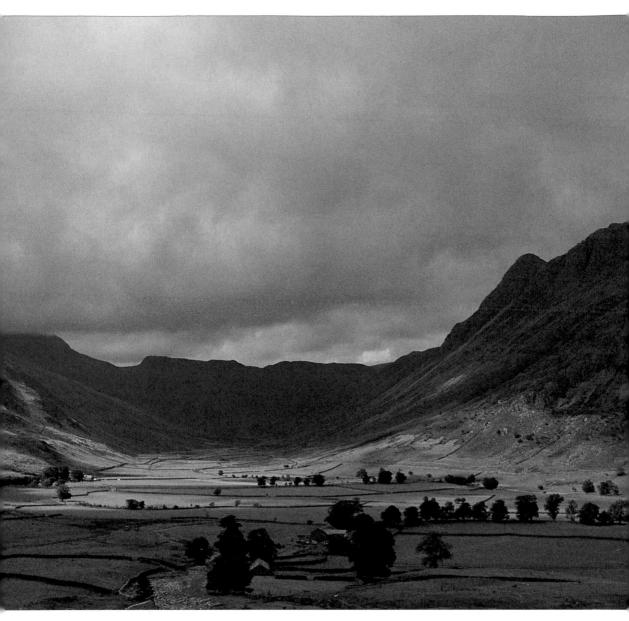

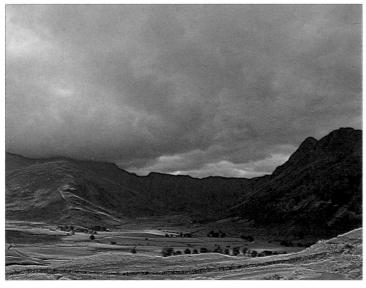

- Graduated filters are useful for landscapes. A grey or ND graduate allows you to darken the sky, reducing the contrast in the scene to allow a better exposure for the foreground.
- Coloured graduates allow you to add interest to bland, featureless skies. Tobacco and blue are popular colours.
 The sharpness of graduation depends on the focal length of lens and aperture used.
- Image manipulation software allows you to add graduated effects precisely and in any hue.

Shooting into the sun

If the sun is included in the shot, be very cautious. It is potentially as dangerous to look directly at the sun through a camera's viewfinder as it is with the naked eye – even more so if you use a telephoto lens. However, including a low sun in the picture, perhaps seen through haze, can produce spectacular results.

ET'S SET ASIDE THE adage about always having the sun behind you for taking pictures.
Certainly, anything lit frontally by the sun will be fully detailed and descriptive, and will create few exposure problems. But good photography should be more interpretative than that. Sometimes you just don't want to see everything clearly

So your assignment this time is to produce a set of pictures, some featuring the sky and sun as the principal subject, and others where the presence of the sun in the shot gives a new perspective or mood to a familiar subject.

The main problem you will encounter is excessive contrast. Even if you take your reading from the sky at about 45° to the sun, everything else will be under-exposed. If you take a reading from a subject lit by the sun, then the sky itself will be over-exposed. The shots shown here will give you some pointers on how to avoid or exploit excessive contrast in your photographs.

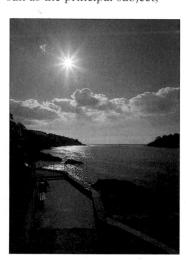

Exploiting contrast By metering from bright sky (above), I threw the ugly pier in the foreground into deep shadow. The sunburst effect comes not from using a filter, but simply from using a small aperture – in this case, f22.

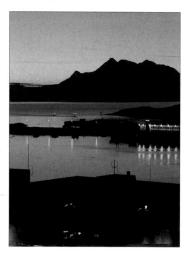

Afterglow A way to avoid excessive contrast is to use the afterglow of sunset as a light source (above). Wait until the sun has disappeared below the horizon. Illumination is strong enough for an attractive sky.

- Digital cameras can have a tendency to weaken the colour of sunsets. The automatic white balance system can try to filter out the red and orange from the sky.
- Using manual white balance with a sunny daylight setting will bring back the colours as you'd expect them to be.
- However, to boost the colour of the sky further, you can use the white balance setting designed for cloudy conditions. This will give a warm colour cast to the picture.

Obscured sun Another way to overcome excessive contrast is to wait for the sun to drop in the sky towards late afternoon and hope that clouds will partially obscure it (right). The dramatic crepuscular rays of light thus formed bring alive an otherwise ordinary scene.

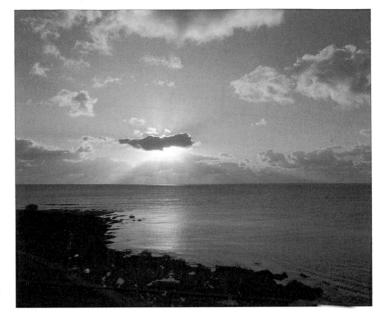

Hazy sun The atmospheric haze associated with large cities can work in your favour (below). Here, dust particles reduced light levels and scattered light generally, showing a little, but vėry important, modelling on the skyscrapers of New York's famous skyline.

Difficult weather conditions

Difficult weather conditions by implication usually mean poor light. In mist, rain, fog or snow, light readings are low, colours muted or obscured completely, and the temptation is to stay indoors out of harm's way. The irony is that some of the best photographs are often taken in the most hostile weather conditions.

OU WILL HAVE TO carry out this project over an extended period, waiting for a variety of different weather conditions. Remember, the greater the range of conditions you include, the better the set of pictures you will produce.

Because of the almost inevitable poor light, reasonably fast film or a high-sensor-sensitivity setting are useful if you are going to hand-hold the camera. You will also have more choice of exposure settings with a fast lens: working at maximum aperture all the time gives you very few depth-of-field options. If you can't change the ISO setting, or you have a single zoom, then another solution to these low-light situations is to use a tripod.

An important point to bear in mind is that in mist and snow scenes there tends to be a lot of scattered or reflected light about. A general light reading can then lead you to under-expose your pictures, especially distant figures or buildings.

Moonlight snowscene This shot (right) was taken not long after dusk, with the moon already high. The reading was from the sky, which has made the scene generally lighter.

Mist One of the most useful features of mist (above) is the way in which it obliterates the background. For this reason, scenes and objects not normally of much interest to you can take on a completely new feeling.

TECHNICAL TIPS

- Cameras may not function well in very cold conditions.
- Batteries, in particular, may give out less power, and camera operations may stop or slow down.
- Try to keep the camera warm by putting it under your coat.
 Carry fresh batteries in your pocket ready for action.

Frosty dawn This magical scene (right) meant being in position for sunrise. Half an hour later, the frost, the mist and the silvery luminescence would have gone.

Rain Pouring rain (above) has muted and softened all the colours in this scene, producing a study in colour harmony and concentrating the viewer's attention on the crazy juxtaposition of houses and windmill.

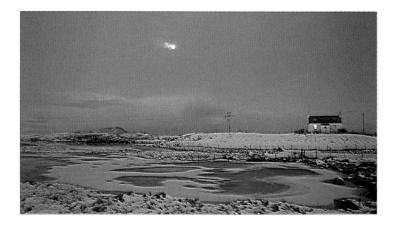

Featuring dominant skies

All too often, photographers concentrate on the physical features in their pictures, such as buildings, people, a line of hills or trees, and other natural or artificial elements. Doing so is to fail completely to notice whether the area of sky included in the frame is making a positive contribution to the composition.

ECAUSE OF THE LACK of attention paid to the sky in many pictures, the majority of shots are arranged so that the horizon falls a third of the way down the frame to give the land prominence in the finished picture. Although this works in many situations, the sky

is often worthy of being the subject itself, with the landscape or buildings below playing a supporting role.

Although this project will sharpen your awareness of the sky as a picture element, it is equally about correct exposure. There is often a difference of many stops between the

Leaden sky This briefly leaden sky in Portugal (above) acted almost like a lid, trapping light and intensifying colours. Light reflecting from the mottled-white paving threw illumination to the sides.

sky and the ground, and the contrast latitude of the film or chip may well not be able to cope. Therefore, you have to decide just what you are going to meter for. Avoid taking a reading from an area on the ground that will cause the sky to be rendered as a block of featureless white.

Setting sun The setting sun through a hazy atmosphere (left) spreads a wash of colour over the landscape below.

Summer storm Near darkness falls as a storm front rolls in (below left). Here, I exposed for the clouds, reducing to silhouette the distant copse of trees.

Above the clouds Cloudy shadows cover the land (right), and the elevated viewpoint reveals sunlight on the other side of the valley.

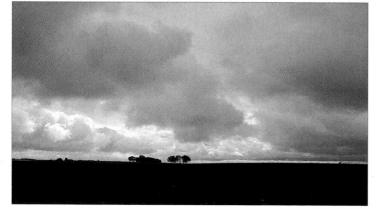

- Film is sensitive to UV light, even though our eyes cannot see it.
- UV filters are useful in areas of high UV, such as at altitude or by the sea, as they reduce the blue colour cast that UV light creates on film.
- A skylight is an ambercoloured UV filter, which warms the landscape up further.

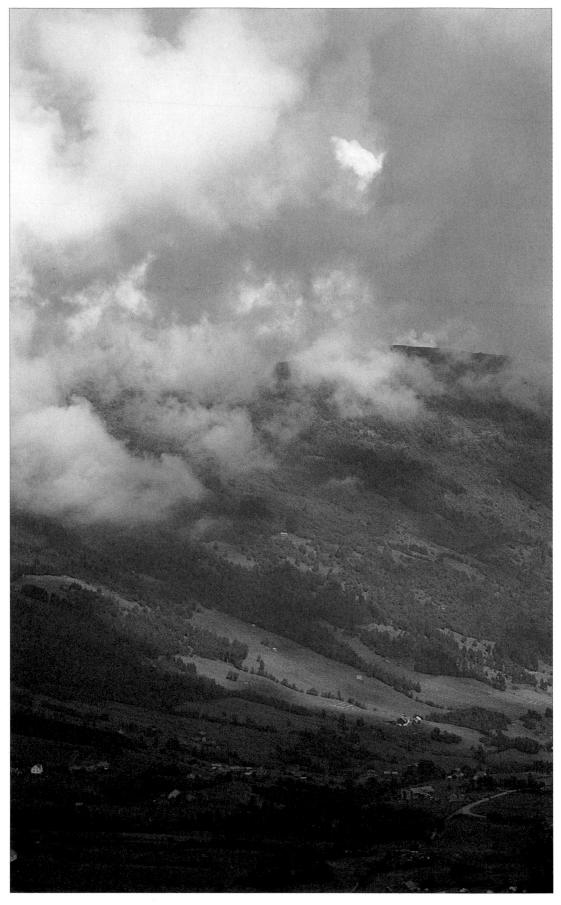

Dusk and night photography

Once the colour and drama of the sunset sky have largely subsided, most people pack away their cameras. However, today's fast films and high-sensitivity, low-noise digital chips allow photography to continue well into the night if you use some type of camera support combined with long shutter speeds.

ROBABLY THE BEST TIME for most 'night' pictures is that transitionary period between dusk and night proper. It is then that there is still sufficient illumination to give a degree of modelling to your subject, and there is still some colour left in the sky.

Once all sunlight has vanished, contrasts become impossibly harsh for film or digital imaging to cope with. You are left with either overbright, spreading highlights surrounding streetlights, or impenetrable shadows. Skies are a featureless jet black.

For this project, get yourself into position before sunset. Set your camera on a tripod to frame up a suitable landscape or city scene.

As light levels begin to drop (and this will happen more rapidly at some latitudes, or in some months, than others), you may notice that a feature that was insignificant in full light takes on far more prominence once reduced largely to shape. Electric lights also become more noticeable as darkness falls. So be prepared to alter your framing continuously as the light level changes.

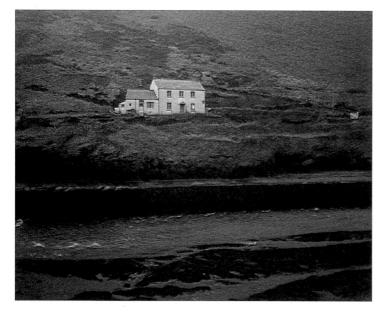

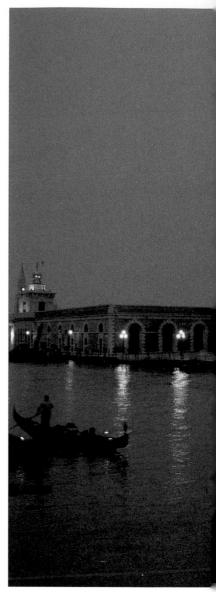

Reflected lights Venice is a photographer's delight (above). The sun had been below the horizon for about 10 minutes when this shot was taken. I stood waiting for the gondolier to reach that beam of watery light. Exposure was 1/4 sec.

A touch of light The gloom of early evening (left) was entirely appropriate for this scene. The only hint of warmth comes from a single lit window, its colour strengthened by being shot on daylight-balanced film.

Sunset glow In a bleak and desolate location in Normandy (right), golden sunset light has produced a welcoming and friendly landscape.

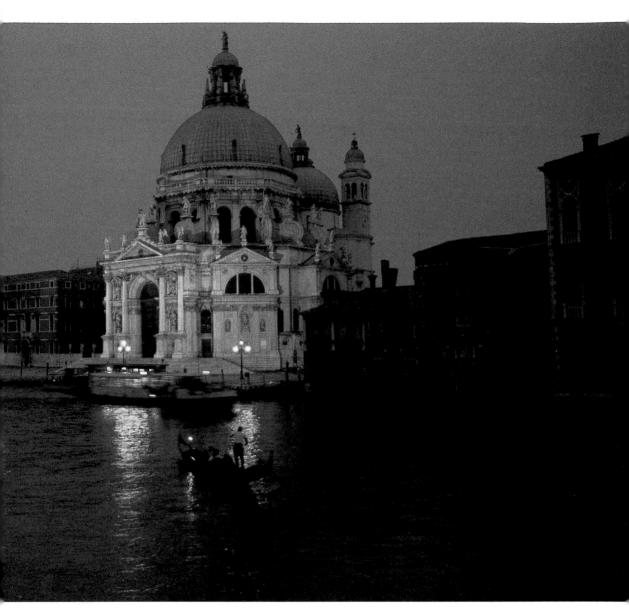

- The longest automated shutter speed varies significantly from camera to camera: it may be a fraction of a second, or many seconds.
- For longer exposures, most cameras have a 'B' setting which is used to keep the shutter open for as long as the camera trigger is depressed. Even though this should always be used with a tripod, to avoid vibration a cable release should be used (some cameras use electrical cable releases; others use a mechanical system).

An industrial landscape

The scope for powerful landscape imagery is by no means confined to picturesque postcard scenes. As you can see from the pictures on these pages, even a landscape suffering the heavy imprint of industrial development and decay offers you every opportunity to sharpen your technical and pictorial skills.

OR THIS TYPE OF IMAGERY, you should not have to travel far. You will find that every city, town or village will show some signs of industrial activity. You do not necessarily have to visit the large-scale estates I came across in northern Europe (opposite) and in Frankfurt, Germany (below). It may be easier to find nearby the smaller-scale examples of tragedy or decay, as in the shot of the abandoned farm in Cornwall (right).

The effect of light The oblique lighting of late afternoon (above) was ideal to bring out the wonderful roundness and texture of the smoke spewing from this factory chimney.

You will need to find two or three different industrial landscapes, aiming to convey a strong documentary message – giving a real feeling, say, of pollution or degeneration. Remember, industry does not exist in isolation; there is also a vital human element.

Change of use What was once an idyllic agricultural scene (below) is now dominated by pyramids of waste dug in search for china clay. Note how the tyre in the foreground helps sum up the feeling of abandonment.

TECHNICAL TIPS

- Industrial scenes are often stronger when depicted with heavy grain. There are several ways to do this.
- Use ultra-fast or pushprocessed film.
- Keep the scene small in the frame, and then enlarge the section you want.
- With digital images, it is simplest to add the grain in post-production. With an image manipulation program, the degree, size and shape of grain is altered to suit the image.

Industrial haze A dull day has compounded the filtering effect of industrial discharge from the plant chimneys (right). By keeping the buildings low in the frame, I have accentuated the strong vertical elements.

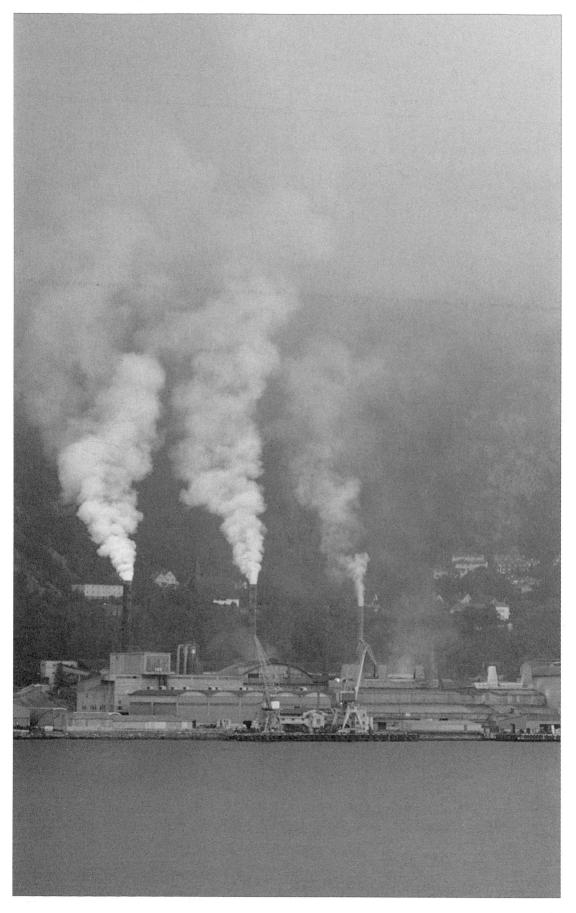

Beauty in strange places

It requires an inquisitive personality and a more refined sense of 'seeing' to find beauty in strange or unusual places. Landscapes devoid of obvious elements of pictorial charm make a refreshing change from scenic views. Instead, they can become fascinating abstract compositions in shape, texture and form.

UST AS NIGHTMARE images can have a disturbing persistence and a magnetic quality that persists long after wakening, so, too, can photographs such as these, which seem to have taken on an almost alien character.

Nothing demonstrates more clearly your ability and familiarity with the photographic medium than a well-rounded portfolio of pictures containing plenty of contrast in both subject matter and style.

In light of this, you need to find an unusual landscape setting, not necessarily one devoid of human habitation, but one that would by most ordinary standards of judgement be termed an eyesore and 'unphotogenic'.

The things that you should be looking for primarily are: powerful, graphic shapes; strong contrasts in light and dark; unusual lighting effects; and, most important, subject matter that does not immediately 'reveal all' to the viewer.

For these examples, I restricted myself to a small area of Cornwall, using as my subject the different aspects of the clay pit excavations shown in a shot in the previous project.

TECHNICAL TIPS

- In both landscape and documentary photography, you frequently want as much depth of field as possible, whatever the weather conditions.
- Use a tripod, so that shutter speed becomes unimportant.
- Use the depth-of-field scale on your lens (if you have one) to readjust the focus so that as much of the scene is as sharp as possible given the aperture.
- Alternatively, a rough-andready method is to focus at a point a third of a way up the image area you want to shoot.

Working around a subject Although this was a landscape devastated by mining activity, I soon began to see nothing here but beauty. These waste heaps, set against a pink-streaked twilight sky and mirrored in the waters beneath (above), take on a grace of their own. Perched on top of the excavations (left) is the original farmhouse, long since abandoned. But the steep clay cliff running away from it has more of the appearance of an artist's palette with a river of pink down the middle. The final shot (opposite) is a flooded pit, striking against an equally dramatic, rain-heavy sky.

Shooting a cityscape

The richness and diversity of subject matter to be found in any large urban setting makes cityscape pictures a favourite with photographers. The pattern and line of towering buildings, the contrast of the modern and traditional, or the human element that is the heart of the city, make a feast of images for your camera.

ARGE TOWNS AND CITIES vary enormously in feel and character. Some are largely of the here and now, having come into being only during the past few decades, or having swamped entirely whatever original settlement might have existed. Others may have managed to retain their architectural and historical links with the past, alongside newer features.

The idea behind this project is to produce a portfolio of photographs that encapsulate your perception of a particular town or city.

Remember to watch out for those small details and juxtapositions that will really convey the real atmosphere of the neighbourhood.

TECHNICAL TIPS

- Even if you do not have a tripod, you can frequently find ways to give your camera more support, and to allow you to use slower shutter speeds.
- Lean hard into doorways as you shoot, rest your hands on railings, or sit down.
- For long shutter speeds, put the camera on a ledge or car roof. Set the shot up carefully, then fire the shutter using the self-timer to minimise vibration.

Telling detail During a very brief stopover in the Gambia, Africa, my eye was immediately taken by the incongruity of the tropical light falling on this quintessential British symbol, the red pillar box (below).

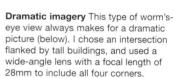

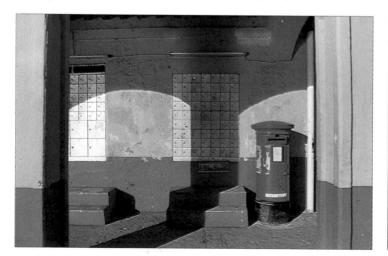

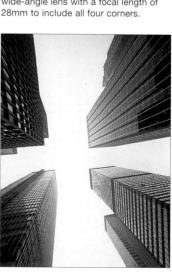

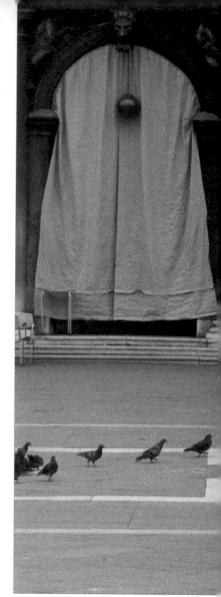

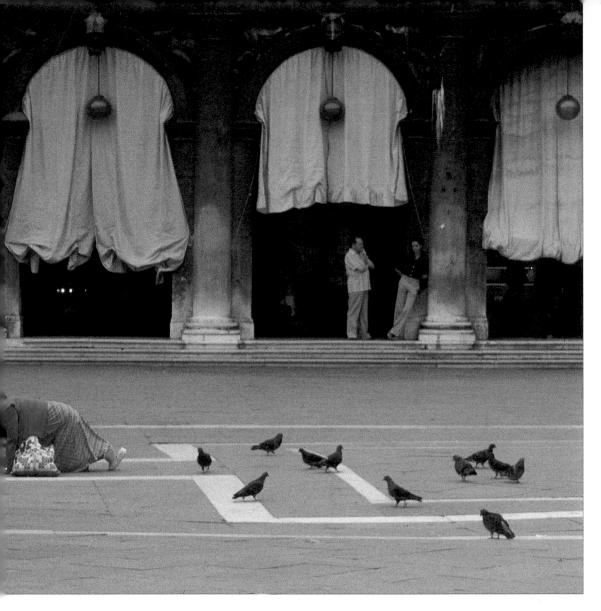

Human touch In this view of St Mark's Square, in the heart of tourist Venice (below), the passing early-morning jogger seems to suggest that the Italian city is more than simply a popular travel destination.

Humorous element Again in St Mark's Square, Venice, a woman gets on all fours to feed the local pigeons – watched seemingly by four enormous, shrouded figures formed in the arches behind (above).

Reflections Here, at Blackpool (below), a distant view has been used so that the famous illuminations are included twofold: taking advantage of the wet sand and shallow water, which acts as a mirror, to give a very evocative effect.

Architectural viewpoint

Most professional architectural photographers use medium- and large-format cameras for their work. However, all the pictures on these pages were taken using a 35mm SLR and a compact camera. Far more important than equipment is having a clear notion of precisely what you want to achieve.

T IS TIME OF DAY, AND hence the direction of natural sunlight, that is your chief ally in architectural photography. Architectural structures are multi-faceted and often minutely faceted objects: three-dimensional as a whole but also threedimensional when viewed in detail. Light striking a particular surface might at one hour of the day reveal a rich profusion of detail; in a picture taken just a few hours later, you might see nothing more than an area of deep, featureless shadow.

In conjunction with time of day and the direction of light, you should also consider carefully where to position yourself in relation to the subject. In narrow streets hemmed in on all sides, your options might be limited. However, where the setting allows, always wander around, looking all the time through the viewfinder to see how various perspectives relate to the shape of your picture format.

For this project, you are to produce a set of pictures of the same building or structure. With each image you should endeavour to communicate something fresh about the subject matter, using lighting direction and viewpoint.

High viewpoint For this shot of Florence Cathedral (below), I used a second-floor window opposite. This viewpoint gave a more accurate perspective than would have been possible from street level.

TECHNICAL TIPS

- Converging verticals, caused by tilting a camera to include the tops of tall buildings, can work in pictures, but they can often be avoided.
- Try to shoot from farther away with a longer lens.
- Hunt out a higher vantage point such as a roof, terrace or window of a neighbouring building.
- Some digital software allows you to stretch the top of a building, and to squeeze the bottom, to hide the converging verticals in your pictures.

Low viewpoint With these Egyptian columns (right) still standing after a thousand years, I tried to convey the majesty of the civilisation that built them, using a low-camera viewpoint and a wide-angle lens pointing straight up.

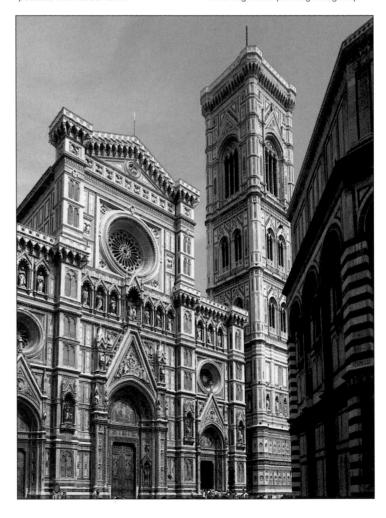

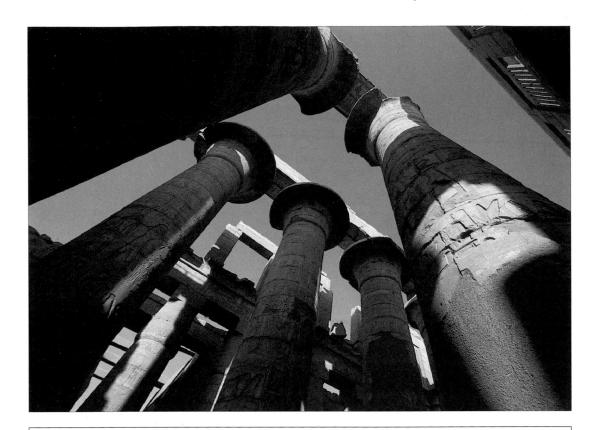

Working around a subject The three pictures you see here of the Eiffel Tower in Paris were taken late in the afternoon, within 45 minutes of each other, using a compact camera with built-in zoom lens. For the traditional shot (below), I was relatively close to the Tower. My camera angle deliberately cut off the bottom of the structure so as to hide the crowds of people, while foreground interest was added with the inclusion of the statue of the horse. In the next picture (right), the viewpoint was from across the river. The composition encompasses

the Seine to give a better feel of the Tower's setting. The addition of bare autumn branches to the frame helped to introduce a little more interest into the immediate foreground, and has avoided having too much grey sky. My favourite shot, however, was taken from directly beneath the Tower (below right). It is in fact the earliest shot I took in this sequence, and shows the low sun striking the tracery of ironwork. In terms of visual interest, I think it holds the viewer's attention far longer than the others. The zoom lens was set at 35mm.

Architectural detail

The camera's ability to isolate detail makes it a unique recording device, but the photographer's ability to recognise this potential in the first place is paramount. Isolated architectural features can frequently take on a meaning of their own, but again you must learn to do more than look – you must learn to see.

have been taking you closer and closer into architectural subjects, starting with cityscapes, and then zooming in on single structures. Here, you are going in still further, refining all the time your ability to seek out and appreciate the images within the images.

For this project you are asked to produce a wide range of pictures of architectural details, each one carefully selected so that it stands alone, without relying on the viewer's knowledge of the building. It does not matter if you use the same building for all the shots, as long as each one highlights something new.

Windows and doors are obvious candidates for your attention. Stone carvings and signs are other possibilities. However, don't overlook the often abstract qualities of pattern, shape and colour discord found in all buildings.

Painted panels This simple image (above) was taken straight on with a mid-range telephoto lens setting. It shows the weather-worn painted panels of a fisherman's cottage in Romania. Obviously once brighter and gaudier, the panels have mellowed over time.

Selective focus To isolate the alabaster figure (below left), I used the widest aperture my lens offered to throw the background out of focus.

Decorative motifs It is only when seen in isolation and at leisure (below) that you can truly appreciate the beauty of a mosaic of this scale and quality. It was taken by subdued window light.

Pattern in isolation The front of this barn in Romania (above) has been transformed into a wonderful exercise in pattern. The woven fence in the foreground leads the eye on to the strong verticals of the door timbers, again framed by wooden tiles.

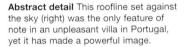

Texture and pattern Late afternoon sunlight (below) has created just enough shadow to make a feature of the incredible pattern and texture inherent in this stone and glass.

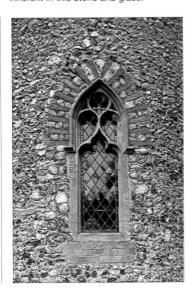

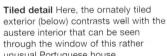

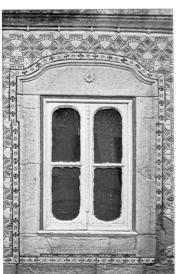

- · Although architecture is usually thought of as a wideangle subject, it really requires a full range of focal lengths.
- · Long telephotos (around 300mm) are useful for distant views of buildings within a landscape. Telephoto zooms (covering focal lengths up to 200mm) are useful for isolating details. Good close-up ability is useful.
- · Ultra-wide lenses (around 17mm) are useful for interiors.
- · General wide-angle settings (around 28mm) are useful for shots near buildings.
- · Shift lenses exaggerate or correct perspective distortions.

Knobs and knockers

When out photographing in a particular locality, it can be instructional to pick on a very narrow theme. This could be any manner of things: windows, churches, postboxes, children's playgrounds, market stalls, and so on. A good and varied set of pictures can generate a lot of interest as well as being fun to shoot.

HIS TYPE OF PROJECT can be undertaken when you have a few spare hours in an area, whether on holiday or just out visiting somewhere. For my example here, I chose door knockers.

Keeping to the theme of knobs and knockers, there are some technical aspects to be taken into consideration. Because these objects are generally quite small, a reasonable telephoto lens setting of around 100mm to 200mm will be needed. A compact camera with a zoom is fine, but pay attention to the close focusing distance or macro mode capabilities offered by the camera. If the close-up capabilities of your gear are limited, choose a theme with bigger subjects!

As doors are often recessed and, therefore, in shadow, you will need moderately fast film (somewhere in the region of ISO 400, or equivalent setting on a digital camera) so as to avoid the inconvenience of carrying a tripod.

Although it might be possible to shoot pictures at open aperture with a slower ISO setting or film, the extra sensitivity should allow the use of a mid-value aperture (f8, say) to ensure good depth of field and image resolution.

Variations on a theme All these photographs were taken in a small town in Germany, and I purposely limited myself to two hours, using a compact camera with a built-in zoom lens. I took many, many more shots in that time than shown here, but these examples give a flavour of what can be achieved. Although the door knockers can be fascinating artefacts in their own right,

TECHNICAL TIPS

- A thematic sequence of pictures looks more powerful if you can present them side by side (as on the opposite page).
- Digital imaging makes it easy to print a number of images on to a single sheet of paper simultaneously.
- Some software packages have facilities for compiling 'contact prints', with specified pictures shown at your chosen size in a grid formation.

 Desktop publishing programs allow you to be more flexible in the design, enabling you to alter the size of each shot.

coming in so many shapes and forms, they gain extra strength from the surfaces against which they are presented – battered woodwork, peeling paintwork, gleaming metal. Hence, this particular project has also become an exercise in texture: some smooth and highly polished; some more interestingly crazed, weatherworn or bubbled.

Simple interiors

When shooting an interior setting, a choice has to be made between two basic approaches. You either have to rely on available lighting from doors, windows, skylights and domestic lights; or you have to use additional artificial lighting, such as portable flashguns or studio lighting units.

HE APPROACH YOU adopt will probably largely be governed by circumstances: if available light is sufficient, giving good enough quality, then you will not need to supplement it. Bear in mind, however, that light from doors and windows, especially if small in relation to the size of rooms, tends to be 'contrasty' and directional, highlighting some areas of the room while casting others into deep and featureless shadow. Note that the quantity of light is not crucial: in dim conditions vou can use a slow shutter speed and a tripod.

You should be able to use your own home to produce a set of pictures of simple interiors for this project. Even if some rooms do not immediately appear suitable, part of your task is to use the inherent contrast of directional light in order to select and simplify the setting. For example, if you take a highlight reading inside on a bright day, the shadowy areas will be lost in darkness in the photograph, adding drama and mystery to the scene.

Framing In this picture (right), the framing is entirely in keeping with the simplicity of the passageway and furniture. Notice how the blocks of shadow act as visual full stops.

- If you are forced to use your own lighting for interiors, try and make it as soft and diffuse as possible. This will provide more even illumination, and will make the effect more window-like.
- Bounce flash off white walls or ceilings, or off a reflector.
- With studio flash units, place the flash well out of shot. Soften the effect by bouncing off a brolly attachment or, better still, use a special softbox attachment.
- Use giant reflectors out of shot to give fill-in: use white sheets pinned to dark walls or furniture.

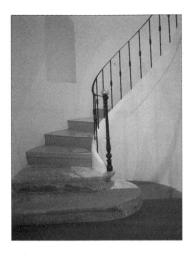

Mixed lighting This gracefully curving stairway (above) was lit by daylight and artificial light. This makes a colour cast inevitable, although the orange glow brings a welcome warmth to the shot.

Contrast Strong directional top-lighting has illuminated only the treads of the stairs (above right), but this has produced a simple, abstract composition of light and shade. Remember that interiors do not need to show a whole room: home in on the pattern, texture, shape, form and colour you will find all around.

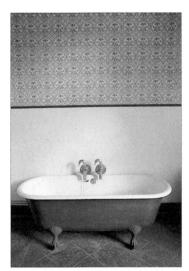

Large window area Note how a window that is large in relation to the room produces a more even type of lighting in this bathroom interior (above). I was drawn by the unusual position of the bath.

Lifestyle The simple lifestyle of the people of the Outer Hebrides (right) is reflected in this picture of a kitchen/sitting/living room.

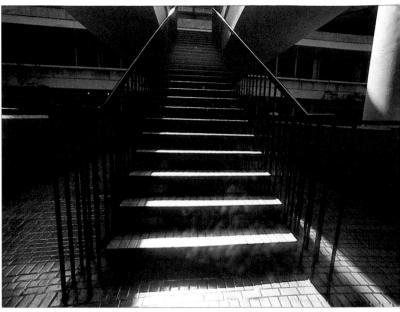

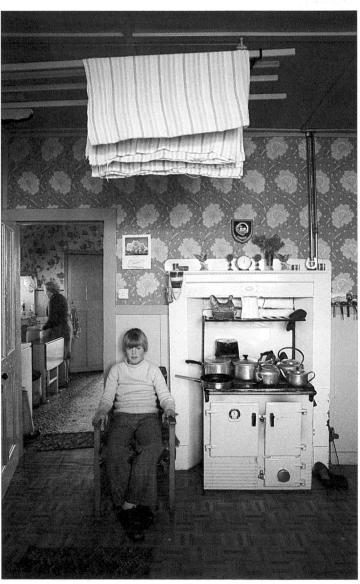

Large-scale interiors

Photographing large-scale interiors does not differ fundamentally in approach from the previous project. The only new factors that may have to be taken into account are selectivity of subject matter, what to include and what to leave out; and the fact that the larger the interior, the harder it will be to light artificially.

HEN PLANNING your project on large-scale interiors, I cannot emphasise enough the importance of preparation and pre-planning.

Visit the site you intend to photograph beforehand. Go at the time of day you will actually be shooting in order to see how much light there is to work in, what lenses and accessories (such as a tripod) will be most useful, and which camera positions are likely to give you the best results. Also, note any interesting features that you may wish to photograph separately.

Many important buildings have been photographed by professionals, and their work printed in books or brochures, or as postcards. The local tourist office will almost certainly have illustrated pamphlets to give away.

It is always worthwhile researching this material to see which vantage points have been chosen, and which you feel are worth trying to recreate.

Tonal contrast This view of an interior courtyard in the Alhambra, Granada, Spain, shows well the delicate stonework of the Moorish building. The strong tonal contrast draws the eye deep into the frame towards the lighter areas of the composition.

- Firing your flashgun more than once during an exposure is a good way to increase its effective guide number. This gives a greater range, or allows you to use a smaller aperture. Most guns have an 'open flash' or 'test' button, to fire the flash manually two or more times during a long exposure.
- 'Painting with light' uses the same approach, but the flash is moved during the exposure to increase coverage. It is important to fire the flash in such a way that you do not appear in the picture.

Pattern and texture A beam of sunlight spotlights this statue (above) standing in a courtyard of the School of Art in Venice. Sufficient light has spilled over to provide a wealth of valuable pattern and texture on the surrounding walls.

Church interior In this interior (right), I used ISO 400 film and hand-held the camera at 1/30 sec. I positioned myself in the middle of the central aisle and used a 28mm lens to include as much of the splendour of the church's floor, walls and ceiling as possible. The light levels were not perfect, but the high clerestory windows provided useful downlighting.

Detail For this shot (far right), I preset the focus and placed the camera directly on the floor, so that it was pointing up at this wondrous ceiling in a church in Rome. I then used the self-timer to trigger the shutter.

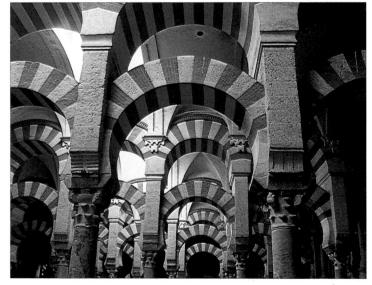

Multiflash To capture the colonnaded magnificence of the Grande Mosque of Cordoba, Spain (right), I used a technique known as 'painting with flash'. I set the camera on a tripod with the shutter locked open on B, and then fired a flash from different positions at least half a dozen times to lighten the building's dark interior.

People and interiors

One of the difficulties that you may have experienced with the two previous projects was finding the best time of day or the most appropriate viewpoint to shoot your chosen interiors free of people. Including figures in your interiors not only removes these problems but can make more interesting pictures.

of a person can add warmth and purpose to a room setting, the setting adds understanding and context to the person. For this project, the correct balance of elements must be determined, using lighting, camera position, lens type and aperture to produce a photograph that tells the viewer something of the person and, through that person, something of the setting.

Remember, photographs are a frozen instant, and timing becomes much more vital when photographing people than when shooting interiors alone.

TECHNICAL TIPS

- All the pictures here were taken with black-and-white film, which has some advantages for this type of photography. It is easy to push-process to increase sensitivity, and super-fast versions are available.
- The lack of colour means that colour cast problems caused by mixed light sources are immediately eliminated.
- Contrast problems can be reduced using variablecontrast printing techniques, along with dodging and burning.

Viewpoint By shooting from the front of the judging table at this village flower and produce show (below), the orderly lines of runner beans and onions give context to the seemingly bizarre appearance of the judge holding up a cabbage. The composition is deliberately arranged so the cabbage seems to replace the man's head (a technique known as 'false implication').

Lens and aperture Another photograph at the same show (above), this time showing the judges examining the baking entries, used a similar shooting angle but from a much lower position so that the cakes fill the foreground. However, so that the emphasis remains on the people, an aperture of f4 on a 50mm lens was used so that the bottom of the picture is slightly out of focus.

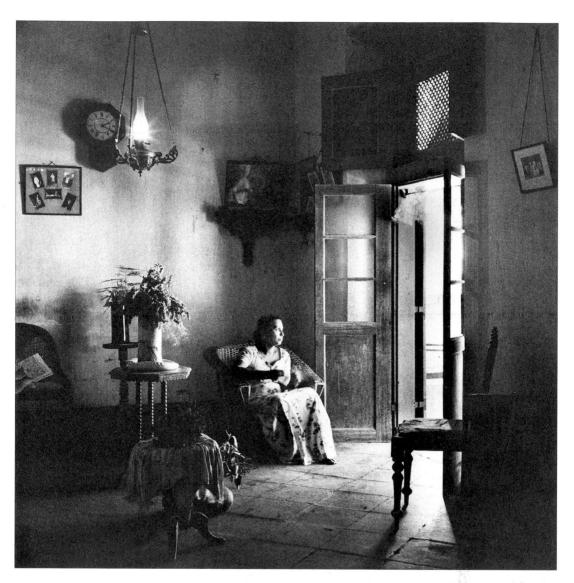

Low-key Suitably filtered by the doorway, the intense tropical sun of Sri Lanka paints a low-key scene of delicate and subtle tones (above). Even a casual glance tells us that this room is central to the life of its owner, who sits in the half-shade gazing into the light of a new day, and surrounded by objects from her past. The camera position gives a viewpoint from the deepest shadows of the room, implying that the presence of the photographer is unknown to the subject.

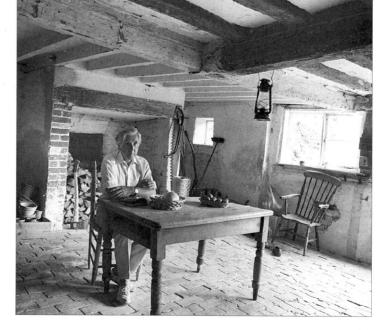

High-key Although as sparse as the room above, high-key lighting has reached into every corner and removed the last vestiges of intimacy from this scene (right), giving the room a much more open, less painterly, atmosphere.

Photographic montage

If you want to get away from the conventional recording aspects of photography, then photographic montage is certainly worth trying. This fascinating technique combines different images to build up a composite. This mosaic can be produced using traditional prints, or employing newer digital techniques.

Mont mosaic You can see from this montage of Mont St Michel (below) that it would have been difficult to include the foreground, island and buildings on a single frame without moving much farther back, and then the impact and scale would have been much reduced. Instead, I used elements of eight different shots taken from exactly the same position for the final mosaic effect. This uniform perspective gives the work continuity, while minor variations in tone or colour are acceptable as they provide texture. The different angles of the shots have created an overall shape to the montage that closely resembles that of the mount itself. The diagram (right) shows the first stages of the assembly process. The overall design of the composition has been worked out, and the eight individual photographs have been positioned and then roughly taped in place.

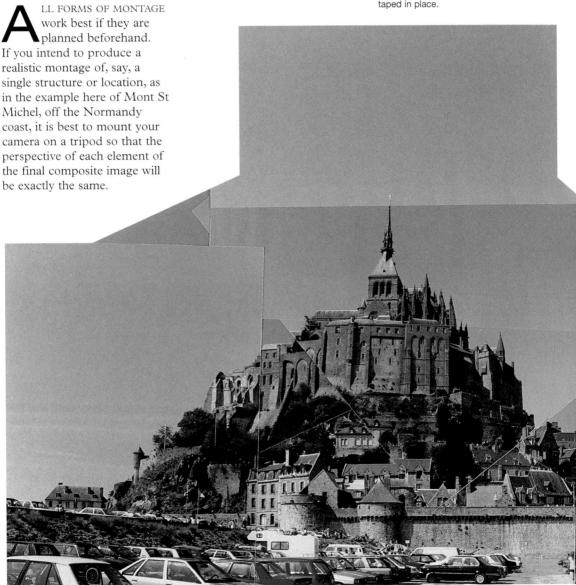

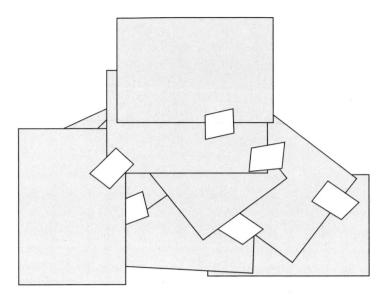

Basic technique

Look carefully at all four corners and edges of the viewfinder, taking special note of how much of the scene you are including with each framing. After the first shot, pan the camera on its tripod so that the next shot overlaps with the first. Continue to pan either across or up and down.

Remember that if you want the final montage to appear continuous, you must allow for plenty of overlap between shots.

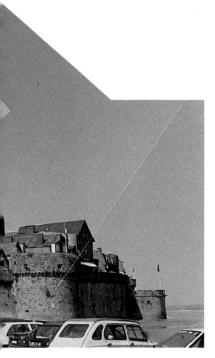

The technique can be particularly useful when photographing wide panoramas or tall buildings, where it is impossible to fit the scene into the one shot; or when a wide-angle approach would create large areas of wasted space. Here, the image area is tailored to the dimensions of the scene that you take. It is possible to compile such mosaics using hundreds of images.

An advantage of the technique is that it provides a more detailed shot of the scene; with a digital camera, the effective number of pixels used to create the image may be vastly increased.

Plan how many shots you want or need before you actually take the shots; this will let you see where the overlaps will occur, and will allow you to pick a suitable focal length (a short telephoto lens is usually the best choice).

Some digital cameras have special facilities to help you line up panoramas using this technique. There is also a number of software programs available that will help simplify the stitching-together process on the computer. Using careful alignment and basic digital retouching skills, it is possible to create mosaics in which the

Assembly

- 1 If prints have white borders, trim these off.
- 2 Lay all the prints out on a clean, flat surface.
- 3 Arrange the prints so as to form the mosaic roughly, and so that each of the prints overlaps.
- **3** With a knife, remove any surplus from each print, leaving some spare for taping.
- 4 Apply double-sided tape to the back of each print, and assemble the montage.
- 5 Use pencils, pens or dyes to hide any joins, add shadows, etc.
- **6** When dry, use double-sided tape to stick the montage to a backing board.

joins between the individual images are impossible to see.

The traditional way of creating these pictures is to use negative film, and then to suck together the enprints. It can then be displayed in this way or the assembled jigsaw puzzle can be re-photographed (see box below). Either way, it is difficult to avoid the joins showing between the individual prints.

The technique can be used for all manner of static subjects. You can also be more 'artistic' in your approach: using cubist principles, for instance, to show a building or face from all angles within the same mosaic.

Copying your montage When copying any print, document or artwork, you must ensure that the original is parallel to the camera back. In this way, all of the original is the same distance from the film or sensor, and will be recorded in focus. To copy your montage, lay it flat and position the camera directly over the centre, with the lens looking down. Special copystands are available for this. These have built-in lamps and a vertically adjustable camera mount. However, with many photographic enlargers you can remove the head and attach the camera by the tripod mounting thread.

Still-life

Whereas many areas of photography rely on quick reflexes and being in the right place at the right time, shooting still-lifes is more a matter of patient observation and having an eye for a pleasing arrangement. Projects in this chapter deal with both 'found' still-life subjects and those arranged specifically for the camera. Because of the nature of the subject matter, lighting is critical: the play of shadow against highlight, the colour of natural daylight at different times of the day, or the quality of studio lighting, are all of the utmost importance.

A restricted palette The essence of good still-life composition is refinement, of shape, colour, tone and form. Here, all the essential qualities that convey the reality of these simple objects are described by light from a single window and by the use of a limited palette of colours.

Using found still-lifes

A still-life is any object or group of objects arranged, either intentionally or by chance, in such a way as to make a pleasing composition. In this introductory project on still-lifes, we will be concentrating on 'found' still-lifes: in other words, objects that have not been primarily arranged for the camera.

OW MANY TIMES HAVE you caught yourself in an idle moment reaching out your hand and making some minor adjustment to the position of an ornament around the home? Perhaps a table lamp, an ashtray, a family photograph or vase of flowers has looked slightly out of place. If you work at a desk, you probably have a preferred position for the tools of your trade: the telephone in relation to your computer keyboard, or the contents of your book shelf. Whether you realise it or not, these preferred arrangements of inanimate objects are found still-lifes. and the world abounds with them.

For this project, you will need to take the time to look and see these unintentional arrangements. In many instances, though, found still-lifes are entirely natural: a wind-built mound of autumn leaves piled against the trunk of a tree; a piece of bleached and twisted driftwood cast up above the high-tide line; the still glistening, salt-encrusted fingers of seaweed exposed by low tide; or the scattered objects of the garden shed. All are legitimate subjects.

TECHNICAL TIPS

- As most still-life subjects are relatively small, they are generally shot from close range. This makes precise focusing and adequate depth of field essential.
- Try and use a tripod whenever possible, as this will allow you to use smaller apertures to ensure maximum sharpness, without any risk of camera shake.
- As you have more time than with many other subjects, check that the camera is correctly focused.

Isolated element With this figure (left), what first attracted me was the colour contrast still visible in his battered appearance; then, I was taken with how uncharacteristic he was of the over-animated, always shouting typical football player.

Colour harmony Colour is one of the best ways to link different objects into a successful group. Here, the similar warm brown tones of the potatoes, bench, fork, containers and knife help the elements bond together into a successful composition (right). Remember that whites and blacks count as neutrals when combining colours.

Public display This amusing still-life (below), on both sides of the window, presents to all passers-by a wonderful contrast between the past, the present and the future.

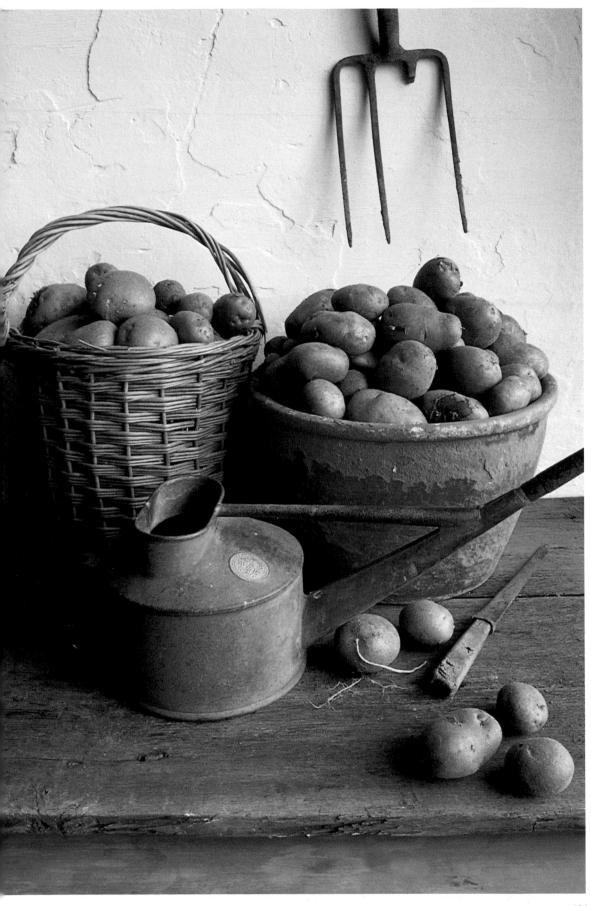

Shooting around a subject

Once you are satisfied with photographing found still-lifes, you can start to create your own. By choosing one simple object and using different camera viewpoints and lighting effects, you can create a series of very different pictures. And the choice of subjects for the still-life photographer is practically endless...

on arranged still-life subjects, you will need to come to terms with how very subtle changes of camera position and lighting can have a dramatic effect on your finished pictures.

The best way to do this is first to place the camera on a tripod, as this will allow you to make small adjustments to the arrangement more successfully. You should arrange the subject where

you can move freely around it, leaving plenty of room to place your lights or reflectors. This positioning will also allow you to view and shoot subjects from different heights, producing the series of shots required for this project.

When arranging any still-life subject it is vital that you keep monitoring it through the camera's viewfinder whenever you move something or add to the composition. There is no point in judging the elements of the composition, and checking that the direction of the illumination is satisfactory, when you are standing beside the still-life if the camera is in a different position and at a different height.

Even a difference of an inch in viewpoint can change the apparent relationship of one object to another with these close-ups. Develop the habit of always viewing the set-up from the camera position alone.

Changes in camera position In this first shot of the exercise (below left), I shot the vase of sunflowers using a 28mm lens. By coming in this close, I have changed the apparent size of the flowers in relation to the room. Next (below centre), I moved in a little closer and to the

right, allowing space for the two figures, who act as stepping stones that take the eye through the frame. For the final shot (below right), still using a wide-angle, I pulled right back to reveal the sunflowers in their relationship to the table, and the table to the room.

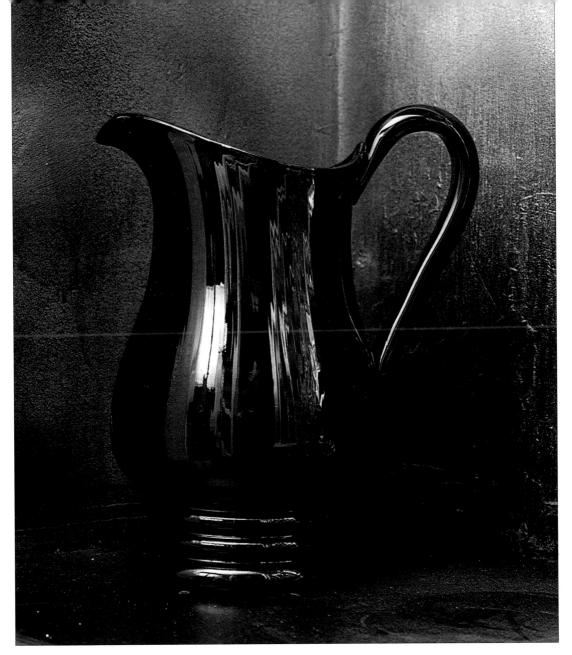

Changes in light It is hard to believe, but both these photographs are of the same black glass jug. In the first picture (above), it is seen in its normal colour, positioned in a grey-coloured alcove that I painted specially for the shot. The lighting here is noonday sunlight. For the next picture (right), I left the jug untouched and waited until sunset to take the picture. The light at this time of day is so heavily filtered by its passage through the atmosphere that the golden light has transformed the jug's colour.

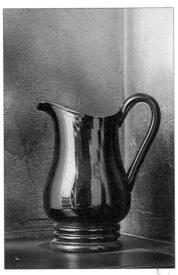

TECHNICAL TIPS

- The most successful still-life shots are those with a very limited number of objects. Sometimes a single one will even work well.
- A good approach when shooting several objects is to build the image up gradually.
 As you position an object, look at it through the viewfinder to check if it has helped the composition. Add more things until the shot is perfect, taking back-up shots along the way.

Themes in still-lifes

In this third project on still-lifes, the emphasis is very much on selecting a particular theme. Perhaps the most difficult discipline in this type of photography is knowing when you have finished: in other words, when to stop arranging elements of your composition. This task is considerably easier when you have a theme in mind.

AVING WORKED ON THE previous two projects on still-lifes, you should now have a more developed idea of the type of subject matter you find interesting or appealing.

In this project, you will be dealing with multi-element compositions that you have chosen because of how the objects relate to each other.

In the following pictures, I have taken ordinary domestic items, typical of those found

around most people's homes, as my source.

These compositions work well largely because the items of each photograph appear logically to belong in close association with each other, thus relieving the composition of the need to justify or explain the selection made.

The objects could be linked by their shapes, forms, colours or materials as well as by their functions. This is perhaps the key issue in putting together still-life pictures: choosing and arranging objects that work together as a whole, in a sympathetic lighting scheme, and in a relevant and appropriate setting.

You need to develop the skills of an interior designer: learning to be instinctive about which colours go together well; which backdrops will accentuate the subject; and how textures, shape and form can be subtly enhanced with the careful use of lighting.

Keep it simple A mistake beginners often make is trying to cram too many objects into the frame. In this image (below), I have used just three items, allowing the tonal contrast of the objects themselves against the plain white background to add strength to the overall effect.

High-key This composition (below) contains objects made of a variety of different materials and with different surface characteristics, heights and colourings. However, by arranging them in full sunlight and over-exposing slightly, they blend well into an appealing high-key image.

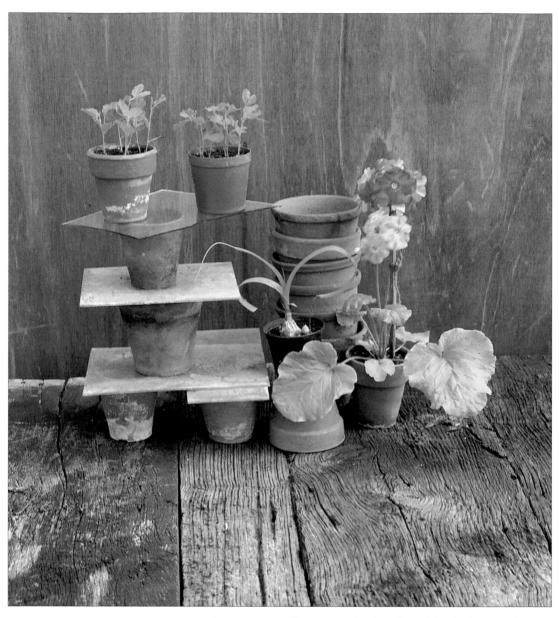

Minor intervention Apart from adding the flowering plant (above) to balance the stack of pots on the left, this composition is exactly as I found it on a greenhouse shelf.

Sympathetic shapes This entire composition (left) has taken as its theme simple, rounded shapes: the eggs themselves, contained in their dark wire baskets, and the enamelled jug. Soft sidelighting has been used to emphasise form.

TECHNICAL TIPS

- Access to a good range of props is vital for the successful still-life photographer. It is often the small elements that are added, say, to a food shot, that finish off the composition.
- Keep a constant look-out for bowls, jugs, containers, tools and so on that you can borrow from friends and relatives for use in your own still-life projects.

Variations on a theme

Small changes make big differences. If you bear this fact in mind, you should be able to avoid some of the more obvious mistakes often made in still-life photography. The colour and style of your background, for instance, are crucial components in the still-life composition. Lighting, exposure and film are also part of the way you interpret the shot.

ACKGROUND COLOUR can set the mood and atmosphere in photographs. Dark colourstend to limit the spatial quality, giving a confined, intimate or even brooding feel.

In stark contrast, light or pastel colours impart a sense of space and freedom. This is the essence of this project.

It will help if you can organise a space within which to arrange your still-life that

TECHNICAL TIPS

- A still-life backdrop is not just the material that you see behind the subject: often, it can encompass the surface on which the subject is resting. It may even be the same if you are using a gently curving cove, or photographing the arrangement from above.
- As with props, still-life photographers collect suitable materials to act as backdrops. Not just lengths of cloth, but pieces of interesting-looking wood, sheets of metal, panes of glass, tiles, and so on, can be of tremendous use. The key is to have choice.

can easily be changed in terms of its colouring and lighting. In the pictures below, for example, the little alcove in my studio has been used many times and has been painted countless colours.

Colour variations For the first shot (above left), I experimented with different paints before finding this warm brown colour, entirely suitable for the pastels and beige of the dried flower arrangement. For the next picture (above right), I painted over

the brown with a coat of lemon-yellow emulsion. Immediately, the image seems to have far more space, though camera viewpoint is practically identical. Over-exposing the picture by half a stop has increased the feeling of warmth and light.

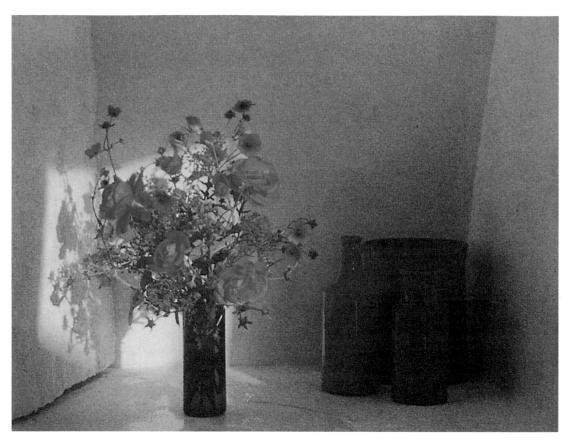

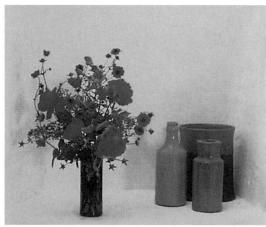

Soft and sharp These two images of an identical set-up were taken within five minutes of each other using subdued daylight. The alcove itself is constructed from painted plywood. In the first version (above), I used light from the side and from the alcove's open top to produce a well-balanced, straightforward shot with plenty of contrast. For the next (left), I simply added a diffusing filter to the lens.

Direct and indirect In the two shots below, a change in lighting has radically altered the atmosphere and appearance of the simple still-life. In the first (below left), diffused lighting on both sides of the table creates an almost shadowless scene with soft colours. With the second approach (below right), both studio lights are placed to the right side of the table, and are less diffuse. This creates strong, graphic shadows, and intensifies the colour in the sections of pear that are well-lit.

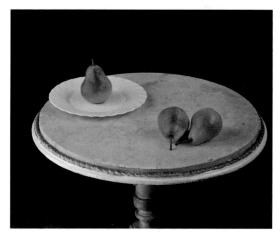

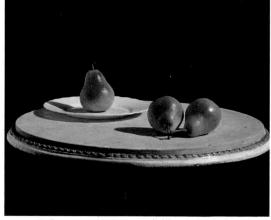

Difficult materials

Certain materials encountered with still-life subjects present particular problems. Clear glass objects can be problematic, especially when you want to show both form and transparency. Silverware, glaze ceramics and any highly polished material can frequently cause problems with reflections. Most difficult of all is a mixture of these materials in one shot.

or This Project, Two still-lifes using difficult materials are required. The first one should contain objects with shiny and highly reflective surfaces. The second shot should contain objects made of glass.

Glass and polished surfaces can act as mirrors, reflecting back light in the form of intense highlights, or 'hotspots'. Also, just like a mirror, they can produce recognisable reflections of anything in front of them, thus confusing the image generally and the object in particular. A way to avoid this is to use diffused, indirect lighting, such as that from a photographic brolly or daylight through netted curtains.

Indirect light may, however, give a dull and lifeless

appearance. To avoid this, include some controlled reflections. A square of white or black card (whichever is appropriate) could be held in front of an object so that it is reflected in its shiny surface. This simple technique can add that all-important element of form and help define shape, and is particularly useful when photographing glass objects.

Black reflector The lighting for this picture (above) was a special photographic 'window light', which simulates the effect of natural daylight. It gave me the overall illumination I wanted, but I also reflected a piece of black card in the lines of the fork while allowing the knife handle to reflect the white tablecloth.

Photographic umbrella Initially, when this plate and spoon (above) were lit with photofloods, the reflections were such that nearly all colour was desaturated and thoroughly unsatisfactory. The solution was to bounce the light using white brollies, which give a very even, diffused illumination.

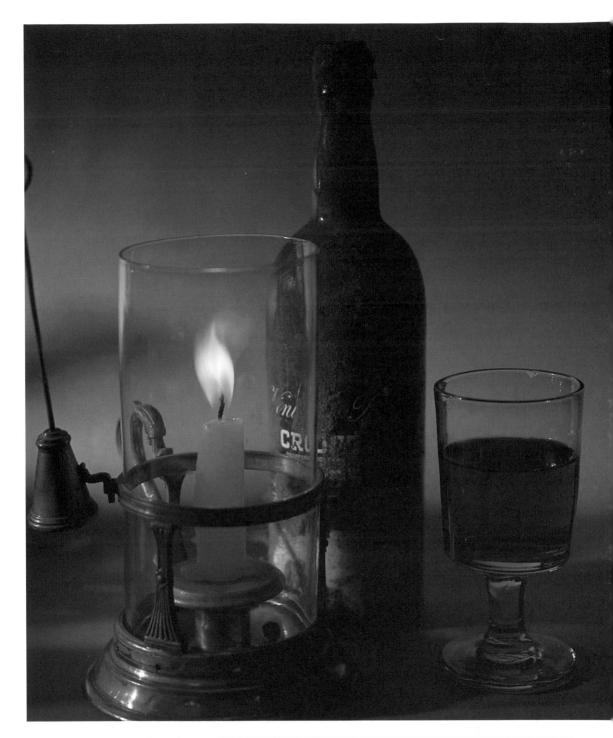

Warm glow For this picture (above), to avoid too many confusing reflections subdued lighting was used. It is deliberately photographed to look as though it is shot with candlelight, but the main illumination is actually provided by a desklight to the side of the scene. By using daylight-balanced film (or a daylight white balance setting), this creates a warm, orange colour cast across the arrangement.

TECHNICAL TIPS

- With very shiny objects, there is a risk that the camera and the photographer will be recorded in the picture as a reflection.
- A solution is to surround the object in a 'light tent', a cylindrical
 or conical arrangement of translucent white drapes. Lights can be
 placed as required around the tent, and a small hole is made for
 the lens to look through into the tent. Alternatively, a large sheet
 of black card with a hole cut for the lens can be fitted on to the
 front of the camera.

Food as still-life

As well as being a pleasure to eat, food also makes an excellent subject for still-life photography. Meat, fish, bread and fruits, as well as cakes and pies, have a wide variety of textures, shapes, colours, patterns and forms. Best of all, you can often find them already displayed to perfection in shops and restaurants.

have to produce a set of pictures featuring food as the main subject. The shots can be 'found' still-lifes, in as much as they were not created specifically for the camera, or pictures of food that you have arranged yourself at home.

Shop window displays are often a good source of found still-life subjects. The shopkeeper will have tried to make the food appear as appetising as possible, and there is nothing to prevent you from taking advantage of the photographic opportunity presented by these windowdressing skills.

If reflections from the glass are a problem, a polarising filter will often help. Remember to rotate the filter until the polarised reflections are reduced as much as possible. Make sure you look at the surface of the glass properly for dirt or condensation, and do

TECHNICAL TIPS

- The type of lighting that works best for still-life is governed, at least to some extent, by how complex the arrangement is.
- Simple set-ups, with one or two objects, might be lit with sidelighting to emphasise form and texture.
- With elaborate subjects with a myriad of objects, directional lighting will not usually work, as each object casts a shadow that obscures something else in the picture. Flat, diffuse lighting that illuminates everything evenly is required.

not overlook the fact that your own reflection may be visible.

If, however, you want to photograph a food display inside a restaurant, where you will often find some very appetising arrangements, you must request permission. I have never yet been refused – in fact, my request has usually been taken as a great compliment – but you must ensure that you do not cause a nuisance, either to the staff or to other diners.

Eye-catching display The shopkeeper of this establishment (above) has obviously decided that every square inch should be covered with sausages, smoked hams and prepared meats of all descriptions. From a photographic viewpoint, fewer elements might have been better, but it is still an interesting shot. You can always simplify such a scene by zooming in closer to concentrate on just a small area of the display.

Advancing colour This is another found still-life (above): the arrangement had been created by a gardener to use as a table display. Light was from a bright, open sky, but I shot the picture in partial shade and not in direct sunlight. It is interesting how strongly the red strawberries advance towards the view when seen against the cooler green colour of the leaves.

Compliments to the chef After enjoying the most marvellous fish meal in a restaurant, I asked the chef if I could take his picture (above). He was more than pleased and, since it was towards the end of lunchtime, he even had his kitchen staff refill the rather depleted display of fish from which we had chosen our food. The shot was taken in bright, overcast conditions.

Epicurean feast Compositions that fill the frame, such as kitchen scenes, are worth shooting. However, they involve painstaking work to get everything in a suitable place so that the scene looks enticing rather than just a jumble of different foods. Still-life shots like this can take hours to set up successfully.

The Natural World

his chapter is largely concerned with the photography of animals. Domestic animals and pets are relatively straightforward subjects, since they are usually very familiar and comfortable with people in close proximity. However, wild animals, in zoos, wildlife parks and sanctuaries, are altogether more challenging. Often, many patient hours will have to be spent motionless in hides to obtain a good picture, or special flash set-ups used for nocturnal creatures. With small or cautious subjects, the need for telephoto or macro lenses is paramount.

Patience and luck Getting good wildlife shots means being in the right place at the right time. Sometimes, you can be fortunate; at others, there is nothing for it but to sit and wait patiently for the subject to arrive. Either way, to maximise your chances it helps greatly to know something about the flora and fauna you are photographing.

Animals on home turf

LTHOUGH, TRAGICALLY, there have been many casualties among animal species because of the activities of mankind, many

Pictures of wild animals represent a special challenge for photographers. Animals that survive to maturity do so because of a highly developed sense of caution. Even the scavengers that have learnt to take advantage of man's waste or generosity are innately shy and difficult subjects.

> Winter forage Pheasants (below), long bred for hunting, have lost some of their natural instincts; in country areas, in the early morning, they will come very close to houses. This shot was actually taken from inside the house using a zoom compact camera.

Garden birds Although a common sight in many gardens, the thrush (bottom) is still well worth photographing. Its most noteworthy feature is its proud, speckled chest, so ensure that this is prominent in the shot or it could look rather dull

animals, a 300mm lens is adequate. However, this focal length won't do it all for you. You still have to be quite close to take shots of birds such as robins in order to fill the frame.

· For most garden birds and

TECHNICAL TIPS

- A zoom (say 75-300mm) is ideal for garden work, giving the option to take wider shots.
- · Longer lenses are useful for more exotic birds and mammals, but these can be expensive. A teleconverter is a good low-cost alternative.

need to take pictures of at least two different types of wild creature: say, a gardenfeeding bird; and a more testing subject such as the wild fox featured opposite. By necessity, subject matter must be governed by the types of animal you have in your particular locality. You can make your task

others have learnt to adapt

and even flourish, and can

be approached sufficiently

a rewarding pastime.

closely to make photography

For this project, you will

easier by providing local animal species with a ready source of food and drink, something that will be especially welcome during winter when birds and animals will venture nearer houses in search of scraps of food or ice-free water.

A good telephoto lens is invaluable for bringing subjects closer in and getting a good-sized image: a 300mm focal length is a good starting point. If you are trying for pictures of insects, the macro lens or extension tubes are almost essential.

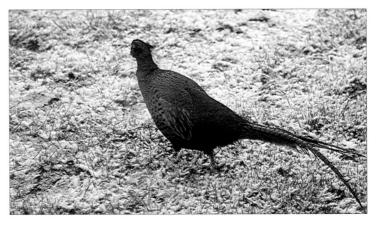

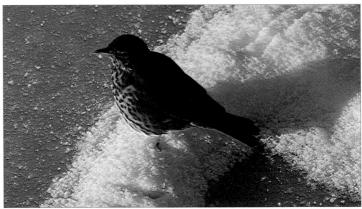

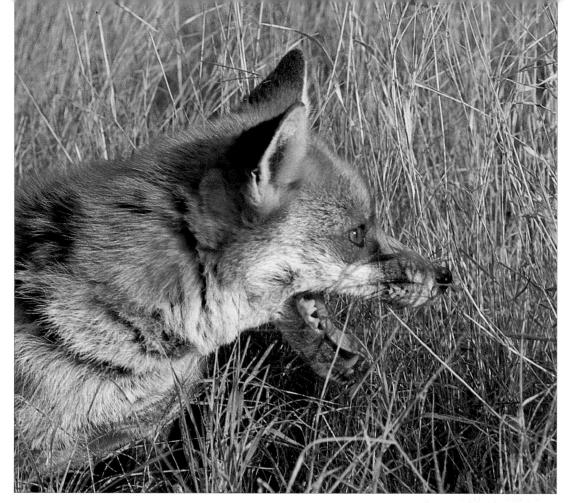

City foxes Many foxes (above), having been hunted out of country regions where they are considered vermin, have made a successful transition to city life. They can be seen at night in suburban gardens and, sometimes, even sunbathing on quiet roofs during the day. This picture was taken in late afternoon on a stretch of wasteground.

Friendly mouse This shot (right) is a bit of a cheat, since the mouse was semitame and readily accepted food from the hand. However, it makes a great natural-looking shot all the same.

Anyone for cricket? For this picture (right), the macro facility on some zoom lenses is adequate to give a good-sized image. Be careful not to put your own shadow over the subject when you are working very close-up.

A day at the farm

If you are photographing people going about their normal work, you need to take an easy-going, good-humoured and flexible approach so as not to get in their way. This is especially important in an environment such as a farm, where everybody is usually occupied with specific tasks.

TECHNICAL TIPS

- In this type of situation you are not trying to show the animals on their own: in any cast, most are large enough and tame enough to make long telephoto lenses unnecessary.
- Wide-angle and standard lens settings are ideal for showing the animals in context: in their groupings, and against the backdrop of their environment.
- Remember that farms are working businesses, so listen carefully to any instructions you are given about safety and animal welfare.

OU CAN REGARD THIS project as a type of photoreportage, where the assignment is to capture images of as many aspects of the farm and the agricultural way of life as you can in a single session.

If vou don't know of a farm nearby, do not despair. The telephone book will give you the numbers of many farming associations which will give you some leads. Local schools often arrange annual visits to a farm, and you might be able to go along as a helper. Failing this, it is not uncommon to find city farms - small areas set aside and stocked with typical domestic livestock which city kids can visit to get the feel of the countryside.

Some general advice: wear old clothing and water-proof boots. Farms are often muddy, and you don't want to be worrying about where you put your feet. Deep pockets in a coat will be useful for spare lenses, extra film, filters, and so on, to save you carrying a camera bag.

Arrive as early in the morning as possible: the farming day starts at sunrise, and you will need to get in as much activity as you can.

High-steppers Early-morning light (above) casts long shadows from these chickens, which seem to be stepping daintily over the hard ground as if it is too rough for their liking. A high viewpoint creates a relatively plain backdrop against which to frame them.

Rotund sheep This shot (below) works well because it shows the sheep so replete after their day's feeding that they cannot be bothered to graze. The backdrop of a wonderful old thatched barn creates a strong diagonal line that leads the eye through the picture.

Side issues Here (above), the farmer's wife carries home her small dog that had hurt itself on some wire. For complete coverage, you need to show the daily routine of the people.

Reawakening appetites The cooler afternoon had rekindled the desire for food in these pigs (right). They were obviously very relaxed and content rooting in the grass.

Final chores The cows being brought into the near paddock (below) provide the final photograph of the series.

Flowers and flower gardens

Photographing flowers in a garden setting can present a problem: there is a danger that images may look like little more than illustrations for a seed catalogue. Unless you require a straight record shot of a specimen, it is often best to compose the shot to include some other garden feature, or a person.

Single-species planting The merit of this shot (above) lies in the quality of the lighting. The sky was quite dark, and this has helped produce wonderfully saturated colour.

Single bloom For this shot (left), I used diffused flash. This was sufficient to allow me to select a much smaller aperture, throwing the background into contrasting darkness while keeping the light looking natural.

Mixed planting This shot (below) demonstrates that mixed planting often makes for a much more interesting and lively picture.

ARDENS ARE DESIGNED primarily for walking in, for breathing deeply the fresh fragrances of flowers or new-cut grass, for the sounds of birds or moving water – and not, unfortunately, for the sometimes dispassionate single eye of the camera. This is not to say that you cannot take evocative flower studies, only that it is not always an easy task.

Flower close-ups

One often effective method of introducing a little drama into flower pictures is to move in close and fill the frame with just a single, open bloom.
Certainly, if you want to attempt this technique with a small flower then you will need somewhat specialist equipment and, preferably, an SLR.
Close-up tubes and macro lenses are designed specifically for this task (see page 43), but many digital and film compacts have macro facilities that provide close-focusing capabilities which are adequate to cover many flower species.

Larger flower specimens, however, are easy to photograph with the telephoto setting of a zoom lens. Just after rain is a

Naturalised planting It is easy to see from this photograph (right) the additional strength that is imparted to a composition once a feature other than the plants themselves is introduced. Use your hand to crop out the fallen tree and you will immediately notice the difference. This woodland setting was an extension of a formal park. The intensely bright sunlight was softened considerably by the canopy of leaves.

Formal garden For a general view such as this (below), the roses would have appeared poor subjects for a photograph without the unifying structure of the box hedge to hold the composition together.

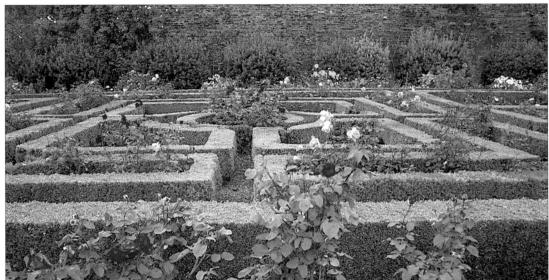

good time for such shots. Assuming the petals have not been distorted or damaged, the flower will look fresher and there may still be tiny water droplets within the bloom.

Flowers in situ

Broader views of singlespecies plantings, mixed plantings, formal gardens or natural-history shots of naturalised flowers do not require any specialist equipment. With these, unless you can find some type of unifying structure to the composition, or include in the shot some form of garden feature, results could be dull and disappointing.

To accomplish this project, you do not have to restrict yourself to any time span or location, although you may find that your own garden or a nearby park has all the elements needed.

You should aim for a series of pictures ranging from single blooms through massplantings and more traditional garden views to a naturalised flower display. Each of the photographs must stand on its own merits, and not rely on the others in the sequence to give it purpose.

TECHNICAL TIPS

- Floral colour looks strongest in frontal, direct light, but the strong shadows created can mean the subtlety is lost.
 Semi-diffuse light, with sun just covered by cloud, often works best.
- To keep flowers from swaying in the wind as you photograph them, get a helper to hold a sheet of card or board to act as a windbreak.
- Alternatively, use canes or wires to stake the stems.

Zoos and wildlife parks

With zoos, wildlife parks and animal sanctuaries continuing to proliferate in most countries around the world, photographers have never had such easy access to exotic animals of all types. Nevertheless, to take good pictures of animals roaming with a reasonable degree of freedom still requires skill, patience and a fair amount of luck.

o PRODUCE A satisfactory set of photographs for this project, you will need to pay a visit to one of the animal institutions mentioned above. But more than simply snapping animal portraits, concentrate on revealing through your work something of the animals' habits or habitats.

Thankfully, the type of zoo with animals penned behind bars in sterile concrete bunkers is fast disappearing. However, very often there is still a wire safety fence separating you from the animal enclosures.

If the mesh of the wire is wide enough to push your camera lens through without danger, then there is no problem. With close-mesh barriers, however, you need to place the front element of the lens as near to the wire as possible and use the widest aperture you have available (use the same technique when you are photographing through perspex).

This will render the wire so out of focus as to be invisible, although a slight softening of detail and contrast may be evident throughout the photograph. The longer the focal length, the more effective the technique will be.

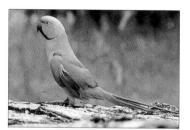

TECHNICAL TIPS

- With close-up shots of animals in captivity, you will be using a telephoto lens, set at a wide aperture to obscure foreground fencing and to obliterate man-made backdrops. This will mean that depth of field will be very limited.
- It is essential, therefore, that focusing is accurate. Focus on the animal's eyes. If these are sharp, it doesn't matter if other parts of the animal are out of focus (the same technique should be followed with close-up portraits of people).

Depth of field Selecting an aperture of f2.8 on a 135mm prime lens (left) gave a narrow zone of focus that was just sufficient for this parakeet.

Observation port This unusual view of seals (below) was provided using an armoured glass observation port.

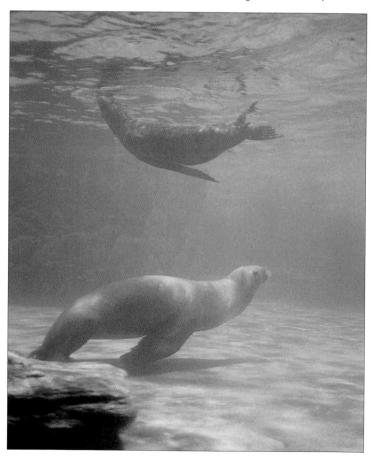

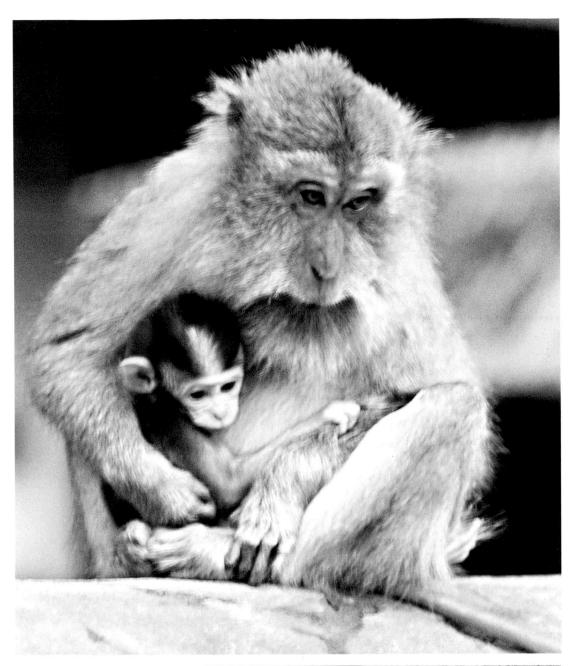

Mother and baby It is hard to avoid getting cute, successful pictures when photographing young mammals. But it is often better to show them interacting with their parents or siblings, rather than photographing them in isolation. Here, the inclusion of both mother and baby macaque makes a charming scene (above).

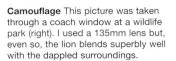

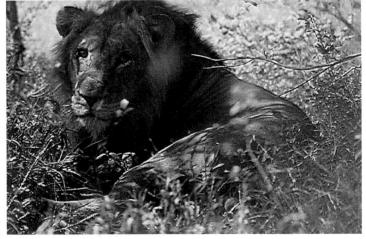

Domestic animals

Unlike the wild animals in the previous project, pets and domestic animals are relatively easy to deal with photographically. Used to being handled, approached, fed or pampered, many of these animals more readily identify with humans than they do with other creatures of their own species.

HEN PHOTOGRAPHING pets, the chief things you need to bear in mind are to make the most of the time. You will need to work quickly but calmly, and it is helpful to have some food or playthings to maintain the animal's interest. Keep the camera as close as possible to the animal's own eye level (as with children). Use flash, since the best shots are often of very quick movements and fleeting facial expressions.

TECHNICAL TIPS

- Just as having a mother to hand when photographing children, a pet's owner can be invaluable in getting the animal to cooperate and to adopt a suitable pose.
- Animals will often respond to verbal commands or to hand signals, and the owner (keeping just out of shot) can assist greatly by getting the pet to look in the right direction.
- Be prepared at all times: the great expressions are usually gone in an instant.

Port in a storm A friend's pet goat (left) unhesitatingly took refuge from the elements in the back of my car, resulting in a comical image.

Using perspective Although the farmer and cow are relatively small in the frame, the converging lines of the track draw the eye towards them (right).

Studio sitting Formal portrait techniques work surprisingly well with pets, particularly if they are reasonably well-trained. Here, the addition of the dogs (bottom right), creates a more informative picture than just showing owner or animals alone.

Feline opposites These shots show how the same type of subject can be handled. The Outer Hebridean tom (above) looks pretty capable in any situation, while the pampered pedigree (right) seems more inclined towards the comfort of upholstered armchairs.

Birds in flight

With wildlife photography of this type, patience and a large measure of luck are your chief allies. Unless the subjects are caged birds, it is necessary to build up a complete picture of the subjects' movements and habits: where they feed, their favourite resting places, where they are nesting, and so on.

HEN PHOTOGRAPHING birds, you must take pains not to interfere with their routine in any way. If, for instance, you found birds with chicks, an insensitive intrusion could cause the parents to abandon the nest and the young to die. A well-camouflaged hide and, of course, a long lens will reduce the likelihood of this.

Offerings of suitable food left along their flight path may well encourage birds to come closer to a concealed camera position or to land on a particular post or branch – as well as improving the chances of survival of any chicks.

For this project, it is not necessary to use wild birds (as in these pictures), but setting and background, as always, are vital components.

If the subjects are caged or aviary birds, it is a good idea to construct a large, wired-in flight area, covered on the inside with a neutral-coloured background paper against which the birds will stand out in bold contrast. Inside this extended cage you can position the flash units and camera, and then trigger the shutter remotely from outside so that the cage is not seen in the photographs.

Bird sanctuary For these studies of a barn owl in flight, I was very fortunate to have had the cooperation of a wild bird sanctuary, which had pairs of nesting birds. To take the shots, two high-output flash units were used: one was attached to a slave unit to fire in synchronisation with the master unit that was wired to the camera. These were placed on one side of the barn, with a large matt-white

TECHNICAL TIPS

- Set to automatic, and used at short distances, the burst of light from a flashgun may last only for 1/40,000 sec. In low light, this enables a flash to capture crisply fast movement that would be blurred with a high shutter speed.
- On full power, a flashgun burst from a portable may last as long as 1/1000sec; a flash from a studio lighting unit may last even longer.
- When using flash, the shutter speed used must be faster than the maximum 'sync speed' of the camera.

reflector on the other to provide fill-in. The lens was a 135mm telephoto, which would frame the bird loosely enough to allow for any slight deviations in its flight path. Flash output was so brief that the owl, captured in mid-flight, hardly even realised that it had been fired. The speed was sufficient to record everything but the tips of the wings sharply.

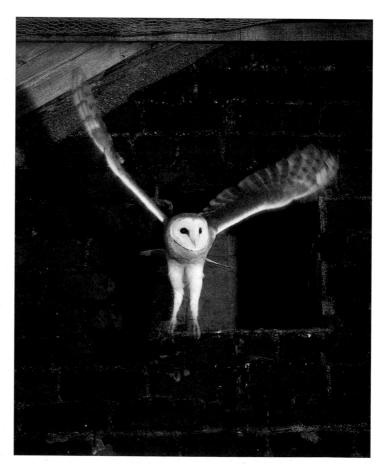

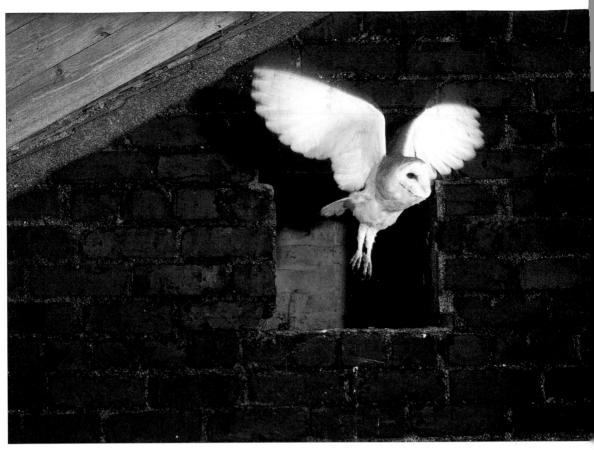

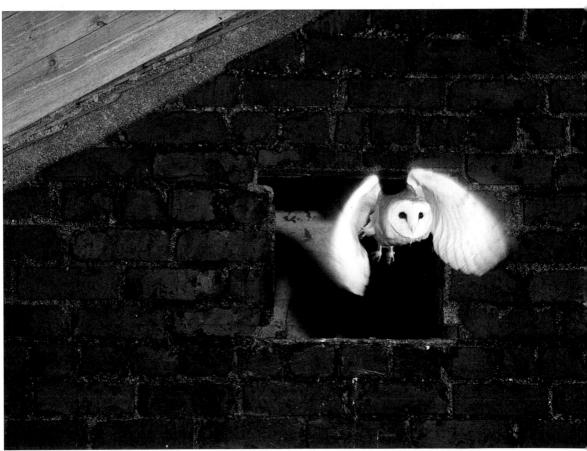

Using specialist equipment

In the vast majority of photographic situations, a reasonable zoom covering basic wide-angle and telephoto lenses is all that is necessary – even a compact may do. But there are some wildlife subjects for which you need an SLR camera, simply because this will allow you to fit specialist lenses designed to give you the necessary angle on your subject.

Macro lens For this close-up of an exotic slipper orchid, a 100mm macro lens was used. Coloured cardboard provided a neutral background but also acted as a windshield.

OR THIS PROJECT,
you may well have to
hire equipment. Even
professional photographers
frequently hire more exotic
pieces of equipment for an
assignment, rather than buying
them. A piece of equipment
you've always dreamt of trying
may be surprisingly affordable
to rent for the day.

The particular optics we are interested in are macro lenses, perspective control (PC) lenses and more extreme wide-apertured tele lenses.

Macro lenses are designed to give optimum results at extremely close focusing distances, allowing 1:1 (lifesize) or 1:2 (half lifesize) reproduction.

Shift lenses allow some of the lens elements to be shifted off-centre, thus correcting the 'converging-vertical' effect noticeable when a wide-angle is tilted upwards to include the top of a tall building.

Extreme telephoto lenses allow very distant subjects, such as timid wild animals, to be photographed at a good image size. Most are primes (rather than zooms) with extrawide maximum apertures for use in low-light situations and to throw the background completely out of focus.

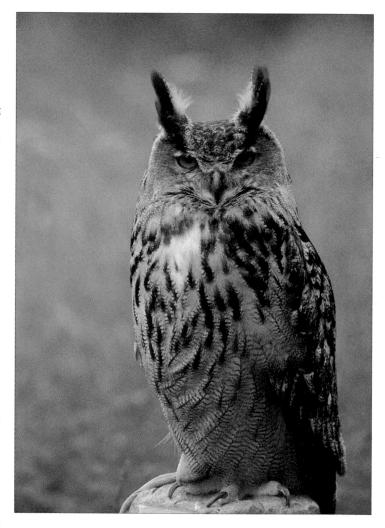

300mm lens Detailed studies of wild birds, such as this Eagle Owl, require a long lens. Here, I used a 300mm lens and an aperture of f4.5 (the widest this lens had). The shallow

depth of field has helped to isolate the bird from the background. This is particularly useful when photographing subjects with subdued colouring or good camouflage.

PC (perspective control) lens For this picture (above), the camera was positioned well below the castle. To have included it all would have meant tilting the lens upwards, causing vertical lines to appear to converge. Instead, I held the camera straight and used the PC facility of the 28mm shift lens to 'slide' the top of the castle into the frame.

500mm lens This photograph of a dramatically coloured bird (left) was taken using a 500mm lens from the position of a well-camouflaged hide.

TECHNICAL TIPS

- There are other, low-cost options to some of these specialist lenses.
- Teleconverters can be used to increase (often double) the maximum focal length of an existing lens. They are available for some built-in zooms.
- Close-up lenses (a filter-like attachment) and extension tubes are low-cost alternatives to a macro lens.

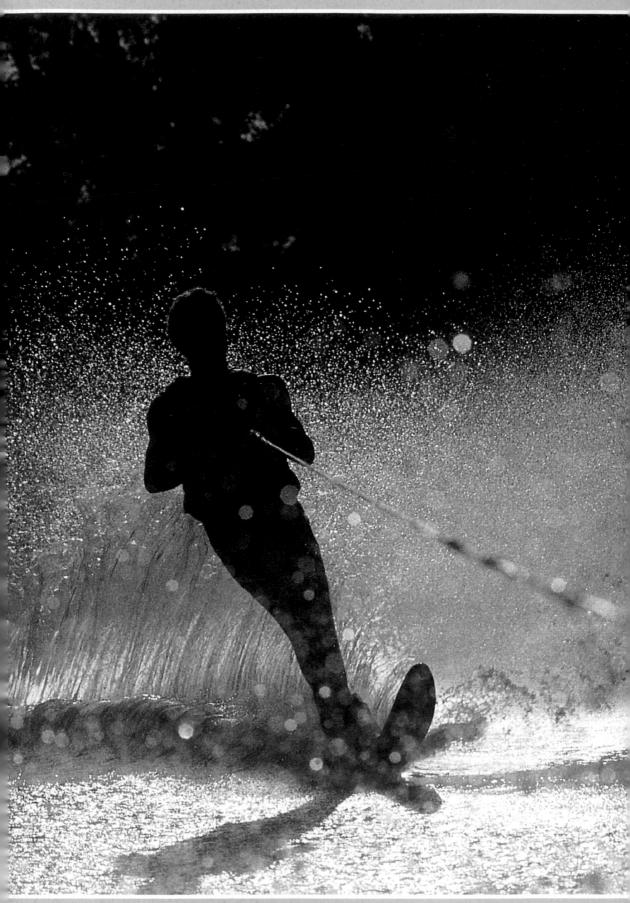

Action

A ction can either be real or illusory, as the projects in this final chapter reveal. The way in which the various camera controls are used is vitally important to the appearance of action sequences on the final image. Shutter speed, for example, is central to the recording or 'freezing' of movement. In some situations, the actual shutter speed might be rendered irrelevant because the stopping power of flash is being used instead. In almost all instances, the closer into the action you can get, either through camera position or through focal length, the more impressive the results will be.

Timing Luck plays a significant part in good action photography. Backlighting catching the spray from the waterski here forms a glistening curtain, separating the figure from the shadowed background.

Technique for action

This first project on action photography is all about interpreting fast-moving subjects, using shutter speed, camera position and choice of focal length. The aim is to produce evocative and exciting images. Often, however, being able to anticipate the way the action is developing is the most important prerequisite.

T IS A FALLACY TO THINK that fast-moving action pictures necessarily require fast shutter speeds. As often as not, relatively slow shutter speeds will give far superior results. This is particularly true when the sense of action is best conveyed by a less-than-sharp image, either with the subject itself being slightly blurred or the background alone (as in panning) appearing blurred.

Related to this are viewpoint and focal length, since these not only determine the size of the subject but also decide the disposition of other elements in the frame in relation to the main subject.

You will need to produce action pictures of at least two different activities. One photograph should feature panning using slow shutter speeds, and the other should capture an instant of frozen action using the fastest shutter speeds available with your camera.

Panning across With action subjects that pass close to your camera position, as with this cyclist (right), you have little alternative but to pan the camera if you want the subject recorded sharply in the frame. How blurred the background becomes, however, will depend on the shutter speed selected.

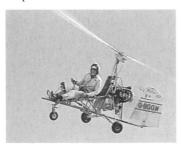

Fast shutter It was important in this shot (above) to use a shutter speed that did not completely freeze the motion of the rotor blades. I opted for 1/1000 sec.

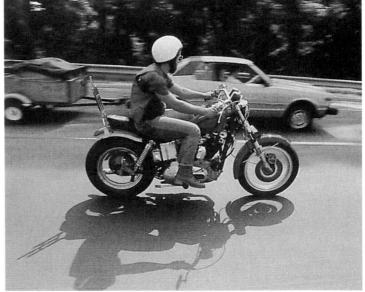

Moving pan In this variation of panning (right), I was travelling at exactly the same speed as the motorcyclist. I panned him using a shutter speed setting of 1/30 sec.

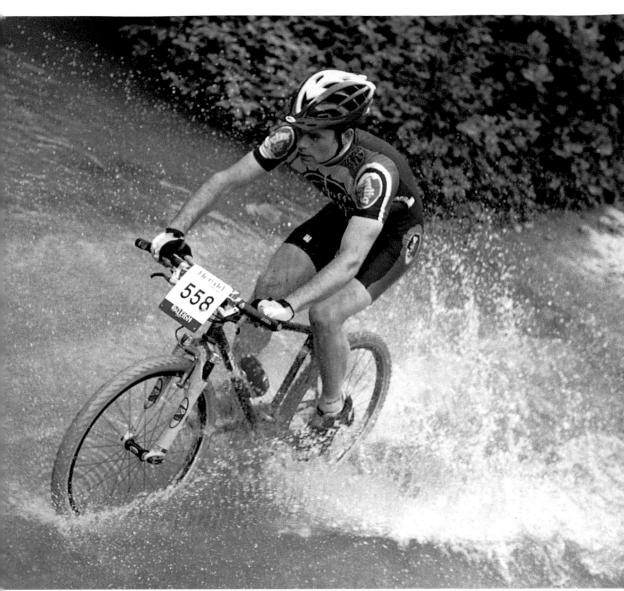

TECHNICAL TIPS

- To pan smoothly, support the camera steadily with two hands, with feet slightly apart.
- Swing your body round from the waist; do not rotate more than a quarter turn.
- Start the panning movement as the subject approaches, firing the trigger as you turn. Try different shutter speeds.

Viewpoint and lens To take this shot (left), I positioned myself on a bend that forced the canoeist towards the bank. I used a 90mm zoom setting and a shutter speed of 1/500sec to freeze some of the water spray.

Capturing action with flash

Using flash to capture action presents the subject in a totally unrealistic way: a bird frozen in mid-flight, wine pouring from a bottle as if a solid crystal of liquid. All this 'trickery' is possible simply because electronic flash delivers its light in a single burst of illumination that lasts for only a fraction of a second.

HE MAXIMUM SHUTTER SPEED that you can use with flash depends greatly on the type and model of your camera.

Compact models use a leaf shutter design, which enables flash to be used at any of the shutter speeds that it offers. The more cumbersome focal plane shutter used on SLRs means the top speed that can be used with flash is limited – generally to between 1/60 and 1/300 sec, depending on the model. If this 'flash synch' speed is exceeded, only part of the film will be exposed to the flash, leaving a dark bar across the exposure.

With many modern cameras, activating the built-in flash

or attaching a dedicated flash to the camera hotshoe means that the suitable shutter speed is set automatically.

Flash duration with modern units depends on the amount of light being reflected back by the subject: the more light picked up by the built-in flash sensor, the shorter the burst of light and the greater the 'freezing' effect. For maximum effect, therefore, use the flash only over short distances.

Arrange your subject in subdued ambient lighting, otherwise light levels may be high enough for a blurred 'ghost' image of your subject to be recorded while the shutter is open, in addition to the frozen flash image.

TECHNICAL TIPS

- There are occasions when you may want to combine flash with the ambient light available in low-light situations.
- With moving subjects, the 'ghost image' created with ambient light can look appealing, and can be enhanced by using a shutter speed below the usual 'synch' setting. Many cameras with built-in flash offer an automated 'slow synch' mode.
- A slow shutter speed with flash may also be useful with static subjects so that the background (where flash has no effect) is not too dark.

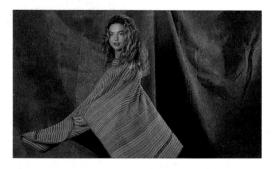

Twin flash For these two photographs of the same model (above and above right), I used two flash units. One was attached to the camera, and the other 'slaved' so that it fired in unison, to overcome the dark and

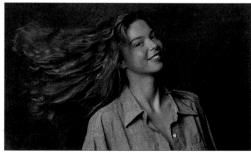

non-reflective surroundings. To get the poncho to stand out rigidly, the girl twirled around while staring directly at the camera. The second shot is similar: I pressed the shutter when her hair was at its fullest.

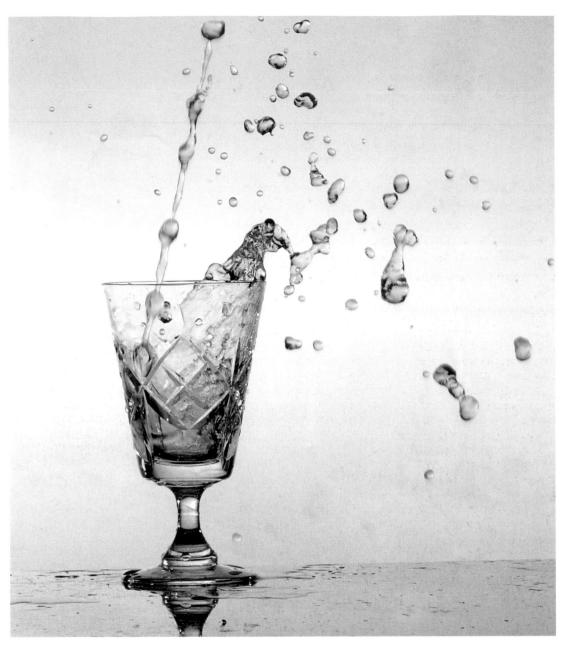

Frozen liquid This type of image (above) is often used in advertising shots. It looks professional but is very easy to recreate. The bright surroundings ensure that any reasonably powerful flash unit, set to automatic, should deliver a sufficiently brief burst of light to freeze the liquid. With film cameras, you cannot tell if the overall effect is right until the film is developed, so take a lot of exposures. With digital cameras, of course, you can review the success of the set-up immediately on screen.

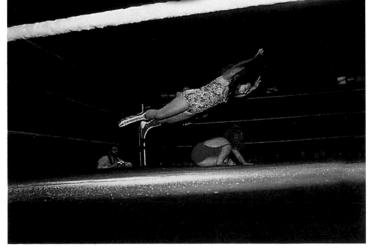

Creating a sense of action

As already demonstrated in the two previous projects, shutter speed has a far more creative role to play in action photography than simply being one of the factors determining correct exposure. Used with imagination, the choice of shutter setting can introduce you to a way of seeing movement and action that is impossible with the naked eye.

Using blur In this shot (right), blurred and sharp detail are combined. The model held still as the balls shot across the table, recording as streaks in a 1/2 sec exposure.

Frozen in space A high shutter speed can mean a moving subject looks stationary. But for this rock portrait (below), the action is still evident despite a 1/1000 sec setting, as the guitarist is suspended in mid-air.

SING THE KNOWLEDGE that as long as the shutter is open the digital sensor or film will record whatever moves in front of the lens, this project is designed to manipulate reality to create some bizarre movement effects with the camera.

The task will be easier to accomplish with a camera that allows you full control over the shutter speed set for a particular shot. However, as you can see from the two waterfall pictures on the opposite page, a fully automatic camera with programmed exposure can be made to cooperate (at least to some extent), with the help of some neutral density filters.

Another important point to remember is that only continuous light is to be used (from domestic bulbs or tubes, photofloods or natural daylight, for example), not flash. Finally, ensure that at all times during the exposures the camera is stationary, preferably mounted on a tripod, because slow shutter speeds are to be used. In all the examples on these pages, the effects are the result of light acting on the film for relatively long periods.

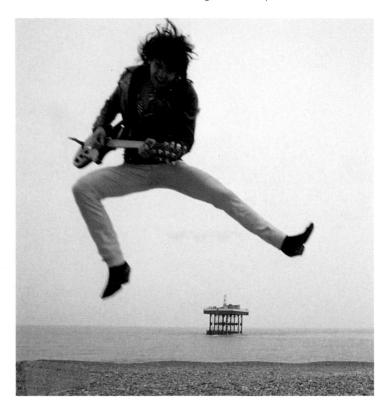

TECHNICAL TIPS

- Always try a variety of slow shutter speeds when trying to blur movement, so you can choose which effect looks best.
- These are good starting points for common slow shutter shots... Streaked car headlights and tail-lights on a busy road: 30 seconds; stars in night sky shown as trails of light: 40 minutes-plus; blurred, foamy water over seafront rocks: 5 seconds.
- If light levels mean that slow shutter speeds can't be achieved, fit a neutral density filter which will cut out much of the light.

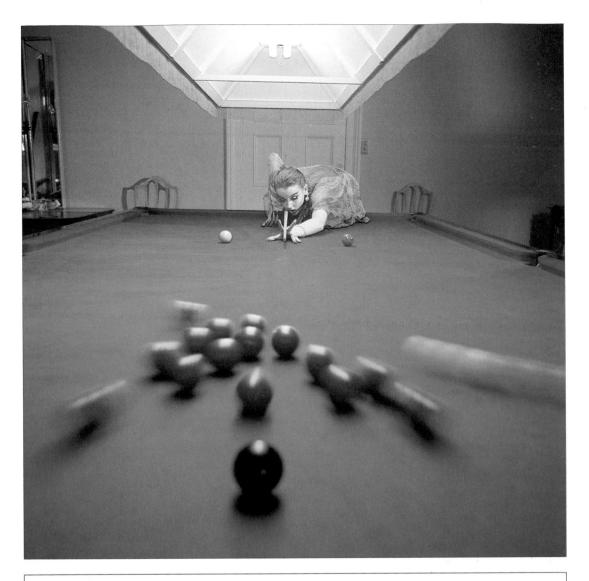

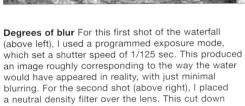

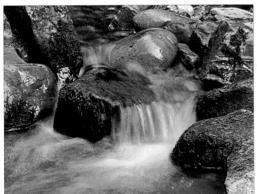

dramatically the amount of light entering the lens, and forced the camera – still set to fully automatic – to select a shutter speed of about a full second (requiring the use of a tripod). This gives the moving water a much higher degree of blurring, an effect that can be very useful in action photography for creating a feeling of rapid movement.

Glossary

Α

Ambient light Term describing the light naturally available for photography. This can be daylight or ordinary room lighting indoors, but not any additional light provided by the photograph (such as flash). Also known as available light.

Angle of view The amount of subject area encompassed by a *lens*. A *wide-angle lens* has a greater angle of view than a *standard* or *telephoto lens*.

Aperture A circular hole inside the *lens* that admits light to the film. The size of the *aperture* can be varied.

Aperture priority Describes an *exposure mode* where the user sets the *aperture* size and the camera sets the *shutter speed* to give correct *exposure*.

APS Advanced Photo System: modern film format used for *compact cameras* (rarely for *SLRs*).

Autofocus (AF) System that automatically adjusts the *lens* to bring the image into focus.

В

Backlighting Any type of lighting coming from behind the subject directly toward the camera. Used for silhouettes. Barndoors Four flaps that fit around a *studio flash unit* that can be adjusted to vary the spread of light.

Bounced light Any type of light (but usually from a flash) that reaches the subject via another surface, such as the ceiling or a wall. Bounced light gives a softer, more diffused effect. Bracketing A series of photographs taken both above and below the settings recommended by the *exposure meter*. Technique used to help guarantee the correct exposure for an image.

B-setting A *shutter speed* setting that keeps the *shutter* open for as long as the *shutter release* is kept pressed down.

Byte Standard measurement of memory of digital storage devices. Digital camera memory is usually measured in *megabytes* (1024 *bytes*).

C

Cable release An electrical or mechanical device that controls the *shutter release*. Allows the *shutter* to be fired without the camera being touched – usually when the camera is fixed on a tripod – to avoid vibration. Locking the release keeps the shutter open when the camera is on the *B-setting*.

CCD (Charge Coupled Device) Light-sensitive chip commonly used in *digital cameras*.

CMOS (Complementary Metal Oxide Semiconductor) Light-sensitive chip commonly

used in *digital cameras*. **Colour cast** An inaccurate

overall or local colour on an image. **Colour saturation** The purity

of a colour resulting from the absence of white or black.

Colour temperature The assignment of a temperature rating, in K (Kelvin), to the colour quality of light. The more orange-red the colour, the lower its temperature; the more bluewhite, the higher.

D

Dedicated flash A flash designed to work with a particular model(s) of camera. Once fitted to the hotshoe, it integrates with the camera's circuitry and cuts off light output from the flash when correct exposure is achieved. Depth of field The zone of acceptably sharp focus both in front of and behind the point of true focus. Depth of field is dependent on the aperture set, the focal length of the lens, and the focusing distance. The smaller the aperture, the shorter the lens, and the farther the focusing distance, the greater the depth of field.

Diffuser Any material used to scatter and thus soften the quality of illumination from a light source.

F

Emulsion An even mixture of light-sensitive crystals and gelatine coating a transparent, flexible base. It is the emulsion that carries the film image.

EXIF (Exchangeable Image File) Data recorded by a *digital camera* along with the image that records such things as *shutter speed, aperture,* date taken and other camera settings used. Can be read using some image-editing software.

Exposure The amount of light received by the film. It is a product of the intensity of light (determined by the *aperture*) and the length of time that intensity of light acts

on the film (determined by the *shutter speed*).

Exposure latitude The range of brightnesses of light that a film or digital sensor can record with acceptable subject detail.

Exposure meter A device, usually inside the camera, that measures the amount of light falling on or reflected by the subject.

Exposure mode Any of a number of ways used to convert a camera's meter reading into a shutter speed and aperture that may be available on a camera. Program, aperture-priority and shutter-priority modes are common examples.

F

File format The 'language' in which a digital image file is saved. See *RAW*, *TIFF* and *JPEG*. The format affects which programs can open the file, and the size and detail in the image. Flash synchronisation The precise instant when the *shutter* is fully open and the flash fires. The *shutter speed* required for flash synchronisation varies, depending on camera type, but it is usually 1/250 sec or slower with *SLR cameras*.

F numbers Also known as f stops, a series of numbers on the outside of the lens barrel denoting the sizes of aperture available. The higher the f number the smaller the aperture. Changing from one f number to the next – either opening or closing the aperture – doubles or halves the amount of light passing through.

Focal length Optical measurement that defines the angle of view and image

measurement that defines the angle of view and image magnification provided by a lens, or particular zoom setting.

Focal plane The plane at which light from The lens is brought

light from the *lens* is brought into focus. This plane coincides with the position of the film at the back of the camera.

Format The size and shape of a particular type of film or

camera. The 35mm format, for example, refers both to the film and to the camera that accepts it. **Frame** A single *exposure* on a roll of film, or a compositional element that surrounds or helps isolate the main subject. **F stops** See *F numbers*.

G

GN See *Guide number*.
Graininess The appearance of the clumps of light-sensitive silver halide crystals contained within the film *emulsion*. These crystals are more noticeable the higher the *speed* of the film and/or the bigger the enlargement of the original film image. Excessive graininess destroys the resolution of fine image detail.

Guide number (GN) A figure that denotes the power (or light output) of a light source (most commonly flash). This figure is usually quoted in meters at ISO 100. Dividing the guide number by the subject distance gives the aperture to use for correct exposure (assuming the use of ISO 100 film). Guide numbers are now not commonly used for determining exposure, as most flash units do this automatically.

H

in focus.

High-key Refers to an image composed predominantly of light *tones* or colours. This type of effect can be accentuated by slight *over-exposure*.

Highlight The brightest part of an image.

Hotshoe A holder on top of a camera shaped to accept the 'foot' of a flash unit, and containing electrical contacts that fire the flash when the *shutter* is released. Hue The name of a colour, such as red, blue, green or yellow. Hyperfocal distance Shortest distance at which a *lens* can be set (for a given *aperture*) while keeping the horizon (at infinity)

I

ISO Abbreviation for the International Standards Organisation. A numbering system denoting the *light* sensitivity, or speed, of a film. The scale is frequently used to measure the light sensitivity of a digital image sensor.

·

JPEG (Joint Photographic Experts Group) A digital file format commonly used by digital cameras. The amount of memory needed is less than that required for TIFF or RAW files, as the information is 'compressed'; the amount of compression is variable, with digital cameras usually having a choice of different 'quality' recording settings.

ı

Latitude See Exposure latitude. LCD panel Liquid crystal display giving information about camera systems and functions. Colour LCDs are used to preview and replay images taken on digital cameras.

Light trail A streak of light on an image caused by a moving light source during *exposure*. Low-key An image composed predominantly of dark *tones* or colours; often accentuated by slight *under-exposure*.

M

Macro lens A type of *lens* that is specially designed to give optimum results when used close up to the subject. Usually these are *prime lenses*, and provide life-size or half-life-size images. However, many types of *zoom lens* have a macro switch that can be engaged when the lens is at a particular focal length setting to allow closer focusing.

Maximum aperture Refers to the widest aperture (represented by the lowest f number) available on a particular lens.

Megabyte Measurement of digital memory, equivalent to 1024 bytes.

Megapixel Units used to measure the maximum resolution of a digital camera's CCD or CMOS image sensor; equivalent to 1024 pixels.

Minimum aperture Refers to the smallest aperture (represented by the highest f number) available on a lens.

Motordrive A motorised windon system built into, or bought as a separate accessory for, a camera that winds the film on after each *exposure* while the *shutter release* button is depressed. The number of frames that can be exposed in any given length of time depends on the speed of the motor and the shutter speed setting.

Negative Developed photographic image showing (with black-and-white film) subject highlights as dark tones and shadows as light tones; or (with colour film) subject colours as their complementaries.

Neutral density (ND) filter A grey-coloured filter that reduces the level of light entering the lens without affecting its colour content. Particularly useful in bright conditions when aperture cannot be stopped down further and shutter speed cannot be shortened.

Normal lens See Standard lens.

Open flash Firing a flash unit manually without releasing the shutter, or with the shutter set on a timer.

Opening up Increasing the size of the aperture (by selecting a smaller f number) in order to allow more light into the lens or to reduce depth of field.

OTF Abbreviation for 'off the film'. A light measurement system where sensors detect the amount of light reflecting back from the film surface.

Over-exposure Allowing photographic material to receive too much light, either by using too large an aperture or too long a shutter speed.

Panning Moving the camera to follow the direction of travel of a subject while the shutter is open. This produces a relatively sharp image of the subject while blurring all stationary objects in the field of view.

Parallax error A problem occurring with many compact cameras because they have a separate viewfinder and lens. It is brought about by the slightly different viewpoints on the subject that each has, and can lead to inaccurate framing with close-up subjects.

PC lens Abbreviation for perspective control lens. A type of lens containing some elements that can be shifted offcentre in order to correct the type of perspective problems noted when a camera is tilted upwards. Thus, the tops of tall structures, trees, etc, can be photographed without distortion. Also known as a shift lens.

Perspective A way of representing the depth and distance of the real world on the two-dimensional surface of a print or slide.

Pinhole camera A basic type of photographic recording device that uses a pinhole instead of a lens to collect and focus light from the subject, to give a soft image.

Pixel A single light-sensitive element in a digital camera's sensor. The basic unit used in measuring the resolution from a digital camera or in a digital image.

Positive Developed photographic image showing (with black-and-white film) subject highlights as light tones and shadows as dark tones; or (with colour film) colours corresponding to those of the original subject.

Predictive autofocus Advanced autofocus setting where focus is adjusted continually not only until the

trigger is fired, but right up until the shutter actually opens. Primary colours Of light: red,

blue and green. Of dyes: red, blue and yellow.

Prime lens A term used to describe a lens with only a single, fixed focal length. The description is used to distinguish a lens that is not a zoom.

Program *Exposure mode* where shutter speed and aperture are set by the camera.

RAW High-resolution file format used by digital SLRs. Red eve An optical effect with flash where the pupils of the eyes appear red instead of black. Occurs when angle between flash and lens is too narrow. Reflector Any material or surface that reflects light. Reflectors are often used in photography to soften the effect of the main light or to bounce illumination into subject shadows.

Sharpness Term used to describe the amount of fine subject detail that can be seen in the photographic image. Shift lens See PC lens. Shutter A light-tight barrier that can be opened for a range of timed intervals to allow light from the lens to act on the film. In an SLR camera, the shutter is situated just in front of the focal plane; in a compact camera, the shutter is more usually situated inside the lens itself.

Shutter priority A semiautomatic exposure *mode* where the user sets the *shutter speed* and the camera sets the *aperture* to give correct *exposure*.

Shutter speed Any of a series of timed intervals, often ranging from 1 sec to 1/2000 sec, during which the *shutter* is open and light from the *lens* can act on the film.

Single lens reflex (SLR) A type of camera, commonly available in the 35mm film format or with digital recording. It features an angled mirror behind the lens and a topmounted pentaprism. With this system, the viewfinder image is always exactly the same as the image seen by the lens, no matter which optic is used. Slave unit An electronic unit with a photosensitive cell which attaches to a flash unit. This cell reacts to light from another flash by triggering the flash that it is attached to virtually instantaneously. SLR See Single lens reflex. Speed 1. Film: refers to the light sensitivity of the emulsion: the faster the film speed, the higher its ISO number and the less light it requires for correct exposure. 2. Lens: refers to the maximum aperture available on that lens: a fast lens has a wider aperture than is usual for the focal length (typically from f1 to 2.8), which makes it more flexible in low-light conditions. Spotlight Studio flash unit with a simple focusing system, producing an intense, adjustable beam of light.

Standard lens A focal length (which varies according to the format of the camera) that produces an image encompassing approximately the same amount of a scene as the naked eye. For the 35mm format, this is a 50–55mm lens. Also known as a normal lens. Stopping down Decreasing the size of the aperture (by selecting a larger f number) to allow less light into the lens or to increase depth of field.

Т

Telephoto lens A focal length with a narrow angle of view. It enlarges distant objects and is ideal for such subjects as head-and-shoulder portraits and natural history. Depth of field at any given aperture is restricted, making accurate focusing critical.

TIFF (Tagged Image File Format) High-quality, but memory-hungry, file format available on some digital cameras.

Tone A uniform and distinct shade of grey between pure white and featureless black. Black-and-white images are composed entirely of *tones*.

TTL Abbreviation for 'through the lens'. A type of metering system that utilises sensors inside the camera body, which measure only the light coming in through the *lens*. This system is now universal on *SLR cameras*, since it produces accurate results no matter which lens is attached to the camera.

Tungsten lamp A type of artificial light source (domestic and photographic) that uses a tungsten filament heated by an electrical current. The light given off has a different *spectrum* (and thus *colour temperature*) from that of daylight.

Tungsten light film A type of colour film with an *emulsion* designed to reproduce accurately the colours of subjects illuminated by *tungsten lamps*. Tungsten light is deficient in the blue end of the *visible spectrum*, and so this film has increased sensitivity to these wavelengths. Usually tungsten light film is for slides, for which there is no printing stage when any *colour cast* can be corrected, as with colour print film.

U

Under-exposure Allowing photographic material to receive

too little light, by using either too small an *aperture* or too brief a *shutter speed*.

Viewfinder An optical or televisual sighting device that allows the camera user to see the scene encompassed by the lens. Exposure settings may be displayed alongside the viewfinder in many cameras. Visible spectrum That part of electromagnetic radiation (light) that is visible to the naked eye. When separated out into its different wavelengths, the visible spectrum forms the familiar colours of the rainbow; when added together again, these form white light.

W

White balance System found on *digital cameras* that automatically adjusts the colour balance of the image being recorded to suit the *colour temperature*.

Wide-angle lens A fixed focal length lens with a wide angle of view. It makes all middle and far distant objects seem small and far away; and very close-up objects appear enlarged and distinct. It is useful for panoramas or in very confined spaces. Depth of field at any given aperture is extensive, making accurate focusing less critical.

Z

Zoom effect Deliberately altering the *focal length* setting of a *zoom lens* during the exposure to create blurred radial lines.

Zoom lens A *lens* with a *focal length* that can be continuously varied within its design limitations.

Zoom ratio Measurement of the extent of a *zoom lens*: the ratio between its longest and shortest *focal lengths*.

Index

	beach pictures 128-9	colour film 28–9
abstract patterns 101	birds in flight 204–5	colour framing 79, 116
action photography	black reflectors 188	colour temperature 28–9
and blur 214–15	black-and-white photography	compact cameras 18–19
creating a sense of action	88–9	composition of pictures 98
214–15	converting to colour 56, 57	depth of arrangement 112
equipment 41	with digital cameras 31	rule of thirds 104
flash units 212–13	film 30–1	contact prints 168
freezing movement 26–7	landscapes 146–7	continuous shooting 21
panning 210–11	portraits 122–3	contrast 55, 70, 76–9, 130, 150
shutter speed 26–7, 210,	tone 92–3, 94–5	tonal contrast 87
211	blur 62, 63	and top-lighting 171
Adobe Photoshop 55	and action photography	converging verticals 62, 63, 164,
Alhambra 172	214–15	206
ambient light 212	and backgrounds 63	crickets 195
animal subjects see wildlife	body language 122	cropping images 53, 60, 74
photography	bounced flash 33	
aperture settings 16, 24–5	brightness 55, 76–7	curves control 56, 59
and backgrounds 25	originaless 33, 70-7	_
and depth of field 25		D
f numbers 17	C	
and sharpness 15	O	darkrooms 48–9
APS film 20, 21	cable releases 157	depth of arrangement 112
architectural subjects 38–9	camera bags 38	depth of field 21, 24–5, 160
detail 167, 173	camera obscura 16	and digital cameras 85
facades 140–1	camera shake 26	
gardens 142–3, 198–9	camera types 18–19	detail in architectural subjects
knobs 168–9	cases 38	167, 173 differential focus 96
knockers 168–9		
viewpoints 164–5	character, in portraits 118–19	diffused colour 84–5
archive systems 50	children 124–5, 126–7	diffused light 109
arranged still-lifes 182–3	chromogenic film 30 church interiors 173	diffusers 44
		digital cameras 18–19, 29, 50–1
autofocus systems 20–1, 69, 116	circuses 132–3	archive systems 50
automated settings 20–1, 157	cityscapes 162–3	black-and-white pictures 31
_	classical framing 11	continuous shooting 21
B	close-ups 43, 200	cropping images 53, 60, 74
	lenses 22–3, 207	depth of field 85
Postting 26, 157	clouds 154	file formats 51
B setting 26, 157 back lighting 92	colour	filters 45
	adjustments to 56–7, 59	hard drives 50
backgrounds 98–9	against muted backgrounds 80–1	printing pictures 52–3
aperture settings 25 blurring 63		removable memory 29
colour against muted	brightness 55, 76–7	resolution and file size 51
backgrounds 80–1	diffused colour 84–5	sunsets 150
matching with foreground	and impact 78–9	tonal range control 95
123	and printing 53	white balance setting 150
123	saturated colour 82–3	see also image manipulation

shutter speed 126

for still-life 186-7

and shape 69

see also contrast

diminishing scale 96	bounced flash 33	
distance and depth of field 25	duration of flash 212	
		· .
documentary photography 160	fill-in flash 83, 130	
domestic animals 202–3	flash fall-off 33	illusions 102
doorways 100, 166	multiflash 172, 173	watery illusions 115
knobs and knockers 168–9	and reflective surfaces 115	
		image manipulation
double profiles 115	ringflash 43	black-and-white to colour
dramatic lighting 94	and shutter speed 212	conversion 56, 57
dust marks 60	and stage performances 132	blur tool 62, 63
dye sublimation printers 53	twin flashes 212	colour adjustments 56-7, 59
	flowers 198–9	
dynamic shapes 69	***************************************	converging vertical
	focal length 22-3, 27, 74	correction 62, 63
10 J	and portraits 110	curves control 56, 59
	focus	exposure 54–5
_		
1 1 1 2 7	autofocus systems 20–1, 69,	layers 58–9
early evening light 35	116	montaging 65
early morning light 34, 85	colour diffusion 84, 85	perspective changes 62
Eiffel Tower 165	differential focus 96	retouching 60–1
emphasising elements 104–5	zone of sharp focus 24–5	rotation 62
evening light 35	food subjects 190–1	sharpening and focusing
exposure 16–17, 54–5	foregrounds 99, 123, 136	62–3
multiple exposure 20	form 70–1	special effects 64–5
over-exposure 93	found still-lifes 180–1	stitching images 64
-	foxes 195	
expressions, in portraits 111,		unsharp mask (USM) 62
118–19	frame advance 21	image stabilisation systems 139
	framing 100–1	impact 78–9
_	classical framing 11	industrial landscapes 158-9
-	colour framing 79, 116	inkjet printers 52
•		
	facades 141	interior photography 39, 170–1
f numbers 17	interiors 170	large-scale interiors 172–3
facades 140-1	portraits 118	and people 174-5
facial expressions 111, 118-19	freezing movement 26–7	inverse square law 33
farms 196–7		
	Frink, Elizabeth 118	ISO numbers 16, 29, 30–1
fast films 31	frosty dawns 152	
field control see depth of field	frozen liquid 213	1
file formats 51	full face portraits 108	J
file size 51	permane rec	<i>a</i>
		IDEO CI - 51
fill-in flash 83, 130	\mathbf{C}	JPEG files 51
film	G	
APS 20, 21		17
black-and-white 30-1	gardens 142-3, 198-9	K
chromogenic 30	Gaussian blur 62	
_		
colour 28–9	geometric shapes 69	knobs and knockers 168–9
continuous shooting 21	ghost images 212	
fast films 31	glass and shiny objects 188-9,	•
loading 21	190	
		· · · · · · · · · · · · · · · · · · ·
medium films 31	Golding, William 119	
motordrive speed 21	graduated filters 149	landscapes 41, 148–9
printing 48–9	Grand Mosque 173	black-and-white
processing 48	group pictures 112–13	photographs 146-7
slow films 30	group pretares 112 13	
		cityscapes 162–3
speed (light sensitivity) 16,	Н	industrial 158–9
25, 28–9, 30–1, 144	11	monochromatic 144–5
filters 39, 41, 44-5, 128, 146		unusual 160–1
and glass reflections 190	hard drives 50	layers 58–9
graduated filters 149	hazy sun 151	leaden skies 154
	-	
UV filters 45, 154	high-key pictures 86, 90, 175	lenses 16, 22–3, 206–7
flash units 32–3, 42, 170, 204	Hockney, David 119	caring for 42
and action photography	home studios 46–7	for close-ups 22-3, 207
212-13	horizontal slices 99	macro 23 43 206

horizontal slices 99

212-13

macro 23, 43, 206

perspective control (PC)	multiflash 172, 173	profiles 108, 115
206, 207	multiple exposure 20	skin blemishes 122
prime 23	muted tone 87	street portraits 120-1, 132
and sharpness 15		three-quarter 108
shift lenses 39, 206	N.I.	weddings 130-1
speed 23	IN	in the workplace 118
standard 22-3		preview buttons 21
telephoto 23-5, 38-9, 167,	natural light 34-5, 138-9, 148-9	Priestley, J.B. 118
206	see also sun	prime lenses 23
ultra-wide 167	neutral density filters 45	printing 48–9, 52–3
wide-angle 23, 24, 25, 38-9,	night photography 35, 156–7,	and colour 53
136	163	paper 52, 95
for wildlife photography 194		prisms 44
zoom 22–3		processing films 48
levels adjustment 55, 56	O	profiles 108
light sensitivity of film 16, 25,		double profiles 115
28–9, 30–1, 144	obscured sun 151	public events 132–3
lighting	off-centre subjects 21	push processing 31
ambient light 212	over-exposure 93	push processing 51
back lighting 92	over exposure 75	_
diffused light 109	_	R
dramatic lighting 94	Р	• •
and form 70–1	-	radio-controlled shutter release
and mood 8	panning 27	40
natural light 34–5, 108–9,	and action photography	rain 152
138–9, 148–9	210–11	RAW files 51
photographic umbrellas 188	Paolozzi, Eduardo 118	red-eye 32–3
and portraits 42	paper for printing 52, 95	reflected light 92
position of the sun 68	parks and zoos 200–1	reflections 85, 93, 110, 114–15
reflected light 92	part views 102	and flash units 115
reflectors 108, 170, 188	patterns 69, 74–5, 167	night photography 156, 163
shooting into the sun 150–1	abstract patterns 101	reflectors 108, 170, 188
in studios 46–7	perspective 62, 96–7, 147	remote release devices 40
sun glare 35	and portraits 111	removable memory 29
and texture 72	perspective control (PC) lenses	resolution and file size 51
top-lighting 171	206, 207	retouching 60–1
lightproof changing bags 48	pets 202–3	ringflash 43
linear perspective 96–7, 147	photographic umbrellas 188	rotation 62
loading films 21	photomontage 59	rule of thirds 104
low-key pictures 86, 175	pinhole camera 17	
	polarising filters 45	0
N 4	portraits 42	S
IVI	in an environment 110	
	black-and-white 122-3	saturated colour 82-3
macro lenses 23, 43, 206	body language 122	scanners 51
medium films 31	character 118–19	scratches 60
mice 195	of children 124-5, 126-7	screens 114
midday light 34-5	double profiles 115	shape 68-9
middle grounds 99	facial expressions 111,	and colour 69
mirrored surfaces 114–15	118–19	repeating shapes 75
mist 152	focal length 110	sharpness 15, 62–3
monochromatic scenes 144-5	framing 118	shift lenses 39, 206
Mont St Michel 136-7	full face 108	shooting into the sun 150–1
montages 65, 176-7	group pictures 112–13	shutter speed 16, 17, 21, 26–7
mood 8	in isolation 110	and action photography
moonlit scenes 152	lighting 42	26–7, 210, 211
morning light 34, 85	in natural light 108–9	automated speeds 157
motordrive speed 21	perspective 111	B setting 26, 157
moving images see action	position and associations	and backgrounds 126
photography	116 17	and flash units 212

116-17

profiles 108, 115

and flash units 212

perspective control (PC) multiflash 172, 173

photography

and focal length 27
and panning 27
silhouettes 68, 69, 147
single lens reflex (SLR) camera
6, 18–19
size of printed images 53
skin blemishes 122
sky 154-5
slow films 30
software packages 54–5
see also image manipulation
special effects 64–5
filters 44
speed of films (light sensitivity)
16, 25, 28–9, 30–1, 144
stage performances 132
standard lenses 22–3
still-life 39
arranged 182–3
backgrounds 186-/
food subjects 190–1
found 180-1
glass and shiny objects
188–9
number of objects 183
props 185
sympathetic shapes 185
themes 184–5
stitching images 64
storms 154
street portraits 120-1, 132
studios 46–7
sun
hazy 151
obscured 151
position 68
shooting into 150–1
sun glare 35
sunsets 150, 154, 156
see also natural light
sympathetic shapes 185
•
т
1

teleconverters 207 telephoto lenses 23-5, 38-9, 167, 206 texture 72-3, 167, 173 three-quarter portraits 108 TIFF files 51 tone 86-7 and black-and-white photographs 92-3, 94-5 and over-exposure 93 and printing paper 95 tonal range 90-1, 94-5 tonal wash 147 toned images 57 top-lighting 171

tripods 26, 102, 139 twin flashes 212

ultra-wide lenses 167 unsharp mask (USM) 62 unusual landscapes 160-1 UV filters 45, 154

viewing systems 16, 18 viewpoints 102-3, 116, 164-5, 174 and portraits of children 124

watery illusions 115 weather conditions 40, 143, 144-5, 152-3 weatherproofing 128 weddings 130-1 white balance setting 150 wide-angle lenses 23, 24, 25, 38-9 and foregrounds 136 ultra-wide lenses 167 wildlife photography 40 birds in flight 204-5 domestic animals 202-3 farms 196-7 lenses 194 in natural surroundings 194-5 zoos and parks 200-1 windbreaks 43 windows 100, 101, 166 workplace portraits 118

zone of sharp focus 24-5 zoom lenses 22-3 zoos and parks 200-1

ABOUT THE AUTHOR

John Hedgecoe has had a long and distinguished career as a photography teacher. He is Emeritus Professor of Photography at the Royal College of Art in London and is one of the world's best selling writers on practical photography. John was staff photographer and Associate Editor of *Queen* magazine for 12 years and has worked for the *Times*, the *Daily Telegraph*, the *Observer*, *Vogue*, *Life* and *Paris Match*. His pictures are on permanent display in major international collections. His previous books, including *How to Take Great Holiday Photographing Landscapes* are recognised as standard reference works and have sold more than nine million copies worldwide.

ACKNOWLEDGEMENTS

The author would like to thank Chris George for all his help with the writing of this book; Olympus; Pentax; Agfa Films; Jon Anderson at Calumet; and Don Birch and Lindsay Spalding, The Beechwood Hotel, North Walsham, Norfolk.

The publishers are grateful to Tecno Cameras, of London EC2, for the loan of photographic equipment.

Photographic credits

Equipment photography in the first section of this book by Geoff Dann; all other photography by John Hedgecoe.

Artwork credits

All diagrams by Trevor Hill and David Ashby.